D1511964

NATIONAL ENDOWMENT

for the ARTS

A HISTORY
1965–2008

Edited by

MARK BAUERLEIN

with

ELLEN GRANTHAM

NATIONAL ENDOWMENT FOR THE ARTS

WASHINGTON, DC

Editor: Mark Bauerlein
Associate editor: Ellen Grantham
Production manager: Don Ball
Design: Beth Schlenoff Design
Cover photo: Terry J. Adams, National Park Service

202-682-5496 Voice/TTY
(a device for individuals who are deaf or hearing-impaired)

Individuals who do not use conventional print materials
may contact the Arts Endowment's Office for AccessAbility at
202-682-5532 to obtain this publication in an alternate format.

Library of Congress Cataloging-in-Publication Data

National Endowment for the Arts.
National Endowment for the Arts : a history, 1965–2008/
edited by Mark Bauerlein with Ellen Grantham.
 p. cm.
Includes index.
ISBN 978-0-615-23248-5
1. National Endowment for the Arts—History.
2. Federal aid to the arts—United States—History.
I. Bauerlein, Mark. II. Grantham, Ellen, 1979– III. Title.
NX735.N384 2009
700.973—dc22

 2008049381

"The arts and sciences are essential to the prosperity of the state and to the ornament and happiness of human life. They have a primary claim to the encouragement of every lover of his country and mankind."

George Washington

Contents

Foreword

HIS HISTORY of the National Endowment for the Arts attempts to give a concise, documentary account of the agency's major activities over the past forty-three years since its creation by the United States Congress. The book provides not only an authoritative survey of major programs and influential personnel, but also examines the complex and evolving role of the agency in the cultural and political life of the United States during that time. The history of the Arts Endowment is an eventful and sometimes controversial one, to be sure, and we have sought to present its many achievements and difficult episodes with candor, clarity, and balance.

Many hands have contributed to the book. Early drafts were prepared by Stephen Schwartz, Jon Parrish Peede, and me, with careful review and revision by Eileen Mason, Larry Baden, Ann Guthrie Hingston, Karen Elias, Felicia Knight, Tony Chauveaux, Patrice Walker Powell, Michael Faubion, and Victoria Hutter. Other NEA staff including Tom Bradshaw, Shana Chase, Mario Garcia Durham, Maryrose Flanigan, Carrie Holbo, Sunil Iyengar, David Kipen, Leslie Liberato, Pennie Ojeda, Jeff Speck, and Paula Terry contributed to the book. Ellen Grantham led the editorial team in the book's final stages, assisted by Laura Bradshaw, Michael Dirda, Jr., Michael Kettler, Eleanor Steele, and Jena Winberry. Don Ball managed the book's production.

I would like to thank all the previous NEA chairmen, whose memoirs, papers, speeches, and publications offered a wealth of information and perspective. Many former employees and associates were interviewed for the book, including Anne Arrasmith, Ann Meier Baker, Ed Birdwell, Gigi Bradford, Linda Earle, Henry Fogel, Leonard Garment, Jay Gates, Adrian Gnam, R. Philip Hanes, Jr., Omus Hirshbein,

Murray Horwitz, James Ireland, Arnold Lehman, Margaret M. Lioi, Rick Lowe, Robert Martin, Nancy Netzer, Brian O'Doherty, Earl A. Powell III, Peter Prinze, Ralph Rizzolo, Marc Scorca, Patrick J. Smith, A. B. Spellman, Andrea Snyder, Ana Steele, Jac Venza, William Vickery, and Joseph Wesley Zeigler.

As the project progressed, we decided to add several sections focusing on the Endowment's impact on six key fields in the arts. Written by the NEA directors of each discipline, these chapters highlight programs, policies, and influence of the National Endowment of the Arts in each area. Several individuals helped the directors prepare these chapters, including David Bancroft, Court Burns, Wendy Clark, Carol Lanoux Lee, Janelle Ott Long, Juliana Mascelli, Anya Nykyforiak, Georgianna Paul, Katja von Schuttenbach, Mary Smith, Jan Stunkard, Jeff Watson, Laura Welsh, and Alice Whelihan.

Mark Bauerlein

The HISTORY *of the* NEA

Introduction

T HE NATIONAL ENDOWMENT FOR THE ARTS—the NEA—is a unique agency in the panoply of federal institutions. Created by the Congress of the United States and President Lyndon B. Johnson in 1965, the NEA was not intended to solve a problem, but rather to embody a hope. The NEA was established to nurture American creativity, to elevate the nation's culture, and to sustain and preserve the country's many artistic traditions. The Arts Endowment's mission was clear—to spread this artistic prosperity throughout the land, from the dense neighborhoods of our largest cities to the vast rural spaces, so that every citizen might enjoy America's great cultural legacy.

The National Endowment for the Arts differs greatly from the prior federal arts programs established earlier under the Works Progress Administration (WPA) with which historians have most often compared it—the Federal Arts Project and Federal Writers' Project. These New Deal programs were created in the 1930s to employ jobless artists and writers during a national economic crisis. Out of the 15 million unemployed victims of the Great Depression, nearly ten thousand were artists. New Deal administrator Harry Hopkins defended federal support for artists by saying, "Hell, they've got to eat just like other people." In many instances the Federal Arts Project and similar efforts associated with it, such as the photographic work of the Farm Security Administration, bolstered President Franklin D. Roosevelt's political vision of how the nation would recover from economic devastation.

By contrast, the Arts Endowment was created neither to provide work for the unemployed nor to deliver a political message. The idealistic optimism expressed at the

A mural created by the Brandywine River School artists in the 1930s as part of the Works Progress Administration (WPA). The mural hangs in the John Bassett Moore School in Smyrna, Delaware. (Photo courtesy of Smyrna School District)

birth of the NEA was very different from the hope for restoration of American prosperity during the Depression. In the NEA's case, hope bore no connection to despair, but functioned purely as an exaltation of the spirit.

The distinctive origins of the federal arts programs of the New Deal and of the National Endowment for the Arts were reflected in the kinds of art with which each federal initiative was associated. The New Deal programs *produced* art, most memorably in the visual fields. Murals, such as those by Thomas Hart Benton, and other paintings in a recognized style, some with a similar visual approach, became a hallmark of WPA-produced art. Other artists not subsidized by these programs echoed this style. A school of "WPA art" thus became a major phenomenon of the New Deal era. Paralleling the political mission of WPA art in supporting New Deal programs, such works also reflected a commitment on the part of many artists in that epoch to collectivist values and the promotion of government in society. In 1940, President Roosevelt spoke of the effects his arts policy initiatives had on the American public:

> They have seen, across these last few years, rooms full of paintings by Americans, walls covered with all the paintings of Americans—some of it good, some of it not good, but all of it native, human, eager, and alive—all of it painted by their own kind in their own country, and painted about things they know and look at often and have touched and loved.

Neither the Arts Endowment nor the artists or arts administrators who advised the agency over the past four decades have sought to align the NEA with a sociopolitical agenda. Nevertheless, the NEA has some elements in common with that of New Deal programs for artists and writers. The first and most obvious similarity is that both strived to bring culture to the people. The second is that both endeavors represented irreplaceable records of the intellectual and ideological challenges that have gripped America. During the New Deal, the photographic scrutiny of Walker Evans, Dorothea Lange, and others subsidized by federal arts programs did not turn

away from the drama of America struggling to rise from economic deprivation. Similarly, in America over the past 40 years, a wide range of works supported by the NEA, as well as the occasional controversies that have accompanied its activities, have reflected social and cultural changes in direct and illuminating ways. Few federal agencies can offer the public or future historians so thorough and eloquent a record of American cultural development as the NEA.

Pablo Casals performs for President John F. Kennedy, Puerto Rican Governor Luis Muñoz Marín, and other distinguished guests in the East Room of the White House, November 13, 1961. (Photo by Robert Knudsen, White House/John Fitzgerald Kennedy Library)

Hope and Inspiration

W ITH THE ELECTION of President John F. Kennedy in 1960, enthusiasm for America as a nation dedicated to the arts seemed poised to become a widespread movement. Even before the election, at the end of the Eisenhower Administration, a precursor of this new energy in the arts was witnessed when poet Carl Sandburg and actor Fredric March addressed a Joint Session of Congress on February 12, 1959 to mark the 150th anniversary of the birth of Abraham Lincoln.

At President Kennedy's inaugural, on the steps of the U.S. Capitol, his Administration's commitment to creativity was symbolized by Robert Frost reciting a poem, "The Gift Outright," from the ceremonial dais. Though gusty winds that day rendered him inaudible, the image was captured on television and stirred the public imagination. The Abstract Expressionist painters Franz Kline and Mark Rothko, whose works were anything but conventional, also attended the historic occasion.

Another prominent artistic moment associated with President Kennedy's term was cellist Pablo Casals's performance at the White House in 1961. The Casals event was notable in a number of ways, which President Kennedy emphasized in his opening remarks. First, it was intended not only as homage to Casals, but to Puerto Rico and its reforming governor, Luis Muñoz Marín. Second, President Kennedy pointed out that Casals, who was 84 when he performed in 1961, had also played in the White House for President Theodore Roosevelt in 1904. Finally, President Kennedy alluded to Casals's refusal to return to his native Catalonia, which was then under the dictatorship of Francisco Franco. The President closed his remarks with the words, "An artist must be a free man."

At the end of 1961, President Kennedy further recognized the significance of the arts to the national well-being when he sent Labor Secretary Arthur J. Goldberg to settle a pay dispute between the Metropolitan Opera in New York and the American Federation of Musicians. On announcing the resolution of the conflict, Goldberg called for government subsidies to the performing arts and proposed that business join with labor in supporting the arts.

A high point in the intellectual history of the Kennedy Administration involved the French Minister of Culture, novelist, and essayist André Malraux. A flamboyant and venturesome cultural figure from the 1920s through the 1970s, Malraux had played host to the Kennedys when they visited France in 1961. The following year, Malraux came to Washington, where First Lady Jacqueline Kennedy returned the favor. A White House dinner for the French minister included performances by violinist Isaac Stern, pianist Eugene Istomin, and cellist Leonard Rose. During his visit, Mrs. Kennedy asked Malraux if France would be willing to allow Leonardo da Vinci's *Mona Lisa* from the Louvre to be exhibited in the United States. Malraux assented— to the shock and alarm of French diplomats, who considered the decision hasty. But in January of 1963, Malraux returned to Washington to introduce "the greatest picture in the world," which was displayed at the National Gallery of Art. The painting was also shown at the Metropolitan Museum of Art in New York and returned to France aboard the SS *United States* on March 7. In the 27 days the *Mona Lisa* was on display in Washington, DC, more than half a million people came to view it.

A NEW CONCEPTION

Notwithstanding the breadth of American creativity and the power of federal authorities, the United States had never established a permanent official body dedicated to the proposition, enunciated by President Kennedy, that the nation has "hundreds of thousands of devoted musicians, painters, architects, those who work to bring about changes in our cities, whose talents are just as important a part of the United States as any of our perhaps more publicized accomplishments." To recognize their contributions to the United States, President Kennedy named August Heckscher, grandson of a Gilded Age industrialist who founded the Heckscher Museum in Huntington, New York, as his special consultant on the arts. Heckscher, described by the film critic Richard Schickel as "humane, sweet-tempered, rational, and liberal-minded," had a long list of accomplishments outside the art world—a master's degree in government from Harvard, service with the Office of Strategic Services in World War II, member

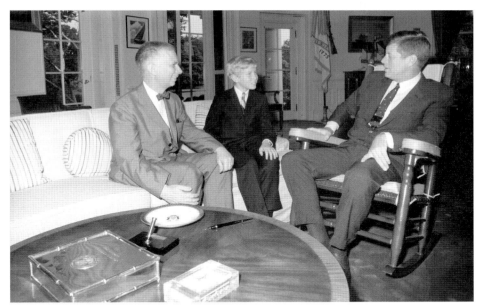

President John F. Kennedy meets with Special Consultant on the Arts August Heckscher and Heckscher's son in the Oval Office. (Photo by Robert Knudsen, White House/John Fitzgerald Kennedy Library)

of the U.S. delegation at the United Nations conference in 1945, and chief editorial writer at the *New York Herald Tribune* in the 1950s. After serving under President Kennedy, he went on to be Parks, Recreation, and Cultural Affairs Commissioner for New York City.

Heckscher completed the report, "The Arts and the National Government," in May 1963, and submitted it to Congress and the President six months before President Kennedy's death. A few months earlier, in January, Senator Jacob Javits (R-NY), with co-sponsors Senators Joseph Clark (D-PA), Hubert Humphrey (D-MN), and Claiborne Pell (D-RI), had introduced S.R. 165 "to establish a U.S. National Arts Foundation," and in April Senator Humphrey had introduced S.R. 1316 "to establish a National Council on the Arts and a National Arts Foundation to assist the growth and development of the arts in the U.S." Initial co-sponsors of S.R. 1316 besides Clark, Pell, and Javits, were John Sherman Cooper (R-KY), Russell B. Long (D-LA), Lee Metcalf (D-MT), Jennings Randolph (D-WV), Abraham Ribicoff (D-CT), and Hugh Scott (R-PA). Supported by the Senate's actions, Heckscher's report led to the establishment of the President's Advisory Council on the Arts, the direct predecessor of the current National Council on the Arts.

President John F. Kennedy viewing a model of the National Cultural Center by its architect, Edward Durell Stone (2nd from right), with future NEA Chairman Roger L. Stevens looking on (far left). (Photo courtesy of the Kennedy Center Archives)

President Kennedy's death delayed the appointment of members to the Advisory Council. But his vision for the arts did not perish with him. At the time of Kennedy's assassination, a proposal was already in the works for a National Cultural Center in Washington, DC. The project was launched in 1958, when President Dwight D. Eisenhower signed the National Cultural Center Act—legislation authorizing construction of a performance and educational space that would be independent and privately funded. (President Eisenhower's role in the project is memorialized in the Eisenhower Theater at the Kennedy Center.) In 1961, Roger L. Stevens, who later became the first chairman of the National Endowment for the Arts, was named chairman of the board for the new performing arts center, which became The John F. Kennedy Center for the Performing Arts—a national memorial to the late president. Jarold A. Kieffer, the first board secretary and executive director of the project, wrote in his 2004 memoir, *From National Cultural Center to Kennedy Center,* "With

bipartisan support in the Congress, President Johnson . . . signed legislation authorizing that the Center bear Kennedy's name and providing a grant of $15.5 million in public funds. Congress specified that this grant was to be matched by an equal sum that the trustees had to raise from strictly private sources."

President Kennedy's legacy remained as much represented by Heckscher's efforts as by the new center. Significantly, Heckscher avoided discussing what America needed from a federal agency for promotion of the arts. In a somewhat flat, governmental tone, his report broached topics that would be non-issues in the first four decades of the NEA, such as acquisitions for "government collections of art, public buildings, American embassies," as well as urban planning in Washington, postal rates, copyright laws, employment of artists to memorialize military events and space-exploration episodes, and a wide range of other official concerns.

Yet Heckscher's report did identify the essential stimulus for the creation of a new federal arts agency—the historical development in American society that propelled the process to fruition. America in the 1960s was different from America at the end of the nineteenth century, when its wealthy elite created many of the major cultural institutions in the U.S., and different from America stricken by the heartbreak of the Depression, when citizens needed reassurance that their collective dream could be renewed. When Theodore Roosevelt hosted Casals at the White House, and the New Deal hired artists and writers, impetus for such efforts came from above. Heckscher's report described an avid interest in the arts felt among the populace, and this demand was fueled by growing prosperity and rising expectations. Heckscher wrote, "Recent years have witnessed in the U.S. a rapidly developing interest in the arts. Attendance at museums and concerts has increased dramatically. Symphony orchestras, community theaters, opera groups, and other cultural institutions exist in numbers which would have been thought impossible a generation ago."

Heckscher offered a simple explanation for these trends—namely, "increasing amount of free time, not only in the working week, but in the life cycle as a whole." Heckscher paid due homage to President Kennedy's ideal of an America that would lead the free world to victory over totalitarianism. As Kennedy once said, "The life of the arts, far from being an interruption, a distraction, in the life of a nation, is very close to the center of a nation's purpose . . . and is a test of the quality of a nation's civilization." Most of all, the creation of the National Endowment for the Arts was unquestionably a product of youthful energy and presidential leadership of the 1960s, reflecting a broader interest in the fine arts that began to flower in America after the Second World War.

America was changing profoundly, with more Americans attending college than ever before. As baby boomers matured, so did America's taste, habits, and mores. Far from the traditional centers of culture, people were demanding a local presence for music, dance, theater, and visual art. More and more, along with European immigrants who wanted classical culture, citizens were claiming the heritage of Walt Whitman, Edward Hopper, Frank Lloyd Wright, Martha Graham, Louis Armstrong, and other great American artists as their birthright, and they wanted access to music education, dance performances, professional drama, and regional artists. The National Endowment for the Arts, it turned out, would play a central role in heeding that call.

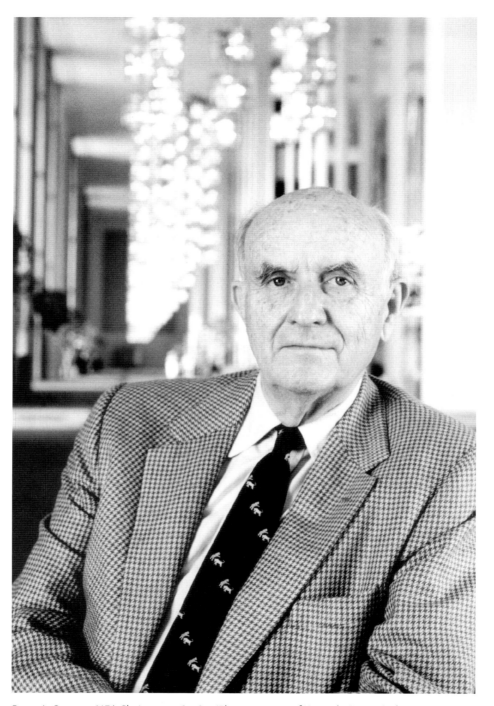

Roger L. Stevens, NEA Chairman 1965–69. (Photo courtesy of Kennedy Center Archives)

A New World Beckons

AFTER PRESIDENT KENNEDY'S DEATH in 1963, the mission of founding a federal arts agency passed to Lyndon B. Johnson, who had credentials as a world-changer in his own right. A southern Democrat, he had broken with the tradition of his region and party to advocate for full African-American citizenship, which he would finalize two years later with the signing of the Voting Rights Act of 1965. President Johnson was also the only American president to have served his political apprenticeship as part of the New Deal. At the beginning of his career, he was the director of the National Youth Administration in Texas, a New Deal agency created to provide education, recreation, counseling, and part-time jobs to high school and college youth. President Johnson carried forward the Rooseveltian tradition in the form of the "Great Society," and quickly warmed to the task of establishing a federal arts agency. He also clearly sought to maintain the youthful and sophisticated persona of the Kennedy Administration.

Soon after becoming President, Johnson named Roger L. Stevens as America's first full-time presidential arts advisor. Not only had Stevens served at the top level on the project that became the Kennedy Center, but he was also a successful Broadway producer and a board member of prominent arts institutions. Stevens began working for passage of a set of Congressional measures intended to realize the visions of Presidents Kennedy and Johnson. On December 20, 1963, after hearings by Senator Claiborne Pell (D-RI), then-chairman of the Senate Special Subcommittee on the Arts, the Senate passed S.R. 2379, which combined provisions of the two earlier bills. Three weeks later, on January 8, 1964, Representative Frank Thompson

(D-NJ) introduced H.R. 9586 "to provide for the establishment of a National Council on the Arts to assist in the growth and development of the arts in the U.S." and H.R. 9587 "to provide for the establishment of a National Council on the Arts and a National Arts Foundation to assist in the growth and development of the arts in the United States."

Senators Claiborne Pell, Hubert Humphrey (D-MN), and Jacob Javits (R-NY) were major figures in modern American politics, and all represented the well-established liberal strains of the Democratic and Republican leadership in the 1950s and 1960s. All three espoused the vision of America as a dominant world leader in culture and education. Senator Pell had overseen hearings on the proposed legislation beginning in October 1963—before the death of President Kennedy—and concluding after two months of debate. Senator Pell, known as a consistent supporter of American education, backed the creation of the National Endowment for the Humanities as well as the NEA. He opened the 1963 hearings with a momentous statement: "I believe that this cause and its implementation has a worldwide application; for as our cultural life is enhanced and strengthened, so does it project itself into the world beyond our shores. Let us apply renewed energies to the very concept we seek to advance: a true renaissance—the reawakening, the quickening, and above all, the unstunted growth of our cultural vitality."

Senator Humphrey was the first to speak in the 1963 discussion on the Senate floor. He had begun his career in elected office as a reforming mayor of Minneapolis, taking leadership of the state's Democratic-Farmer-Labor movement. Known as a "fighting liberal," he had worked for social betterment while also combating Communist influence in Minnesota. He won his first Senate term in 1948; the same year, he led a floor fight at the Democratic National Convention for a commitment to African-American civil rights in the South.

Senator Humphrey's tone during the 1963 hearings was characteristic of his strong personal commitment, as well as his eloquence. He declared, "This is at best a modest acknowledgement . . . that the arts have a significant place in our lives, and I can think of no better time to place some primary emphasis on it than in this day and age when most people live in constant fear of the weapons of destruction which cloud man's mind and his spirit and really pose an atmosphere of hopelessness for millions and millions of people . . . if there was ever an appropriate time for the consideration of this legislation it is now." Senator Humphrey observed, "The arts seldom make the headlines. We are always talking about a bigger bomb . . . I wonder if we would be willing to put as much money in the arts and the preservation of what

has made mankind and civilization as we are in . . . the lack of civilization, namely, war."

Senator Javits, a Republican, was no less a representative of moderate liberalism. A friend of labor and civil rights, he embodied local reform traditions in the Empire State—a practice that drew support across party lines. In the same 1963 Senate colloquy, he said, "Congress is lagging far behind the people in its failure to recognize the national importance of developing our cultural resources through support of the arts. It is high time that Congress took a real interest in this very essential part of our national life. Our national culture explosion is reflected in the number of arts festivals held this year, the growing number of new cultural centers in cities throughout the country, and the increasing list of state and local governments who have set up arts councils on the pattern of the New York State Council on the Arts."

In the past, Javits noted, most support came from philanthropic organizations, not from the federal government; but private funding was no longer enough. Furthermore, Javits continued, "Almost every civilized country in the world provides some assistance to the development of its art and culture." He added, "Some of the most renowned cultural institutions in the world would not be able to exist without government support," citing the Comédie-Française in Paris, the Danish Royal Ballet, the Old Vic Theatre in London, and the Vienna State Opera.

NATIONAL COUNCIL ON THE ARTS ESTABLISHED

Approval for the arts proposals was delayed in the House, but in August 1964, legislation to establish the National Council on the Arts (NCA) passed the House of Representatives by a vote of 213 to 135. The Senate adopted the bill the following day on a voice vote. On September 3, the National Arts and Cultural Development Act of 1964 was signed by President Johnson, establishing the council with 24 members to "recommend ways to maintain and increase the cultural resources of the nation and to encourage and develop greater appreciation and enjoyment of the arts by its citizens." One month later, an appropriation of $50,000 was approved for the NCA.

In March 1965, the Rockefeller Brothers Fund issued a report entitled *The Performing Arts: Problems and Prospects* (Nancy Hanks, a future chairman of the Arts Endowment, was the project director). The publication maintained that federal support was crucial to the future of the arts in America. The first meeting of the National Council on the Arts was held on April 9–10 at the White House and the Smithsonian Institution's Museum of Science and Technology. Council members discussed

numerous issues, including revision of copyright laws, fine arts decoration of all future federally financed buildings, annual awards for outstanding artists, assistance to public television programming in the arts, improved cultural facilities and programs in national parks, transfer of surplus property to nonprofit arts institutions, and the recognition of museums and cultural centers as public facilities equal in importance to libraries and schools.

The council established subcommittees for each artistic discipline. These subcommittees came back with proposals to train professional arts administrators, to provide direct support to dance companies and resident professional theaters, to establish the American Film Institute, and to preserve oral traditions. The council's second meeting took place in Tarrytown, New York, on June 24, 1965. At Tarrytown, the recommendation was made that creative artists be aided financially, to release them from other employment so that they might concentrate on creative work.

Composer/conductor Leonard Bernstein, violinist Isaac Stern, and president of the Metropolitan Opera Association Anthony A. Bliss talk at one of the first National Council on the Arts meetings in Tarrytown, New York. (Photo by R. Philip Hanes, Jr.)

A Distinguished Roster

The National Council on the Arts in 1965 counted among its members some of the most distinguished and talented artists, directors, and academics in the United States. Appointed by President Johnson, the first council included novelist Ralph Ellison; Paul Engle, poet and longtime director of the Iowa Writers' Workshop; actors Elizabeth Ashley and Gregory Peck; Oliver Smith, theatrical designer, producer, and painter; William Pereira, architect and former film producer; Minoru Yamasaki, architect; George Stevens, Sr., film director and producer; composer and conductor Leonard Bernstein; choreographer Agnes de Mille;

violinist Isaac Stern; sculptor David Smith; and newsman David Brinkley. By February 1966, the council had added four new members: Herman David Kenin, president of the American Federation of Musicians, who stepped in following David Smith's death in May 1965; novelist John Steinbeck, who replaced David Brinkley after work demands forced the journalist to withdraw; writer Harper Lee; and painter Richard Diebenkorn.

Museum directors and organization leaders included René d'Harnoncourt, director, the Museum of Modern Art; Albert Bush-Brown, president, Rhode Island School of Design; James Johnson Sweeney, director, Houston Museum of Fine Arts, and a leading historian of modern art; Anthony A. Bliss, president, Metropolitan Opera Association; Stanley Young, executive director, American National Theater and Academy; Warner Lawson, dean, College of Fine Arts, Howard University; Otto Wittmann, director, Toledo Museum of Art; R. Philip Hanes, Jr., president, Arts Councils of America; Eleanor Lambert, honorary member, Council of Fashion Designers of America; Father Gilbert Hartke, Speech and Drama Department, Catholic University of America; and, ex-officio, Dr. S. Dillon Ripley, secretary, Smithsonian Institution. Roger Stevens was named chairman.

EARLY STATE ARTS COUNCILS

During the same year the Arts Councils of America (ACA), later known as the Associated Councils of the Arts, a precursor to the National Assembly of State Arts Agencies, expanded and opened its first office in New York. Nancy Hanks, future chairman of the NEA, played a key role in firmly establishing the ACA. Hanks was a Southerner, and much of the work that culminated in the inauguration of ACA had begun in North Carolina, where business entities in Winston-Salem had joined a council to support the arts to improve the state's national reputation damaged by images of poverty and racial turmoil. A similar major business initiative took place on a national scale in the fall of 1967, when David Rockefeller and other corporate leaders inaugurated the Business Committee for the Arts. Chaired by C. Douglas Dillon, who had served as Undersecretary of State under President Eisenhower and as Secretary of the Treasury in the Kennedy Administration, and later as president of the Metropolitan Museum of Art, the committee aimed to devise strategies to bring the business and arts communities into partnerships and more effective forms of mutual support.

President Lyndon B. Johnson signs the Arts and Humanities Act on September 29, 1965.
(Photo courtesy of the Lyndon Baines Johnson Presidential Library)

AN AGENCY IS BORN

On September 29, 1965, President Johnson signed the National Foundation on the Arts and the Humanities Act establishing the National Endowment for the Arts and the National Endowment for the Humanities. The Arts and Humanities Act included language clearly reminiscent of the Kennedy-era pledge to enhance America as a global exemplar: "The world leadership which has come to the United States cannot rest solely upon superior power, wealth, and technology, but must be founded upon worldwide respect and admiration for the nation's high qualities as a leader in the realm of ideas and of the spirit."

That affirmation appeared in the "Declaration of Purpose" that Congress included as the second section of the act. It further stated:

• "The encouragement and support of national progress and scholarship in the humanities and the arts, while primarily a matter for private and local initiative, is also an appropriate matter of concern to the Federal Government;

- "A high civilization must not limit its efforts to science and technology alone but must give full value and support to the other great branches of man's scholarly and cultural activity;

- "Democracy demands wisdom and vision in its citizens and . . . must therefore foster and support a form of education designed to make men masters of their technology and not its unthinking servant;

- "The practice of art and the study of the humanities require constant dedication and devotion and . . . while no government can call a great artist or scholar into existence, it is necessary and appropriate for the Federal Government to help create and sustain not only a climate encouraging freedom of thought, imagination, and inquiry but also the material conditions facilitating the release of this creative talent."

THE FIRST NEA GRANTS

With its first appropriations bill signed October 31, 1965, the Arts Endowment started its inaugural fiscal year with only eight months remaining, a budget of $2.5 million, and fewer than a dozen employees. The first NEA grant was made to the American Ballet Theatre in December, when Vice President Hubert Humphrey presented the organization with $100,000. The *New York Times* critic Clive Barnes wrote at the time, "History, or at least a tiny footnote to history, was made. . . . At the home of Oliver Smith, co-director of American Ballet Theatre with Lucia Chase, the first presentation of money was made by the National Council on the Arts." The *New York Herald Tribune* commented, "The Treasury of the United States has saved a national treasure."

Other initial grant recipients included:
- The Martha Graham Dance Company for its first national tour in 15 years;
- A pilot program in New York City, Detroit, and Pittsburgh entitled Poets in the Schools;
- Choreography fellowships to Alvin Ailey, Merce Cunningham, José Limón, and Paul Taylor.

The first complete series of grants was made in fiscal year 1967, with a budget of nearly $8 million. These early grants illustrate the great range of projects the Arts Endowment has supported since its inception, as well as its expanding reach across the nation. They included:
- In architecture, planning, and design: 11 grants were awarded, totaling $281,100, to the Hawaii State Foundation on Culture and the Arts and the Lake Michigan

The first NEA grant was made in 1965 to the American Ballet Theatre, shown here performing *Swan Lake*. (Photo by Martha Swope)

Region Planning Council, among others;

• In dance: seven grants totaling $177,325, reaching companies as geographically diverse as the American Dance Festival at Connecticut College and a Washington State Arts Commission summer residency in the Pacific Northwest;

• In education: ten institutional grants and five awards, totaling $892,780, to college graduates of art programs;

• In folk art: one grant for $39,500 to the National Folk Festival Association, later renamed the National Council for the Traditional Arts;

• In literature: the first series of grants to 23 creative writers as well as grants to nine literary organizations, totaling $737,010;

• In music: 18 grants totaling $653,858, to the Composer Assistance Program and to recipients such as the American Choral Foundation, symphony orchestras in Denver and Boston, and the New York City Opera to expand a program allowing training and on-the-job experience for young singers and aspiring conductors;

• In public media: four grants totaling $788,300, in support of a range of educational television programs in the arts;

• In theater: 23 grants totaling $1,007,500, including awards for resident professional theaters such as the Tyrone Guthrie Theater in Minneapolis, Arizona Repertory Theatre, Cleveland Play House, Actors Theatre of Louisville, and the Seattle Repertory Theatre;

• In the visual arts, 60 individual grants and a range of other awards were given, totaling $735,995. Visual arts grants included funding for public sculpture in Philadelphia, Houston, and Grand Rapids, Michigan, as well as support for the Institute of Contemporary Art in Boston, the Amon Carter Museum of Western Art in Fort Worth, and the Detroit Institute of Arts.

In the fall of 1966, regional panels had begun convening to discuss the first NEA grants to visual artists. The New York panel included Metropolitan Museum curator Henry Geldzahler; painter Robert Motherwell; critic Barbara Rose; and sculptor George Segal. Segal had previously denounced the concept of a governmental program to fund the arts as resembling "Soviet-type" manipulation of culture, but he was convinced to participate after discussions with Chairman Roger Stevens.

In retrospect, the first NEA Literature, Visual Arts, and Dance Fellowships are impressive in their critical perspicacity. In the visual arts, the roster of 60 names included numerous artists then outside the mainstream, such as the California artists Wallace Berman, Ed Ruscha, Billy Al Bengston, and Gary Molitor. The first grantees on the East Coast and in the Midwest were equally remarkable. In New York, Alfred Leslie secured one of the many timely grants the NEA would award over the years to assist artists in dire need. A successful artist in gallery sales, Leslie turned from abstract expressionism to portraiture in 1962. The NEA panels that met in 1966 had not considered him, but subsequently a fire destroyed his studio, along with a considerable inventory of his most recent paintings. His NEA grant came in the aftermath and rescued him financially. He went on to receive the Award of Merit Medal in Painting for lifetime achievement from the American Academy of Arts and Letters in 1994.

In literature, the first fellowships assisted notable writers of fiction and poetry such as Maxine Kumin, William Gaddis, Grace Paley, Tillie Olsen, and Richard Yates. The NEA also awarded three grants to biographers made jointly with the National Endowment for the Humanities, including one to Faubion Bowers, biographer of the Russian composer Alexander Scriabin, and one to Allan Seager, biographer of the poet Theodore Roethke.

For choreography, as noted above, the first round of grants went to Alvin Ailey, Merce Cunningham, Martha Graham, José Limón, Alwin Nikolais, Anna Sokolow, and Paul Taylor—an exemplary roster of talent. One of the works subsidized, Martha Graham's *Cortege of Eagles,* inspired by events in the Trojan War, was eventually performed using the final set design created by sculptor Isamu Noguchi. The piece had historical value for another reason, as Graham later wrote: "The last time I danced was in *Cortege of Eagles.* I was seventy-six years old . . . I did not plan to stop dancing that night. It was a painful decision I knew I had to make."

Involvement with the New Trends in Art

These initial grants demonstrated that the NEA was closely involved with the current movements and trends in American creative life. In the visual arts the agency supported pop art and neo-surrealism, while at the same time it fostered appreciation of other styles and genres. The Arts Endowment did not reward only established artists; it encouraged young and fresh talents previously overlooked or growing in acceptance. Other front-line figures in the historic roster of 1967 visual arts grantees included Leon Polk Smith, Mark di Suvero, Dan Flavin, Donald Judd, Manuel Neri, Tony Smith, and H. C. Westermann. None of these artists were traditionalists. The exacting modernist critics Hilton Kramer, then of the *New York Times,* and Thomas Hess, of *ARTnews,* praised the choices as excellent. All of the grantees had been selected by their colleagues, and none had applied for NEA support. The new agency had not yet adopted a mechanism for applications.

The other areas of creativity saw equally impressive awards in the first year. Architecture, planning, and design grants were made for landscape beautification, including hiking and bicycle trails, town redesign, and a series of environmental guides. The architectural and environmental theorist R. Buckminster Fuller received a grant to erect one of his innovative geodesic domes at the 1967 Festival of Two Worlds in Spoleto, Italy.

Hundreds of Grand Rapids, Michigan, residents turned out for the 1969 dedication of Alexander Calder's *La Grande Vitesse*, supported by the NEA public art initiative in 1967. (Photo courtesy of the Grand Rapids Public Library)

FILM, TELEVISION, AND DANCE

A remarkable achievement of the early years of the NEA and its mission to support film was the creation of the American Film Institute (AFI), a durable and productive partnership between the U.S. government and the movie industry. An innovative grant was also made in 1967 to New York National Educational Television (WNET) for two programs on American fashion designers, including an award-winning documentary on Pauline Trigère. In the same year, dance benefited substantially from NEA assistance, with funding provided for the Association of American Dance Companies, the City Center Joffrey Ballet, and individual recipients.

ARTS EDUCATION

From the beginning, education in the arts has been an area of significant investment by the Arts Endowment. In 1967, education grants included major financing of a national film study program by Fordham University to develop film and television training curricula for elementary and secondary schools—an idea that remains

American Film Institute

By the mid-sixties, the U.S. film industry was more than 75 years old, and many groundbreaking works of early cinema were aging past the point of preservation. Recognizing the danger, the newly founded National Endowment for the Arts moved quickly. It commissioned a study by Stanford Research Institute to explore the prospects for a new institution, and then joined the Motion Picture Association of America and the Ford Foundation to create the now renowned American Film Institute (AFI). Gregory Peck chaired the first board of trustees, and producer

The American Film Institute, founded in 1967 with funding from the NEA, has preserved thousands of films, such as *Broken Blossoms* (1919) starring Lillian Gish. (Photo courtesy of AFI)

George Stevens, Jr., became its first director.

The NEA provided an initial grant of $1.3 million to AFI for a project to collect, preserve, and archive nitrate films. By 1971, more than 4,500 films had been recovered and preserved. Through continued NEA funding, the American Film Institute expanded to establish a National Center for Film and Video Preservation, publish the *AFI Catalog of American Feature Film,* and create national exhibition programs. In 1987, the NEA's funding for AFI activities reached its high point with awards totaling $3.5 million.

Though Arts Endowment support decreased over the years, AFI is still thriving. The institute presents more than 3,000 events annually, including film festivals and workshops. Its prestigious Life Achievement Award has honored Billy Wilder, Frank Capra, Elizabeth Taylor, Sidney Poitier, and many others for their contributions to film history. AFI maintains its mission of preservation, and as of 2008, more than 27,500 feature films, shorts, newsreels, documentaries, and television programs dating from 1894 to the present comprise the AFI Collection at the Library of Congress. Among its recent acquisitions are a ten-minute 1912 film, *A Fool and His Money,* produced by the first female director, Alice Guy, and starring an entirely African-American cast; and *The Life of General Villa* (1914), featuring Pancho Villa.

revolutionary today. A large grant, especially in 1967 dollars, of $681,000 was made for a Laboratory Theatre Project to assist in training secondary school students in classical drama. The project supported professional theater companies in three cities with free performances for secondary school students on weekday afternoons and for adults on weekends. It was aimed at improving the quality of school instruction by making high-quality theater presentations integral to high school curricula. The three pilot cities were Providence, Rhode Island; New Orleans; and Los Angeles, and performances included Anton Chekhov's *Three Sisters,* George Bernard Shaw's *Saint Joan,* Thornton Wilder's *Our Town,* and Richard Brinsley Sheridan's *The Rivals.* The spirit of this early NEA program was later revived and transformed through the Shakespeare in American Communities initiative, under future NEA Chairman Dana Gioia.

LITERATURE

In 1967, the Arts Endowment's Literature Program awarded 23 grants to individual writers. In fiction as in the visual arts, the awards demonstrated a clear recognition of excellence. Eleven years after his NEA grant, Isaac Bashevis Singer, who wrote in Yiddish and whose works were traditionally published as serials in the New York daily *Forward,* received the Nobel Prize in Literature. His NEA grant permitted him to finish his novel *The Manor.* Tillie Olsen, whose literary career had begun amid the idealism of the 1930s, was only then emerging as an influential figure in American feminist letters when she received her NEA grant. Richard Yates has come to be seen by literary critics and readers as a leading voice exploring alienation and loneliness in mid-century America.

Literary institutions, including the Coordinating Council of Literary Magazines, were chosen in the first series of grants, which provided advice and funds to publications such as *Poetry, The Hudson Review, Kenyon Review, Southern Review,* and *The Virginia Quarterly Review.* In addition, the Endowment provided $25,000 to the Watts Writers' Workshop, established by the novelist and screenwriter Budd Schulberg in the aftermath of rioting in the Watts district of Los Angeles in 1965. The Experimental Playwrights' Theater received a total of $125,000 to produce plays by Robert Lowell at Yale University and by Studs Terkel at the University of Michigan. In addition, the NEA funded Howard Sackler's *The Great White Hope,* one of the landmark dramatic works of its time starring James Earl Jones and Jane Alexander—who would become Arts Endowment chairman in 1993.

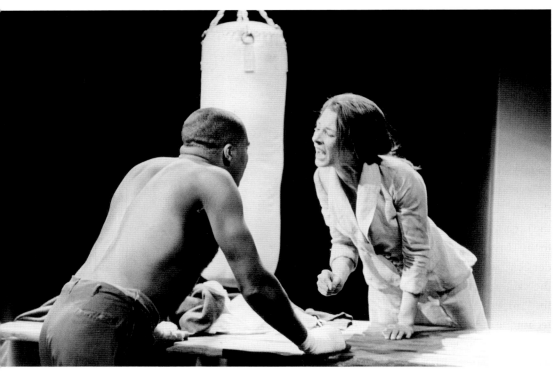

The NEA funded the original production of Howard Sackler's *The Great White Hope*, starring James Earl Jones and future NEA Chairman Jane Alexander. (Photo courtesy of Arena Stage)

The first poets to receive individual NEA grants included Maxine Kumin, Mona Van Duyn (who later became the first female U.S. Poet Laureate), Hayden Carruth, Robert Duncan, and Kenneth Patchen, as well as the translator I. L. Salomon, who was completing the translation of works by modern Italian poets such as Dino Campana. The presence of Duncan on this list demonstrates the range of tastes exemplified by these grants. He was a West Coast figure of mystical bent whose work was known mainly to other poets, though his poems are affecting in their humor, tenderness, and wisdom.

Music

The Arts Endowment's early grantmaking covered the full range of musical fields, with funds going to projects ranging from professional development institutes to organizational workshops, from individual fellowships to major productions. In

1967, large grants supported national tours by the Metropolitan Opera and the San Francisco Opera's Western Opera Theater, along with a grant to Carnegie Hall's *Jeunesses Musicales,* a youth program. The Metropolitan Opera grant enabled the company to give additional performances for labor groups and students in many states so that new audiences could be exposed to the art form. Grants were distributed to composers through a Composer Assistance Program that had begun in 1966 and was administered by the American Symphony Orchestra League and the American Music Center. More general assistance to composers, totaling $30,000, was enabled through the Thorne Music Fund.

Several music projects funded in the first years displayed the variety of support for the arts. A 1967 grant to the National Music Camp at Interlochen, Michigan, enabled the organization to bring the International Society for Music Education Conference to the United States for the first time. A 1967 grant to conductor and violinist Alexander Schneider supported a project to meet the acute shortage of string musicians in the nation. Matching grants awarded the same year to Hofstra University and to Violin Finishes had a preservation goal: respectively, a laboratory workshop on the technique of repairing string instruments, and an experimental analysis of violin varnish believed to have enriched violin quality and resonance more than 200 years ago.

EARLY CONGRESSIONAL REVIEW AND DEBATE

In 1968, the NEA encountered the first critical Congressional review of its programs, and the scrutiny extended to fellowships for individual artists. In that year, after an acrimonious legislative debate, the Endowment's budget stood at $7.2 million, with grants made to 187 individuals and 276 organizations. New NEA programs included a groundbreaking initiative for dance touring and support for museum acquisitions of works by living American artists.

Some legislators expressed anxiety that the NEA would escape federal oversight, as well as bypass the cultural norms of the American majority. Others saw money for new styles in art as a form of state censorship of more traditional styles. Portrait painter Michael Werboff remonstrated, "Under the protection of the Federal [authority], there is nothing to which the traditional artist can appeal for defense of their rights as contemporary American artists. . . . It puts the traditional American artist(s) into the hands of their worst enemy." His view was echoed by Representative John M. Ashbrook (R-OH), who warned that the NEA could "reward the avant-garde artists and discourage the traditional artists." Meanwhile, Representative William

Scherle (R-IA), who was an early critic of the Arts Endowment, questioned the wisdom of any government spending on the arts at all. He commented, "I do not feel that it is past time to give thought to the propriety of Government-subsidized arts."

There was even more Congressional outrage concerning a particular project the Arts Endowment undertook in partnership with private foundations, including the Rockefeller Foundation—The Theatre Development Fund (TDF), later known for its discount TKTS booth in New York City. In 1968, as now, serious plays were increasingly difficult to produce in New York (then the source of most of the work seen nationwide) due to steadily rising costs and economic pressure for blockbuster hits. TDF had two goals: one, to facilitate production of artistically meritorious work; and two, to attract students, teachers, and audiences less likely to attend because of high ticket prices.

The program sparked instant criticism. Some critics cast the program as a way to support dramatic works that nobody wanted to see. Headlines such as "Funds Will Aid Shaky Plays on Broadway" and "$200,000 Fund to Help Sagging Stage Shows" were echoed on Capitol Hill, as members of Congress attacked the initiative as "absolutely ridiculous" and a "prime example of government waste and stupidity." Representative Frank Bow (R-OH) reminded his colleagues that the Vietnam War was on, and "We cannot have guns and butter. And this is guns with strawberry shortcake covered with whipped cream and a cherry on top."

Congressional advocates of the NEA and its partner agency, the National Endowment for the Humanities, recommended an authorization of $135 million (divided evenly between the agencies) over two years, plus administrative funds and funds to match donations to the two Endowments. Congress instead approved a single-year budget for the NEA of only $7.8 million for 1968. Wary of spending money on artists during an expensive military conflict overseas, the House of Representatives passed an amendment abolishing grants to individuals, but this measure was rejected in the Senate. The controversy over grants to individual artists continued to simmer, however, and would stimulate debate over the Arts Endowment's role in American culture repeatedly in subsequent years.

THE PANEL PROCESS

In fiscal year 1970, the NEA budget marginally increased to $8.5 million, and a system of application review replaced the more informal process that had operated from the beginning. In November 1965, the National Council on the Arts voted to use advisory

Dancer/choreographer Merce Cunningham was one of the artists who participated in the NEA's panel review of grants. (Photo by Jack Mitchell)

panels in the grants review process. The first panel on dance met in January 1966, and the first music panel, chaired by Aaron Copland, met in April 1967. By the mid-1970s, the panels would include, among others, dance experimentalist Merce Cunningham, fiction writer Donald Barthelme, jazz performer Cannonball Adderley, composer Gian Carlo Menotti, and producer-director Joseph Papp, the indefatigable impresario behind free Shakespeare productions in New York's Central Park. By 1977, the advisory panel members and consultants numbered 437 in total, though some of them served in two different capacities.

AN AGENCY ESTABLISHED

As Lyndon B. Johnson prepared to leave the presidency, Roger Stevens's tenure as Arts Endowment chairman approached its end. Stevens had worked with vigor and dedication in the founding stages of the Arts Endowment. The agency was established, but with no existing institutional legacy to draw from in the federal system. Yet the NEA proved healthy enough to survive a time of heightened political passions and cultural ambitions. By increasing the funding available for the arts, and by broadening access to artistic activities, the Endowment had successfully begun to serve existing and growing demands for the arts in American society.

R. Philip Hanes, Jr., an original member of the National Council on the Arts who had challenged the chairman on critical issues, remembers Stevens as "a wonderfully wise and capable man who could achieve anything he felt was worth an effort—even what literally everyone knew was impossible. Washington was called a city of Northern charm and Southern efficiency. Not the least of his achievements was changing our nation's capital from a backwater to a cultural Mecca. And the National Endowment for the Arts could never have happened without him."

Nancy Hanks, NEA Chairman 1969–77. (Photo courtesy of the National Park Service)

CHAPTER 3

A Fresh Direction

S THE NEA GREW from year to year, so did its reputation. Much of the credit goes to an event one might never have expected, the 1968 election of Richard M. Nixon and his appointment of Leonard Garment to the White House staff as his special consultant. A New York attorney, Garment's areas of interest and competence included the arts and humanities. When Roger Stevens's term as NEA chairman expired two months after President Nixon's inauguration, Stevens's deputy chairman, arts educator Douglas MacAgy, who had transformed the teaching of art on the West Coast in the 1940s, was appointed acting chairman for six months.

Nancy Hanks, who was destined to leave a deep impression on the NEA, succeeded Roger Stevens as the Arts Endowment's chairman on October 6, 1969. Hanks's leadership at the Rockefeller Brothers Fund and her tenure as head of the Arts Councils of America gave her an important national perspective on arts funding and public policy. Born in Miami Beach on December 31, 1927, she graduated from Duke University after a childhood spent in Texas, Florida, New Jersey, and North Carolina. She served in the Eisenhower Administration as an assistant to Nelson Rockefeller at the newly created Department of Health, Education, and Welfare, and as a White House assistant for special projects. She then moved to New York where she worked for the Rockefellers until 1968.

Garment took responsibility for shepherding Hanks's appointment through the confirmation process with the assistance of another friend and supporter, Michael Straight, who became her deputy chairman. Before her appointment, Hanks met with President Nixon, who assured her of his support for the agency's continued funding.

Prior to being named chairman of the Arts Endowment, Hanks had articulated a vision for national arts policy in a 1968 article. She wrote, "In dollar comparison to our national needs for defense, for poverty programs, for health, for welfare, or for education, the requirements for the arts are minuscule. The support required for the arts, for the improvement of our cities . . . will come from a myriad of individuals, foundations, corporations, as well as governments."

Hanks began her tenure with enthusiasm. In an interview with the *New York Times* soon after her confirmation, she commented, "A great orchestra or a fine museum is a natural resource, like a park. It must be maintained. I believe this, and so does the National Council [on the Arts]." She later recalled in an oral history, "I do not remember having any real question about which way the agency would go. I knew almost all the program directors well. . . . They had used their little money wisely. You had a strong basic staff. You had a very good Council. Therefore, right from the beginning, I had a feeling of total confidence in the people I was working with."

HANKS'S CIRCLE

The appointments of Garment and Hanks reflected a commitment to the arts that few would have ascribed to Richard Nixon, who, in fact, had an abiding love of classical music. Garment maintained that President Nixon's support for the NEA represented a conciliatory gesture to liberal intellectuals, who were increasingly disaffected by the combat in Vietnam. Garment had looked toward a life as a professional jazz musician, playing the tenor saxophone, and he dropped out of college during World War II to perform. He was eventually drafted, and his place in Teddy Powell's band, for which he had been playing, was taken by Lee Konitz, who would later gain fame as an exemplar of the West Coast style of cool jazz. Garment was dismissed from the service on medical grounds, and returned first to jazz and then to college. His new band included Larry Rivers, later acclaimed as a painter, and a young flautist-saxophonist named Alan Greenspan, who would one day become chairman of the Federal Reserve. A few years in college led Garment to the legal profession, and he began a career as a New York investment lawyer. Nixon, after a failed gubernatorial bid in California, moved to New York and joined the law firm where Garment worked. Six years later, Garment joined President-elect Nixon in Washington to help him assemble staff for his Administration.

Other distinctive personalities served in the agency during the Nixon Administration, or, as many NEA veterans refer to it, "the Hanks administration"—a justifiable

President Richard M. Nixon holds an informal meeting in the Oval Office with NEA Chairman Nancy Hanks and Special Consultant Leonard Garment in December 1969. (Photo by Karl Schumacher)

claim, since Hanks's tenure extended beyond Nixon's to 1977. Michael Straight served prominently as her deputy chairman. A writer, philanthropist, and former editor of *The New Republic,* Straight became a close colleague and biographer of Hanks. Straight had served as an unpaid advisor to the State Department, and, briefly, at the Interior Department, during the New Deal. He was offered an advisory position in the Kennedy Administration, which he had turned down because of his former association with a Soviet spy ring. By 1969, after he had briefed the Federal Bureau of Investigation on his knowledge of Russian espionage, Straight was cleared to work under Hanks.

One of the first major events during Hanks's chairmanship was a reception to honor veterans of the New Deal's arts programs. Participants included the painters

Jacob Lawrence, who created iconic works about African-American life, such as *Ironers* (1943) pictured, was one of the artists honored by an NEA-sponsored reception for participants in the New Deal arts programs. (Photo courtesy of the Phillips Collection)

Milton Avery, William Gropper, Philip Evergood, Adolph Gottlieb, Jacob Lawrence (named to the National Council on the Arts in 1978), Louise Nevelson (one of the first recipients of the National Medal of Arts), and Isaac and Moses Soyer. In a memoir of Hanks, Straight recalled that "most of them could not believe that two bureaucrats of the Nixon Administration wanted to honor them. There was a great deal of laughter before the party ended—and a few tears."

Hanks herself had been viewed with suspicion by some in the arts community with traditional artistic tastes. They feared that her work as a staffer to Governor Nelson Rockefeller and his brothers—who, as a family, were involved in founding the Museum of Modern Art in New York and were aggressive promoters of the artistic avant-garde—would entrench an experimental bias in the NEA.

FIRST CONTROVERSIES

Throughout her first term, Nancy Hanks confronted a series of controversies that test-ed her leadership and strained relationships between the Arts Endowment and mem-bers of Congress. One commotion erupted over a grant awarded to the 1969 issue of *American Literary Anthology,* an annual volume of writings drawn from literary jour-nals. The editor of the volume, George Plimpton, included a work by Aram Saroyan, son of the Pulitzer Prize-winning author William Saroyan and a practitioner of a visu-al verse style of writing known as "concrete poetry." Saroyan's contribution consisted of a one-word concrete poem that had been published a year before in the *Chicago Review.* It read, verbatim, "lighght." The grant was attacked in Congress, most notably by Representative William Scherle (R-IA), who denounced the Endowment for devot-ing $750 to the project. A second dispute followed, involving Plimpton's acceptance of a so-called "obscene" work by poet and rock performer Ed Sanders for the 1970 *American Literary Anthology,* prompting the NEA to withdraw support for the annual volume.

The next year, Nancy Hanks and Michael Straight confronted another unexpected controversy. The Arts Endowment had awarded a $50,000 grant to Arena Stage's outreach program, Living Stage, for performances for inner-city high school youth in Baltimore. The project encouraged the kids to express their reactions to the play in whatever idiom they wished. Notwithstanding an agreement between Living Stage and Arena Stage that only performers and youngsters would be present, a Baltimore newspaper reporter secretly viewed the improvised work, and later wrote that the youngsters were being encouraged to use profanity by the Living Stage actors. The story reached Congress swiftly, and occasioned lengthy and personal conversations between Hanks, Straight, several members of Congress, and the leadership of Arena Stage and Living Stage. The controversy dissipated, but took up considerable time and effort.

In 1974, another controversy erupted over an NEA grant that proved to be one of the most significant crises in the agency's early history. Writer Erica Jong received a $5,000 NEA Literature Fellowship in 1973, and soon after her novel *Fear of Flying* was published. A provocative work dealing frankly with sexual themes, Jong's novel included an acknowledgement to the Arts Endowment, raising questions about the Endowment's sponsorship of sexual content. Even though the chairman of the Liter-ature Advisory Panel in 1973, who had recommended the grant, was the prominent book editor Simon Michael Bessie, contention over *Fear of Flying* extended to the

A FRESH DIRECTION 35

U.S. Senate. Only with significant help from pro-Endowment legislators was the controversy resolved.

HANKS'S VISION: ART FOR ALL AMERICANS

Historian Joseph Wesley Zeigler, in a detailed history of government funding for the arts entitled *Arts in Crisis,* noted that Nancy Hanks "had preserved the essential balance between artistic freedom and Congressional concern and oversight." Her successes with both political parties, the arts community, and elected officials enabled her to expand the Arts Endowment in several different directions. August Heckscher, President Kennedy's conceptual developer for federal arts support, had envisioned programs that would imitate the European model, in which central governments supported national theaters, museums, cinema, dance companies, and literary and language academies. The NEA under Hanks, however, preferred to forge numerous partnerships with nonprofit arts organizations, rather than underwrite the budgets of official state-sponsored arts groups.

Hanks favored support of local and regional institutions that would extend access and foster broader creativity. To encourage a wider range of applications and an expanded geographic reach for NEA-funded works, she clarified and strengthened the process for awarding grants. To distribute federal funds more widely, she committed to assisting state arts agencies, reflecting her earlier experience in helping establish the New York State Council on the Arts. She has been described as understanding art as a medium for public betterment, and many of her programs such as Artists-in-Schools reflected her sense of duty to the American citizenry as well as to American artists.

Hanks's "art-for-all-Americans" approach won newfound support from legislators, most of whom represented districts far from the artistic centers of the country. In 1971, the NEA's budget was doubled, from $8.2 million for 1970 to $15.1 million. Hanks's and Straight's deliberation with legislators made the increase possible. The Artists-in-Schools Program, with $900,000 from the U.S. Department of Education, sent more than 300 artists into elementary and secondary schools in 31 states. Such programs were not only artistically meritorious, but also represented Hanks's commitment to ensure the Arts Endowment reached young audiences with few other opportunities to experience the arts. At the same time, the NEA expanded the scope of its programming. Music now included jazz and orchestras, and photography was added to the Visual Arts Program.

Joining Hanks, Garment, and Straight in the NEA leadership was Brian O'Doherty, who was recruited during the MacAgy term and arrived with Hanks in 1969. A former editor-in-chief of the influential magazine *Art in America,* he would direct the NEA Visual Arts Program and then the Media Arts Program for a total of 27 years. O'Doherty was an iconoclastic intellectual even by the standards of the arts scene of the late 1960s. He had been a friend and collaborator of Marcel Duchamp, one of modernism's most inventive personalities, and admired the surrealist poet and critic André Breton—sure indications of his artistic tastes.

As suggested earlier, some believe that the Nixon Administration viewed support for the NEA as a means to quell discontent regarding foreign policy decisions in Indochina. Michael Brenson, a commentator on the Arts Endowment, argued in *Visionaries and Outcasts: The NEA, Congress, and the Place of the Visual Artist in America* that Brian O'Doherty "helped the Endowment to maintain its credibility among the most vocal and activist artists during some of the most explosive years of the Vietnam War." Garment and William Safire, another central figure in the Nixon Administration, both remember how support for the arts figured in the politics of the day. In the 2006 Nancy Hanks Lecture on Arts and Public Policy, Safire recalled, "I knew this remarkable woman [Hanks] during the Nixon years in Washington when I worked in the White House. My fellow speechwriter, Ray Price, was enlisted by this Rockefeller Brothers arts enthusiast in the cause of federal support for the arts. . . . Expectations were low, to say the least, for President Nixon's support of the arts. But Nancy Hanks and Ray had a powerful ally in Leonard Garment. . . . Nancy kept in close touch with Len, providing all the artistic arguments, and Len in turn worked over the President, who admired Eugene Ormandy and the Philadelphia Orchestra. But I can hear Nixon's voice now, saying to me from his place in purgatory, 'You know, Bill, there's not a single vote in this for me.'"

In his own 1989 Nancy Hanks Lecture on Arts and Public Policy, Garment explained why he thought President Nixon favored the Arts Endowment. The extraordinary funding increases "did not come about just because the powers that be suddenly changed their minds one morning and decided it was time to give culture the respect it deserved. Nor did it happen mainly because President Nixon was persuaded of the concrete political benefits that support for the arts would bring him. More important was that Richard Nixon knew the extent to which the Vietnam War had turned America into two mutually hostile camps. The president wanted for his own an issue that would not divide his audience into sympathetic hawks and hostile doves. It was more an effort to soften and survive than divide and

conquer, but this was the reason my arguments found favor."

While the political motivations have faded with the passage of time, the fact remains that President Nixon's support for the Arts Endowment eventually transformed the NEA from a tiny federal program into a significant policy leader in the arts.

HANKS'S BALANCING ACT

Nancy Hanks had the extraordinarily difficult task of navigating the political turmoil of the Administration, the political protests of the intellectuals, the populist tastes of many legislators, and the popularity of extreme positions within the art world. Thanks to her own talent for political persuasion and her recruitment of talented aides, Hanks prevailed again and again, and the agency evolved accordingly.

As the 1970s wore on, attitudes toward the NEA gradually changed, bringing new pressures on its grantmaking. For a new generation of artists, the NEA was part of the existing environment rather than an innovation. Many of them, according to Zeigler's *Arts in Crisis,* "had come to believe that they were entitled to federal funding: 'You, the United States, should be paying for me to create, because I'm here and I'm creating. As an artist, I'm an important member of the society—and so the society should be supporting me.'" At times, these artists would pressure the Arts Endowment to consider them, rather than the American public, the proper focus of the agency's attention. To this constituency, the Endowment appeared more a foundation than a public agency.

In addition, the great expansion of higher education during the 1960s produced a significantly larger number of aspiring artists than had existed in the 1950s. From 1950 to 1961, first-year college enrollments nearly doubled from 2.2 million to 4.1 million. That figure more than doubled again to 8.6 million in 1970, then rose to 12 million in 1980. Many of these students were recruited to arts programs, and after graduation pursued arts careers.

During these transformative years under Hanks, NEA funding rose from $9 million in fiscal year (FY) 1970 to $99.9 million in FY 1977. With a soaring budget and, in accord with Hanks's ambition—to increase the spread of Endowment grantees across the country—the NEA became a central influential institution in the world of American art. In a 1974 article in the *New York Times Magazine,* writer David Dempsey praised Hanks as "the person who has done as much as anyone in government or out, to bring about this change in attitude." Once labeled "the lady from

Culture Gap," Hanks had become the fourth highest female appointee in the Nixon Administration.

Still, the Arts Endowment continued to have its problems. Even NEA supporter Senator Claiborne Pell (D-RI), according to Dempsey, wondered whether the paintings the government was paying for were "realistic," that is, representational, or "did they consist of doodles and swirls?" Dempsey saw the new Visual Arts Director Brian O'Doherty as fitting ably into an environment of "young, bright, dedicated, and suitably hip" staff. Dempsey also observed, "The joy of giving has nurtured a new type of government bureaucrat"—something few expected from the Nixon set. He noted that the NEA had come on the scene as private arts funding "was beginning to shrink," yet this took place simultaneously with a "culture explosion." The reasons for the latter phenomena were identified by August Heckscher during the Kennedy Administration as "more leisure and affluence for the average person . . . a new generation of college-bred taste makers in small towns and cities, life-styles modeled on artistic rather than commercial values."

Helen Milliken, then First Lady of Michigan, engineered Artrain's creation in 1971, with support from the NEA. (Photo courtesy of Walter P. Reuther Library, Wayne State University)

ORGANIZATIONAL EXPANSION

The NEA under Hanks was as prolific as it was well financed, and the national outreach continued. Beginning in 1971, 55 state and jurisdictional arts agencies (including the District of Columbia, American Samoa, Guam, Puerto Rico, and the U.S. Virgin Islands) received Basic State Grants from the Arts Endowment. Illustrating her dedication to serving every citizen, one of Hanks's favorite projects was Artrain USA, a railroad service that brought a locomotive and six coaches carrying silversmiths, macramé artists, potters, and sculptors to towns in Michigan that had no museums. It began as an idea of the Michigan Council for the Arts, which recruited Helen Milliken, the lieutenant governor's wife, to raise $850,000 for the local project. "It was tremendously important to have the backing of the NEA when we went to businesses and major industries asking for fund-

ing," Milliken recalls. "It was the key; we couldn't have raised that kind of money without that initial boost." Soon afterward, when Milliken became the first lady of the State of Michigan, she was able to expand Artrain USA into eight of the Rocky Mountain states, with the Arts Endowment providing funding for half the cost of the trips.

Artrain USA later expanded its operations across the Western states, touring to 30 towns in Arizona, Colorado, Idaho, Montana, Nevada, New Mexico, Utah, and Wyoming. Television reporter Charles Kuralt showcased Artrain USA as it moved through Idaho and Wyoming. Artrain USA continues to this day, and has visited more than 725 communities in 44 states and the District of Columbia, changing shows every two or three years. The 2006 tour, *Native Views: Influences of Modern Culture,* provided a contemporary Native-American art exhibition. As of 2008, this tour, funded with an NEA American Masterpieces grant, had reached more than 160,000 people in 95 primarily rural and Native-American communities across America.

NEA funding doubled in 1972 to $31.5 million, allowing expansion of existing programs and the establishment of support programs for opera and jazz. A total of $2.3 million was awarded in dance to choreographers including Alvin Ailey, Trisha Brown, and Alwin Nikolais; national tours of American Ballet Theatre and the Joffrey Ballet; dance companies such as Salt Lake City's Ballet West; and a broad range of smaller companies.

Music programs received $9.8 million, the largest discipline share. Smaller awardees ranged from the Mobile Jazz Festival to the Bach Society of Minnetonka, Minnesota. More than $5 million went to orchestras in all areas of the country, including Shreveport, Louisiana; Toledo, Ohio; El Paso, Texas; Jacksonville, Florida; Honolulu; Boston; Seattle; and Chicago. And $3 million was directed toward Central City Opera in Denver, Houston Grand Opera, the Metropolitan Opera, Santa Fe Opera, the Mississippi Opera Association, and many other companies.

The impact of early Arts Endowment grants is well expressed by Joan Woodbury, co-artistic director of the Ririe-Woodbury Dance Company in Salt Lake City. In 1972, Ririe-Woodbury received support to participate in two of the agency's dance programs, Artists-in-Schools and Dance Touring. The aid "sent this small dance company from the West on a course of national and international service," Woodbury recalled in 2006. "For the nine-year life of these two programs, the company toured to almost every state in the Union. They developed artists, commissioned new works, and developed artist-teachers to fulfill their goals." The agency had identified a worthy but fledgling organization and granted it sustainability. "Without the 'stamp of approval' from the NEA . . . very few of the accomplishments of this company would

Writer Eudora Welty, center, was appointed to the National Council on the Arts in 1972, joining other members such as jazz pianist Billy Taylor (right) and museum director E. Leland Webber (left). (Photo by David E. Hausmann)

have been possible," Woodbury continued, "We can proudly say, with many others, 'We're still alive and kicking.'"

Initiated in the NEA's earliest years, by 1974 the Dance Touring Program included 94 companies reaching audiences in 48 states and two special jurisdictions for an aggregate of more than 400 weeks, truly a revolutionary change in the American dance landscape. Other programs had similar impacts. Artists-in-Schools, whose pilot Poets in the Schools also began in the Stevens years, reached more than 5,000 schools in all 50 states and five special jurisdictions by 1974, including hundreds of thousands of children and teenagers in the fields of dance, crafts, painting, sculpture, music, theater, film, folk arts, and design.

Many leading authors and poets received grants of $5,000 each in 1972, including Stanley Elkin, Etheridge Knight, William Meredith, Carl Rakosi, James Schuyler, and William Jay Smith. Regional film centers were now funded through a Public Media Program. In 1972, President Nixon authorized the Federal Council on the Arts and Humanities, chaired by Nancy Hanks, to create the Federal Design Improvement Program. The program was intended to examine and upgrade design in the federal government, including architecture, graphic design, and standards for design procurement.

There were now ten discipline-based advisory panels with members generally serving staggered three-year terms. The panels had begun as "peer panels," and stemmed from a 1965 resolution of the National Council on the Arts calling for the chairman to "appoint committees of interested and qualified persons or organizations to advise the Council with respect to projects, policies, or special studies as may be undertaken." The panels had been formalized in 1969, and by 1973 there were more than 200 members. The painter Roy Lichtenstein participated, as did the authors Toni Morrison and Kurt Vonnegut, Jr. Other prominent authors also served

in various capacities. For example, the Mississippi writer Eudora Welty was appointed by President Nixon to the National Council on the Arts in 1972, and she served on the Arts Endowment's Twentieth Anniversary Committee of Leading American Artists in 1984.

Hanks's Second Term

Nancy Hanks was reappointed NEA chairman in 1974. Her first term had seen a seven-fold increase in the Endowment's budget, which now stood at $64 million.

By the end of 1974, President Nixon had resigned, succeeded by President Gerald R. Ford, who appointed Nelson Rockefeller as Vice President. President Ford came out early in support of the agency, recalling the civic impact of an enormous 42-ton sculpture by Alexander Calder in the center of what is now Calder Plaza in Grand Rapids, Michigan—Ford's hometown. The sculpture had been funded by a grant in 1967 of $45,000 from the Arts Endowment's nascent Works of Art in Public Places Program, and it had become a symbol for the city. Each year on the anniversary of Calder's birth, the city hosts an arts festival encompassing ten city blocks and attended by half a million people. According to City Historian Gordon Olson, the project "changed the role of the arts and public sculpture in the life of this community."

In part because of growth in personnel, the Arts Endowment moved from its home in the Shoreham Building at 15th and H Streets to the McPherson Square Building on K Street, which also housed investigators of the Watergate scandal. "Every day we had to face a battery of television cameras when we arrived and left work," recalls Ann Guthrie Hingston, who served under Hanks and again under Chairman Dana Gioia as director of Government Affairs. A few years later the agency moved again to Columbia Plaza in Foggy Bottom, which also housed the U.S. Bicentennial Commission headed by John Warner, later a U.S. Senator from Virginia.

The Arts Endowment's tenth anniversary was celebrated September 29–30, 1975, first at the LBJ Ranch, then at the Lyndon Baines Johnson Library and Museum at the University of Texas at Austin. The event coincided with the public opening of the presidential papers on the arts and humanities and included the participation of Lady Bird Johnson, Nancy Hanks, Roger Stevens, Hubert Humphrey, Jacob Javits, Kirk Douglas, Jamie Wyeth, and Beverly Sills. Thirty years later, in 2005, the NEA's fortieth anniversary also would again be marked with programs and discussion at the LBJ Library and Museum.

Saving the Old Post Office

The Old Post Office Building at the corner of Pennsylvania Avenue and 12th Street, NW, is one of the most unusual buildings in the nation's capital. Sited midway between the White House and the Capitol, the building was completed in 1899 as a new home for the United States Postal Department and the District Post Office. W. J. Edbrooke, supervising architect of the U.S. Department of Treasury, designed the building as an anchor to help revitalize an area that had become a notorious slum by the late nineteenth century.

The structure exemplifies the Romanesque Revival architecture of its time—marked by round arches, horizontal silhouettes, and heavy rough-cut stone walls.

The Old Post Office Building in Washington, DC, which was preserved due to the efforts of NEA Chair Nancy Hanks. (Photo by Terry J. Adams, National Park Service)

It was also the city's tallest building, next to the Washington Monument, thanks to its 315 foot high clock tower. Soon after its completion, architectural tastes changed and Classical Revival became the dominant style. Compared with this new aesthetic of marbled elegance, the Post Office seemed dull and stodgy. *Appleton's Booklovers Magazine* declared in 1906 that the structure "will require obliteration by dynamite before it can be brought into harmony with its surroundings." Every proposal up to 1974 for improving Pennsylvania Avenue called for its removal. By the early 1970s, the structure suffered from wear and neglect, and a permit for its demolition was at last approved.

"Don't Tear It Down"—a citizens action group that is now the D.C. Preservation League—battled to save the Old Post Office. Nancy Hanks, chairman of the National Endowment for the Arts, joined the fight with William Lacy, then NEA Architecture and Environmental Arts Program director and an advocate for the adaptive reuse of historic structures. Hanks persuaded Congress to fund a feasibility study in 1974 and promoted legislation to fund the building's renovation. She testified before the Senate and proposed moving the NEA's offices there. Her commitment saved the structure.

Renamed the Nancy Hanks Center in 1983, the Old Post Office is a national historic landmark, and houses the National Endowment for the Arts, the National Endowment for the Humanities, and the President's Committee on the Arts and the Humanities.

In December 1975, President Ford signed the Arts and Artifacts Indemnity Act. U.S. Representative John Brademas (D-IN) played a prominent role in shepherding the indemnity legislation through Congress. (In 1976, Representative Brademas would again serve the cause of the arts by cosponsoring, with Senator Pell, a four-year reauthorization of the Arts Endowment's operations.) The new legislation facilitated the insuring of art, artifacts, and other objects for exhibition in the U.S. The dollar value of art and other objects from other countries that could be insured by the government at any one time was $250 million. With this program in place, extremely valuable works of art housed around the world could now be transported to the U.S. for exhibition with their value protected in cases of damage, theft, or vandalism. With the entry of major works of art and archaeological artifacts from abroad, America saw the beginning of massive, "blockbuster" museum shows on major themes in art history, ranging from the tombs of ancient Egyptian pharaohs to retrospectives of the greatest modern painters and sculptors.

Earl A. Powell III, director of the National Gallery of Art in Washington, DC, and former member of the National Council on the Arts, hailed the program many years later. "Because of the indemnity program," he commented in a 2000 NEA publication, "members of the public get to experience tremendous works of art that they wouldn't normally be able to see unless they could travel to the countries of origin."

The indemnity program is staffed and administered by the Arts Endowment on behalf of the Federal Council on the Arts and the Humanities. Applications for indemnity are reviewed by the council, which consists of the chairmen of the Arts and Humanities Endowments; the librarian of Congress; the archivist of the United States; the director of the National Science Foundation; the secretaries of State, the Interior, Commerce, Education, Transportation, Housing and Urban Development, Labor, and Veterans Affairs; and other public officials.

CHALLENGE GRANTS

Congress established the Challenge Grants program in 1976 during the final months of Chairman Hanks's tenure with a special allocation in the Arts Endowment's appropriation. NEA grants to organizations typically required one-to-one matching funds; however, Challenge Grants required at least a three-to-one match, initially in new or increased non-federal support. In reviewing Challenge Grants

The Metropolitan Museum of Art in New York has presented many world treasures through the indemnity program, such as Splendors of Imperial China in 1996. (Photo courtesy of Metropolitan Museum of Art)

proposals, the Arts Endowment evaluated applicants' organizational and managerial capacity in addition to artistic quality. Under the new program, federal grants of up to $1 million leveraged private funds for the construction of arts facilities, the development of endowments and cash reserves, or major artistic initiatives. Challenge Grants proved hugely successful, generating many times the government's investment and helping arts institutions build solid financial foundations to sustain them through hard times.

The first round of Challenge Grants awarded $27 million over two years to 66 organizations. Recipients included the Joffrey Ballet in New York, the WGBH Educational Foundation in Boston, the Walker Art Center in Minneapolis, and the American Conservatory Theater in San Francisco, as well as many other prominent institutions. One example of the program's effectiveness is Young Audiences, a nationwide network of more than 5,000 performing and visual artists presenting nearly 100,000 arts programs and services to eight million young people, teachers, and families. According to Richard Bell, executive director of Young Audiences, "Challenge Grants in the 1980s and early 1990s resulted in a 30-fold increase in the organization's endowment,

with matching grants and gains of $6.5 million from the private sector."

Representative Norm Dicks (D-WA) spoke fondly of the impact of Challenge Grants on private giving for arts organizations in his state. In the early years of the program, four Seattle organizations received grants totaling $1.7 million in federal funds, which generated a minimum of $5.2 million in new private funds (in 1979 dollars). The Seattle Symphony Orchestra received $600,000 to eliminate an accumulated deficit, augment its endowment, and meet increased operating costs as it approached its fiftieth anniversary. That year, Representative Dicks joined NEA Chairman Livingston Biddle in Seattle to announce three more Challenge Grants: to the Seattle Art Museum, the Seattle Opera, and the Seattle Repertory Theater. The Challenge Grants program operated successfully for 20 years until the agency's budget was severely cut in FY 1996. During the lifetime of the Challenge Grants program, the NEA awarded nearly $203 million.

ARTS ON RADIO AND TELEVISION

Another area of achievement came through the initiatives of Programming in the Arts (later called the Arts on Radio and Television). Several outstanding individual programs in the early 1970s received Arts Endowment funding. Allan Miller's 1973 film *The Bolero,* with Zubin Mehta conducting the Los Angeles Philharmonic in a performance of Maurice Ravel's piece, won an Academy Award for Best Live Action Short Film. The 90-minute television dance special *American Ballet Theatre: A Close Up in Time* (1973) profiled various ballet and dance performances, and *Alvin Ailey: Memories and Visions* (1974) featured selections from Ailey's work.

In January 1976, two series changed the profile of the performing arts on television, and both were developed with funding from the Arts Endowment. *Dance in America* was a groundbreaking program that used the "true-action method," originally developed to cover football, to capture live performances on film. Jac Venza and WNET adapted this method to film dance, and fused the television medium with the choreographer's art. Famed choreographers including George Balanchine, Robert Joffrey, Martha Graham, and Alvin Ailey teamed with television directors Merrill Brockway and Emile Ardolino to restage works specifically for the small screen. The first broadcast season of *Dance in America* included performances by the Joffrey Ballet, Twyla Tharp, the Martha Graham Dance Company, and the Pennsylvania Ballet. At the same time, the Arts Endowment funded a study of the Joffrey Ballet to determine whether increased television broadcasts would cut into live attendance at the theater. The study

Fred Newman, Tim Russell, Sue Scott, and Garrison Keillor perform a skit during an episode of *A Prairie Home Companion.* (Photo by Jason Bell)

found that television exposure of ballet performances actually increased attendance.

The other series was *Live from Lincoln Center,* one of the most successful programs ever produced for broadcast on public television. The Arts Endowment provided funding for, among other things, development of low-light-level cameras that could record live performances without disturbing the performers or the audience. *Live from Lincoln Center*'s first season featured André Previn conducting the New York Philharmonic with Van Cliburn, the New York City Opera performing *The Ballad of Baby Doe,* and American Ballet Theatre's *Swan Lake.* The year 2008 marked its 32nd season, and the series produced six shows a year for a national audience averaging five million viewers per performance.

Another award in a different medium had a similar long-term impact. In 1974, a grant from the Arts Endowment helped Garrison Keillor and Minnesota Public Radio launch *A Prairie Home Companion,* which has grown into one of the most listened-to radio shows in the country. In testimony before Congress in 1990, Keillor highlighted

Future U.S. Poet Laureate Ted Kooser received his first NEA Literature Fellowship in 1976. (Photo courtesy of Ted Kooser)

the "seed" aspect of NEA grants: "By the time the show became popular and Lake Wobegon became so well-known that people thought it was real, the Endowment had vanished from the credits, its job done. When you're starting out . . . it seems like nobody wants to give you a dime. When you have a big success and everything you could ever want, people can't do enough for you. The Endowment is there at the beginning, and that's the beauty of it." Speaking before the Senate Subcommittee on Education, Arts, and Humanities, Keillor went further, noting that "today, in every city and state, when Americans talk up their home town, invariably they mention the arts." He termed this growing respect for the arts "a revolution—small and lovely—that the Endowment has helped to bring about."

Other awards bore fruit in the careers of Arts Endowment literary grantees as well. Among authors who received NEA fellowships during Hanks's tenure, the following poets went on to win the Pulitzer Prize:

- Donald Justice (NEA 1967, 1973, 1980, 1989, Pulitzer 1980)
- Louise Glück (NEA 1970, 1979, 1988, Pulitzer 1993)
- Stephen Dunn (NEA 1973, 1981, 1989, Pulitzer 2001)
- Charles Simic (NEA 1975, 1979, Pulitzer 1990)
- Charles Wright (NEA 1975, 1984, Pulitzer 1998)
- Philip Levine (NEA 1976, 1981, 1987, Pulitzer 1995)
- Ted Kooser (NEA 1976, 1984, Pulitzer 2005)
- Natasha Trethewey (NEA 1999, Pulitzer 2007)

One of Nancy Hanks's significant personnel decisions was to hire the African-American poet and jazz writer A. B. Spellman in 1975. Spellman first served as a consultant in arts education, from which he was promoted to leading positions in the Expansion Arts Program. In 2005, Spellman recalled the origin of Expansion Arts, a major addition during the Hanks period: "It was founded and named by my predecessor, the late Vantile Whitfield. . . . Its purpose was to find and develop professional arts organizations that were, according to the letter of the guidelines, 'deeply rooted in and reflective of the culture of minority, inner-city, rural, and tribal communities.' We were responsible along with folk arts for . . . expanding the cultural portfolio of the Arts Endowment." The program had a strong social grounding, as it

Expansion Arts Program

In 1971, the National Endowment for the Arts introduced the Expansion Arts Program to honor the nation's cultural diversity. Vantile Whitfield, recruited by Chairman Nancy Hanks as the program's first director, led the NEA's initiative to expand arts resources beyond the familiar opera, orchestra, ballet, and museum settings.

For 25 years, this program nurtured community-based arts organizations from America's inner-city, rural, and tribal communities. Many of the program's first grantees later became nationally renowned—Alvin Ailey American Dance Theater in New York, Appalshop in Kentucky, Arte Público Press in Texas, Daybreak Star Indian Cultural Center in Washington, Institute of Alaska Native Arts in Alaska, Lime Kiln Arts in Virginia, Japanese Community and Cultural Center in California, and Urban Gateways in Illinois. Hundreds of mid-size and smaller nonprofit organizations benefited from initial NEA funding and still remain vital community anchors today.

The Expansion Arts Program is also credited with launching several national projects. Two of these resulted in new NEA programs: the Advancement Program formed in 1983 to respond to the cultural field's growing interest in managerial guidance, and Local Arts Agencies began in 1984 to address the NEA's general policies at the municipal level. Another significant project sponsored by the

Appalshop—whose dedication to preserving Appalachian culture includes producing documentary films such as *Sunny Side of Life* about old-time country music—was one of the organizations originally supported by the NEA's Expansion Arts Program. (Photo by Bill Blanton)

Expansion Arts Program was the Community Foundation Initiative (1985–1994), through which 27 national foundations developed peer-review practices and established permanent endowments for ongoing investment in community-based art projects.

During the program's 25 years of operation, many of its grantees competed successfully in other NEA programs and garnered support from other arts funders. Following significant budget cuts during the mid-1990s, the NEA integrated the Expansion Arts Program into various discipline programs of the organization.

was "geared to low- and moderate-income groups and to people living in rural communities, towns, and inner-city neighborhoods." Leading the effort, Spellman sought to "*assure* [emphasis in original] that no American will be denied the opportunity to reach his or her artistic potential because of geographic, economic, or other social or cultural restraints."

During the next 30 years, Spellman would play an important role in many major Arts Endowment programs, most notably the NEA Jazz Masters Fellowships. Spellman remembered, "In 1975 when I came here jazz was in about the same position as Expansion Arts. Most of the arts establishments simply would not touch it. . . . On the National Council on the Arts the attitude, unfortunately, was the same. Billy Taylor and I had many heated arguments with council members about giving some parity to jazz with classical music in the guidelines of the Arts Endowment. David Baker had many arguments with several council members, including, of course, the late pianist and cultural critic Sam Lipman, again about jazz as a fine arts form. And, of course, David was able to change Sam's point of view." Spellman also summarized the contribution of the Arts Endowment by commenting that after the passage of 30 years, "We see a much, much more inclusive arts world today than we had in 1975."

A RESEARCH AGENDA

Research was explicitly recognized as a central undertaking of the Arts Endowment in 1975. That year, the National Council on the Arts approved the first program budget for the agency's Research Division, headed by Harold Horowitz, a 47-year-old architect who came to the agency from the National Science Foundation. The Endowment's new focus on empirical data collection and analysis was augured by an important study from 1974, *Museums USA: A Survey Report*. Produced by an agency contractor, the study proved critical in advancing quantitative research for the field. By documenting staff levels, attendance, membership, budgets, and regional trends in museums in the United States, the report sparked substantive policy discussions about appropriate support mechanisms for these institutions. In the ensuing decades, the Research Division (later named the Office of Research and Analysis) would repeat this pattern in other areas. Under Horowitz and others, the division issued reports documenting the "state of the arts" for various disciplines and extended those inquiries into artist employment, arts participation, and other domestic indicators that would be used to guide policy.

Two years after the division's founding, Joseph Coates, assistant to the director of

the Congressional Office of Technology Assessment, stated at an agency conference that he welcomed a "long-term commitment on the part of scholars to a program of arts research; not the kind of in-and-out contract research [formerly conducted]." He predicted, "The issue will arise whether the Endowment should be doing basic or applied research. I believe that at this stage it should be committed to applied research; research that has a high utility element." Since then, the NEA has continued to be a leading source of such research studies in the arts and arts education.

HANKS'S LEGACY

During her tenure, the Arts Endowment's support reached all 50 states and six U.S. territories. Nancy Hanks expanded the Arts Endowment's operations and career staff, while developing seed grants for major arts institutions and supporting high-profile initiatives such as the U.S. Bicentennial celebration, which occurred near the end of her second term.

Nancy Hanks's legacy was one of outstanding dynamism, and the effects of her years as NEA chair were far-reaching. One of Hanks's noteworthy achievements was her role in establishing the state arts agencies. By 1977, at the end of her second term, state legislative appropriations for state arts agencies stood at $55.7 million, more than half the NEA appropriation of $99.9 million that year. Other important successes of her chairmanship were the impressive expansion of the audience for dance and the extraordinary spread of regional theaters. As Peter Donnelly, managing director of the Seattle Repertory Theatre, stated in 1976, "What has been accomplished in the last decade with the assistance of the Endowment has been quite phenomenal. A theater which for all practical purposes did not exist except in New York has been created nationally."

Yet Hanks's greatest accomplishment was to bring more federal money for the arts to more communities in the United States than ever before. Her success in doing so—and the popularity of an "arts-for-all-Americans" vision for the agency—may be measured by the Arts Endowment's growing budget in the eight years under Hanks, which increased by 1,400 percent. In 1978, the last year funded under her chairmanship, the NEA's appropriation stood at $123.8 million. To appreciate the scope of the increase, consider that $124 million in 1978 is equivalent to approximately $405 million in 2008. Moreover, the 1978 funding served a total population in the United States that was three-quarters the size of the 2008 population (223 million compared to 304 million).

Thomas Hart Benton's *The Sources of Country Music* portrays 17 nearly life-sized figures and illustrates the various cultural influences on country music, including a train, a steamboat, a black banjo player, country fiddlers and dulcimer players, hymn singers and square dancers. (Image provided by The Country Music Foundation)

Grants were offered in many new areas, including aid to exhibitions, crafts fellowships and workshops, apprenticeships, and a fellowship program for art critics. Hanks provided support for the final work of the great American muralist Thomas Hart Benton, who died in 1975. *The Sources of Country Music,* a monumental painting, was commissioned for Nashville's Country Music Hall of Fame and Museum, with the grant application submitted by Bill Ivey, who would become NEA chairman more than 20 years later.

With the end of the Ford Administration and the election of President Jimmy Carter, Hanks's eight years of service with the Arts Endowment concluded. Michael Straight recalled that the chairman had "a sense that she was accepted by the incoming Administration, but the sense was illusory." When Hanks sought to influence President Carter, her attempt, according to Straight, was too personal—she found a way to meet the new chief executive directly, little realizing that he was a man who preferred contact through his staff. President Carter understood that she expected to be reappointed to head the Arts Endowment, but he did not even request that she continue until a successor was appointed.

The example of Nancy Hanks's leadership lived on well beyond her tenure, how-

ever, and the devotion she inspired was enduring. Original National Council on the Arts member R. Philip Hanes, Jr., provided a telling sign of her character: "When Nancy discovered she had cancer, we all knew that she was not well; but she would take no one at all into her confidence. . . . She was without question one of the strongest and ablest human beings I have ever known and one of the most giving and selfless."

Three weeks after her death in 1983, President Reagan asked Congress to name the Old Post Office complex, which she had sought to save, the Nancy Hanks Center. On April 19, 1983, the building was dedicated as the new home of the National Endowment for the Arts, the National Endowment for the Humanities, the President's Committee on the Arts and the Humanities, the Institute of Museum Services, and the Advisory Council on Historic Preservation. The Old Post Office at 1100 Pennsylvania Avenue, NW in Washington, DC, was renamed the Nancy Hanks Center, in recognition of her tireless efforts to save the building from demolition and as a fitting tribute to her long and productive tenure as chairman of the NEA.

President Jimmy Carter with NEA Chairman Nancy Hanks in August 1977. (Official White House photo)

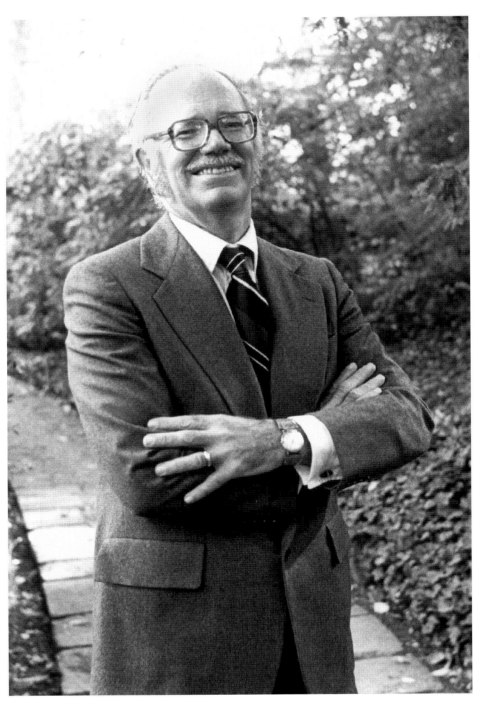

Livingston L. Biddle, Jr., NEA Chairman 1977–81. (NEA File Photo)

A Long Summer

IN NOVEMBER 1977, President Jimmy Carter appointed Livingston Biddle to the chairmanship of the Arts Endowment. Biddle came from a distinguished American family, graduated from Princeton University, and served as an ambulance driver in World War II. He wrote popular novels before coming to Washington to be a special assistant to Senator Claiborne Pell (D-RI), his roommate in preparatory school and at Princeton, who was a key figure in drafting the legislation that established the Arts and Humanities Endowments. Biddle also had served as NEA deputy chairman under Roger Stevens, and later served as Nancy Hanks's Congressional liaison. A Washington insider, he was steeped in the workings of legislation and policy.

Chairman Biddle approached his position with a desire to refocus on the role which Congress initially envisioned for the Arts Endowment. An integral part of that role, Biddle claimed, was a strong partnership between the government and the private community. The emphasis on the role of the private sector led Biddle to recommend three essential provisions for progress in the cultural life of the nation:

• Responsibility should be primarily based on private and local initiatives;

• A comprehensive restriction on federal interference in the determination of NEA grantees, which Biddle defined as "a provision basic to freedom of expression and the creative spirit of the arts," should be in place;

• The Endowment must be guided by a council of private citizens.

Biddle noted that when he was nominated to the chairmanship, "there [had] been suggestion that the arts may be subject to politicalization . . . mean[ing] . . . subject to

Joan Mondale converses with National Council on the Arts member Theodore Bikel during an NCA meeting. (NEA File Photo)

inappropriate governmental pressures." He maintained, "The law prescribes a cata-lyst role for the government . . . to encourage, not dominate, to assist without domineering." Biddle regretted "words like 'elitism' and 'populism' being used to suggest a polarization of the arts," noting that "elitism can indeed mean quality, can indeed mean 'the best,'" while populism "can mean 'access.'" He urged a policy bridging the two ideals, resulting in "access to the best" as a guiding principle.

He had a strong ally in Vice President Walter Mondale's wife Joan, a ceramicist and the author of a book entitled *Politics in Art* (1972), as well as honorary chairper-son of the Federal Council on the Arts and the Humanities. Prior to the 1976 election, Mrs. Mondale had served on the board of directors of the Associated Coun-cils of the Arts, a private association of state arts agencies and community arts councils. During her years in the Vice President's residence, she filled the house with examples of contemporary American painting, sculpture, and crafts. She encour-aged the placement of art works in federal buildings, and in Congressional testimony she urged legislators to alter the federal tax code so that estate taxes would not affect the families of artists so heavily. For her efforts, she earned the title "Joan of Art."

Under Biddle's leadership, the Endowment continued to enjoy rising funding, the

total reaching $158.8 million in 1981. In the first year of the Carter Administration, the NEA made several decisions that strengthened its impact on American intellectual life and improved its outreach to underserved communities. One was the establishment of a 23-member task force to assess the needs of the Hispanic arts community in the U.S. and to develop a means to respond to Hispanic artists and organizations. Other initiatives included the Office of Minority Concerns to act as a clearinghouse for minority artists and art groups in dealing with the NEA, and the establishment of the Folk Arts Program with its own staff.

FOLK ARTS EXPANSION—NEA NATIONAL HERITAGE FELLOWSHIPS

The Folk Arts Program had come under the directorship of Bess Lomax Hawes, a distinctive individual in the NEA's chronicles and in the wider context of American cultural history. The Arts Endowment's program of National Heritage Fellowships originated with Hawes's tenure as director of the Folk Arts Program, beginning in 1976 and continuing beyond her retirement in 1992. Based on the Japanese custom of designating expert craftsmen and artisans as National Treasures, the NEA National Heritage Fellows receive a one-time award recognizing individual artistic excellence and their efforts to conserve America's many cultures for future generations.

The Arts Endowment had long been a strong supporter of folk and traditional arts. According to Burt Feintuch, editor of *The Conservation of Culture: Folklorists and the Public Sector,* the agency's Folk Arts Program "legitimized the traditional arts in the eyes—and budgets—of agencies around the nation, democratizing and pluralizing the concept of the arts. NEA seed money rooted most of the state programs, resulting in a national network of public sector folklorists who, in turn, began to till the soil of their own states." One NEA folk arts panelist, Barre Toelken, recalls an incident after dinner in a New Mexico village after the agency funded a centuries-old play, *Los Moros y los Cristianos.* When the panelists finished their dinner at a local restaurant, "an elderly man stepped forward and said, 'We only want to thank you for helping us to keep our culture. I've lived here since before the income tax came to be, and this is the first time any of our money ever came back to help us.'"

The NEA National Heritage Fellowships boosted folk arts to a new level of prominence. In 1985, Hawes observed that "these fellowships are among the most appreciated and applauded, perhaps because they present to Americans a vision of themselves and of their country, a vision somewhat idealized but profoundly longed for and so, in significant ways, profoundly true." Although the creation of the fellow-

Blues artist Brownie McGhee was one of the first NEA National Heritage Fellows in 1982. (Photo by Tom Pich)

ships was announced in 1980, at the end of Biddle's chairmanship, the first awards were made in 1982, during the presidency of Ronald Reagan. Since then, the NEA National Heritage Fellowships have been bestowed upon a diverse selection of individuals who have "made major contributions to the excellence, vitality, and public appreciation of the folk and traditional arts." The first honorees included the blues singer Sanders "Sonny" Terry and his frequent partner in performance, guitarist Brownie McGhee, as well as the Mexican-American singer Lydia Mendoza, bluegrass musician Bill Monroe, and traditional artists producing Western saddles and ornamental iron.

Since its inception, the NEA National Heritage Fellowship has become the most important honor in the field. In the blues tradition, the influential John Lee Hooker received the fellowship in 1983. In 1984, the recipients included Clifton Chenier, the accordion master of the Cajun zydeco style; Howard "Sandman" Sims, the leading African-American tap dancer; and Ralph Stanley, the Virginia mountain banjo player, singer, and composer. In 2000, after his fellowship, Ralph Stanley would gain national fame when his songs were used on the soundtrack of the Coen brothers' film *O Brother, Where Art Thou?* In 2006 he received the National Medal of Arts. As the years have passed, the program has expanded beyond standard "folk music" and African-American blues to include the musical styles and craft specializations of Native-American and other indigenous and immigrant cultures.

Since the first NEA National Heritage Fellowships were presented, many genres of popular creativity that were seldom thought of as "American folk" expressions were represented and honored, illustrating the assimilation of new ethnic communities into the life of the nation. Recipients have included a Native-American ribbonworker, a performer on the Slavic *tamburitza,* Hawaiian musicians and craftworkers, a Cambodian court dancer and choreographer, a Lao singer, Bukharan and Bosnian Jewish singers, a Ghanaian-American drummer, and such genres as Chinese opera, the north Indian raga, and Basque poetry.

Although it is an individual honor, many recipients regard the fellowship as broader recognition. Gerald Bruce Miller, Skokomish elder and 2004 NEA National Heritage Fellow, announced at the fellows banquet held in the Great Hall of the Library of Congress: "I want to extend my gratitude on receiving this award to all of our ancestors who left us the gifts that we exhibit today; the gift of the song, the gift of the dance, the gift of the story, and the gift of creativity. As long as we keep these traditional arts alive, we speak for our people." Michael Doucet, Cajun fiddler and composer, reflected upon his 2005 NEA National Heritage Fellowship: "You know, it's interesting—it's a national award but it really comes down to your community and what you do for your community. I was very fortunate to be around when a lot of people born before 1900 were still alive—the 'old-timers,' as we call them now. I think that's where most of my inspiration comes from. It's really a process of a continuation—I wouldn't be getting this award if it wasn't for people who came before me."

The NEA National Heritage Fellowship program embodied the daring soul of Bess Lomax Hawes herself. By 1960, Hawes was already a leading figure in the development of folk music as a commercial medium, participating in folk festivals on both coasts. She served on the faculty of California State University at Northridge before coming to work at the NEA. In honor of her powerful legacy, the Arts Endowment inaugurated in 2000 a special recognition within the NEA National Heritage Fellowships: the Bess Lomax Hawes Award for "achievements in fostering excellence, ensuring vitality, and promoting public appreciation of the folk and traditional arts. To be considered, nominees should be worthy of national recognition and must be actively engaged in preserving the folk and traditional arts."

The Arts Endowment has also played an essential role in the creation and support of a network of folk arts coordinators based at the state, regional, and local folk arts agencies and other cooperating nonprofit organizations. In addition, statewide folk and traditional arts apprenticeship programs, allowing master traditional artists

Bess Lomax Hawes, director of the NEA Folk Arts Program from 1977–92. (Photo by Michael Geissinger)

to pass along their unique skills and knowledge, have been developed in more than 35 states with NEA funding. Direct grants continue to support festivals, touring, documentary and media projects, exhibitions, and educational programs.

OPERA, MUSICAL THEATER, AND NEW MUSIC

Folk art was not the only area to see fresh developments during Biddle's chairmanship. In 1979, Ezra Laderman, composer, teacher, and later dean of the Yale School of Music, became director of the NEA Music Program. In the same year, the Arts Endowment introduced a New Music Performance program to support organizations performing or presenting contemporary compositions. The first grants totaled $352,500 and ranged from $1,500 to $28,000. The Arts Endowment's Contemporary Music Performance Program granted $441,500 for performances at institutions such as the New Music Consort of New York, while its Composer/Librettist Program gave $525,420 to individuals and institutions including the Center for Contemporary Music at Mills College in Oakland, California, which had long been associated with the musical avant-garde. Recipients under the Composer/Librettist Program included the composer William Bolcom of Ann Arbor, Michigan, and Lukas Foss of New York City, along with many others.

In 1978, Biddle established the Opera-Musical Theater Program to provide support for "that art form which has a lasting luster in the history of American art." A new panel, representing opera and musical theater together, adopted a policy statement linking classic expressions with popular traditions: "Whether comic or serious, earthy or elevated, music theater, from the time it moved from the courts to the public arena over two centuries ago, has been part of a tradition of people's art at its best. The Opera-Musical Theater Program hopes to eliminate the barriers which separate the various forms of music theater, and to help create an atmosphere of mutual respect and appreciation. . . . The program emphasizes the creation, development, and production of new American works, as well as experimentation with new forms and techniques."

Carlisle Floyd, an American opera composer and recipient of the 2004 National Medal of Arts, as well as the 2008 NEA Opera Honors, participated in the Arts Endowment's panels from 1976 to 1978, a period he remembered a quarter-century later as "an exciting time in the Endowment." Floyd was a leading figure in the creation of the Opera-Musical Theater Program (later, Opera returned to the broader Music Program, and Musical Theater to the Theater Program). He was joined from

Spoleto Festival USA

The Spoleto Festival USA is one of the world's premiere arts festivals, drawing 70,000 to 80,000 spectators for 17 days and nights each spring to Charleston, South Carolina. The only arts festival hosted by an entire American city, Spoleto Festival USA features more than 120 concerts and performances by established and emerging artists from the U.S. and abroad. Spoleto offers many artistic styles and forms, including classical ballet, modern dance, opera, chamber, symphonic, and choral music, jazz, theater, and the literary and visual arts. Since its inception, the festival has hosted nearly 200 world premieres and American debuts, from *Praise House* by Urban Bush Women to the Spoleto-commissioned *Tenebrae*, a chamber music work by Osvaldo Golijov, to noteworthy presentations such as the monumental, 18½-hour Chinese opera, *The Peony Pavilion*. Festival performances take place throughout the city in churches, theaters, and other public spaces. Piccolo Spoleto, the outreach arm of the festival, provides low- and no-cost performing, literary, and visual arts events in a range of community settings. Each year Piccolo Spoleto presents more than 800 events showcasing artists from the Southeast region.

The world-renowned arts celebration started in 1977, when the Festival dei Due Mondi (Festival of Two Worlds) in Spoleto, Italy, set up an American counterpart with help from the National Endowment for the Arts. The next year, the NEA provided $50,000 for administrative and artistic expenses for musical performances, along

Charleston Mayor Joseph P. Riley (left) with Gian Carlo Menotti, one of the founders of Spoleto Festival USA, at the 1988 opening of the Piccolo Spoleto Festival, a free festival sponsored by the city taking place during the same time as the international festival. (Photo by Bill Murton)

with $35,000 for audience development and $25,000 for a television recording of Samuel Barber's opera, *Vanessa*. In 1979, the NEA granted $7,000 for a Spoleto mini-festival in Charleston. The American festival became independent of its Italian parent in 1993, and the NEA has remained a significant and steady supporter.

Spoleto Festival USA has helped transform Charleston into a thriving tourist destination. Since the festival began, the city's annual visitation has increased threefold; each year, attendees spend an estimated $44 million in the Charleston area. Charleston Mayor Joseph P. Riley, Jr. concludes: "If we invest more in the arts, we will get a high return in terms of the economic and physical and social development of our cities."

the musical theater side by composers Stephen Sondheim and John Kander, as well as producers Hal Prince and Stuart Ostrow. In a 2004 interview, Floyd recalled, "We had made a case that opera had more in common with musical theater than with regular classical performance. The association [between the genres] made sense because opera and musical theater alike used costumes and other elements of performance differently from classical music presentations. At the first meetings the opera people were afraid the musical theater people would consider them dull—but they came to realize a basic agreement."

Opera composer Carlisle Floyd, who served on Arts Endowment panels from 1976–78. (Photo by Jim Caldwell)

The program also provided for the creation and performance of new operatic and musical theater works. In the same period, demonstrating that the traditional classical music categories would remain central to the Arts Endowment's work, the Music Program recognized choruses and chamber music as separate fields requiring support.

THE BIDDLE WAY

Biddle began his leadership of the NEA with a major fiscal decision. He removed ceilings on grants, which allowed advisory panels greater discretion in recommending grant amounts. In 1978, under the rubric "Unity, Quality, Access," Biddle explained this decision: "The test all applicants for Endowment support must meet thus becomes the test of quality. If a project of extraordinary merit is in need of funding, is it reasonable to dilute quality as a standard by imposing an arbitrary limit on support?" He distributed funds far and wide in an ever-increasing quantity of new initiatives that sought to parallel the growing innovation and variety in the arts and to reach a diverse American public.

Many more new programs emerged in the Biddle years. The chairman formalized support for "multidisciplinary presenting" of cultural programs at institutions such as New York's Lincoln Center. The Arts Endowment also launched its first major joint venture with the National Endowment for the Humanities. This effort was a

month-long symposium entitled "Mexico Today," which consisted of concerts, poetry readings, films, panel discussions, dance performances, and exhibitions of art and photography. "Mexico Today" visited nine American cities and was seen by nearly half a million people.

In 1979 the NEA's funding reached significant levels. In dance alone some 360 grants were awarded, accounting for $7.9 million. The enormous growth and diversification of the arts during the decade raised new challenges for the agency. Nancy Hanks had convened a Management Task Force to examine the growth of the agency and make structural recommendations. One suggestion was that the Humanities and Arts Endowments no longer share administrative personnel. In 1978, with approval from Congress, the Arts Endowment became self-sufficient and hired its own administrative staff. Until that point, the two agencies had shared staff for budget, finance, and personnel management.

According to Biddle, the great problem for the arts in America was "the danger of fragmentation." When special interests come into play, he maintained, "they can diminish the value of the art, for although art does a great many good things in the world for a great many people, it does them best when it is free. No task is more important now than to keep the arts free—free from their own politicization, free from limiting special interests, free to experiment and explore."

For Biddle, if the pursuit of innovation becomes too strong, art threatens to fragment into islands of expertise, and may end up "forced to serve special interests." The connection between artists and the public is broken, coteries form, and artworks lose their universal appeal. While he considered it the Arts Endowment's responsibility to promote experimentation in art, it also has a duty to keep art central to American society. Much of Biddle's chairmanship might be interpreted as an effort to steer a difficult course between those two mandates.

Revised Structure

Outside pressures not only broadened access to the Arts Endowment's funding, they also compelled various internal adjustments. Annually, when the chairman of the U.S. House Appropriations Interior Subcommittee held hearings on the NEA's budget, not only was the Arts Endowment's chairman called to testify, but the agency's program directors also were asked to provide a status report. Representative Sidney R. Yates (D-IL), the subcommittee's chairman, took great enjoyment in learning firsthand the latest developments in each arts field.

As the Arts Endowment's budget grew, a perception of favoritism and conflicts of interest by individuals serving on grant panels sparked concern in both artistic and governmental circles. Deputy Chairman for Programs Mary Ann Tighe wrote, "How panelists are selected seems to be a subject of particular interest to the arts community. Our process is a subjective one . . . the staff, generally the program director in consultation with individuals in and outside the Endowment, makes the list, with at least one-third of the panel changing every year." Nevertheless, reappointments of some panelists for longer periods of time had occurred since the Hanks period. Biddle reorganized the panel system and enforced the standard that a panel member could only serve for up to three consecutive years.

The NEA also carried out a discipline-by-discipline audit of its practices. In 1979, the NEA added two new areas of support to its traditional dance programs—artistic personnel and rehearsal support—which helped companies pay for existing and new artists and performers as well as rehearsal time.

NEA Dance Program Director Rhoda Grauer with dancer/artistic director Edward Villella at the twenty-fifth anniversary celebration of the National Association for Regional Ballet in 1980. (Photo by V. Sladon)

Rhoda Grauer, then-director of the Dance Program, noted that the United States was "the center, virtually the Mecca, of the international dance community." Grauer praised the field of American dance as one in which "there are choreographers who use classical vocabularies and choreographers who invent whole new languages of movement." In dance instruction, according to Grauer, "Though we have few national dance conservatories and though training in this country has evolved independently and erratically, much of our teaching and our dancers' technical and performance standards are among the world's finest. Still, acceptance has not come easily. In 1965, there was only a handful of high quality, fully professional dance companies in the United States, almost all of them in New York."

In the field of literature, then-program director David Wilk described the NEA's Residencies for Writers Program, which had existed for several years, as "an attempt to put writers in personal contact with their audiences." The NEA had by then spent several years assisting the Coordinating Council of Literary Magazines, an entity that brought together and supported small press journals. The NEA "increased substantially its support for innovative and experimental projects attempting to solve the problems of distributing and promoting fine contemporary creative literature." These included funds for book buses run by the Plains Distribution Service of Fargo, North Dakota, and the Visual Studies Workshop in Rochester, New York. In 1979, "small presses" drew $380,000 in federal funds.

Many creative writing fellowships awarded during Chairman Biddle's term went to fledgling writers who subsequently became major figures in the literary world, including Jane Smiley, T. C. Boyle, Paul Auster, Alice Walker, and Tobias Wolff. One of the most noteworthy literary grants of the era supported the work of an author who had taken his own life ten years earlier. In 1979, the Arts Endowment awarded Louisiana State University (LSU) Press $3,500 to defray publishing costs of a comic novel, *A Confederacy of Dunces,* by unknown writer John Kennedy Toole. Toole had finished the manuscript in the late 1960s while stationed with the U.S. Army in Puerto Rico, where he had taught English to Spanish-speaking recruits. After several publishers rejected the work, Toole committed suicide in 1969. But his mother, Thelma Toole, assisted by novelist Walker Percy, managed to place the work with LSU Press. With the Arts Endowment's help, the work was published in 1980. It was a critical and commercial success, selling 50,000 copies the first year and winning the 1981 Pulitzer Prize for Fiction. It has since been translated into 18 languages, and there are nearly two million copies in print.

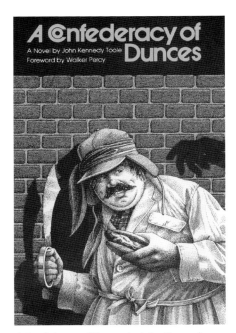

A Confederacy of Dunces by John Kennedy Toole was published in 1980 by Louisiana State University Press with support from the Arts Endowment. (Image courtesy of Louisiana State University Press)

In 1979, the Endowment funded several projects in the area of new media. With

a budget of $8 million, the Media Arts Program under the direction of Brian O'Doherty continued to fund the American Film Institute as well as radio, television, film and video projects, and media arts centers. At the time, O'Doherty warned that "private funds for media arts centers [had] not been forthcoming in significant amount," and that "the work of the independent artist, which maintains an individual voice in a mass medium overwhelmingly devoted to commercial ends, is still a misunderstood and underexploited resource."

The direction of the Visual Arts Program had passed in 1977 to James Melchert, an artist and professor at the University of California, Berkeley. In the NEA's 1979 *Annual Report,* Melchert summarized the state of his discipline and its relationship with the NEA by noting that in one year 7,000 painters, sculptors, crafts artists, and photographers had applied for grants. Most of them were necessarily rejected, with grants awarded at a ratio of three to one hundred applications (the broader ratio in the NEA was one grant to four applications). Melchert was avid about defending the grantees that were chosen and the criteria for their selection. "We are not success-oriented, in the conventional sense," he wrote in the *Annual Report.* "Our ideas of success are different from the usual ones. A fellowship . . . might mean only that the artist spent his time testing new ideas, learning which led up blind alleys and which were artistically valid. We do not require our artists to be . . . popular, either, which is sometimes quite different from having artistic merit."

THE REGIONAL REPRESENTATIVES

In 1980, the Endowment finally reached its full complement of what were called "regional representatives." The regional representatives were the centerpiece of a program initiated in 1972 by Nancy Hanks that would promote better communication between the Arts Endowment and individuals and organizations in different areas of the country. These representatives, most of whom worked out of their homes (and suitcases) with only part-time clerical help, provided vital links between the NEA and those in near and distant states who might otherwise have regarded the growing agency as a faceless and faraway bureaucracy. At the end of Chairman Biddle's term, the program had grown to 12 men and women employed to provide information, contacts, and free services to artists, organizations, and the public.

The "reps" traveled extensively throughout their regions, conducted workshops, represented the NEA at special events, assisted would-be applicants, assuaged unsuccessful ones, and answered hundreds of mail and telephone inquiries. Tied to

their regions, with a history of involvement with arts organizations, they brought the agency leadership into closer contact with local conditions. They reduced the sense of isolation that many actual and potential applicants felt, helped people all over the country learn about the NEA—in particular its grants review process—and enabled those at the Endowment to understand more fully the needs, trends, populations, and regional differences that characterize the arts in the United States. The number of regional representatives was reduced to seven a few years later, and the program ultimately ended in 1991.

MAJOR ACCOMPLISHMENTS

Reporting near the end of his term, Livingston Biddle wrote in 1980, "The Endowment has had some controversial moments; and yet controversy is the yeast that makes the creative loaf rise." During Biddle's chairmanship, he and his staff took advantage of a relatively tranquil era to expand support for diverse artists reflecting American society. The Biddle era was one in which the Arts Endowment attained a well-defined stature as an institution representing American creative aspirations. There were difficulties in trying to reflect a splintering and volatile art world, but Biddle met them by developing new programs for historically underrepresented groups, supporting both traditional and avant-garde art.

Frank Hodsoll, NEA Chairman 1981–89. (NEA File Photo)

CHAPTER 5

The Reagan Era

T HE ELECTION OF President Reagan in 1980 brought a different philosophy to the federal government, and initially, many in the new Administration questioned the propriety and expense of a public agency funding the arts. The NEA's next chairman, Frank Hodsoll, faced a number of challenges, including a funding cut. By the end of his second term in 1989, however, the NEA emerged with a budget increased to $169 million. Important new initiatives such as the American Jazz Master Fellowship—now known as NEA Jazz Masters—and the National Medal of Arts were created, and the agency assumed the mantle of leadership in arts education. At the same time, and deriving primarily from Hodsoll's background in government and public policy, the Arts Endowment focused on building infrastructures and support networks for the arts, cultivating new audiences, and fostering sustainability among arts organizations.

Hodsoll came to the Arts Endowment from the staff of the Reagan White House. With a background as a lawyer and U.S. Army officer, and with 14 years in the Foreign Service, he had joined his friend James A. Baker III in the Reagan election campaign. While working on the campaign, Hodsoll was asked to look into the reasons why Office of Management and Budget (OMB) Director David Stockman was trying to "zero out"—completely abolish—the NEA.

Interviewed almost a quarter-century later, Hodsoll recalled that, at the time, he barely knew what the NEA was or why it was targeted for elimination. As it happened, the matter was an early expression of the "culture war" between liberals and conservatives that was then emerging in American life. A former U.S. Representa-

Actor Charlton Heston was a member of the Presidential Task Force that studied arts and humanities issues in 1981. (Photo by John St. Clair)

tive, David Stockman viewed the NEA as one of many examples of the federal government's excessive influence in public life. Inheriting a sluggish economy and a large federal deficit, Stockman was looking for programs to cut in order to restrict the size of the federal government.

The first indicators of the new Administration's direction were not promising. Under the alarming headline, "Pages from Budget Director Stockman's 'Black Book'" (*Washington Post,* February 8, 1981), a story appeared with the following notes and comments about a proposed 50 percent budget cut: "Reductions of this magnitude are premised on the notion that the Administration should completely revamp federal policy for arts and humanities support. For too long, the Endowments have spread federal financing into an ever-wider range of artistic and literary endeavor, promoting the notion that the federal government should be the financial patron and first resort for both individuals and institutions engaged in artistic and literary pursuits. This policy has resulted in a reduction in the historic role of private individual and corporate philanthropic support in these key areas." The Reagan Administration had to consider whether arts funding should continue at existing levels when cuts were to be made in welfare and other social programs.

Initially, Livingston Biddle bore the responsibility of defending the Arts Endowment, but for the most part, Hodsoll led the fight in the Reagan White House. Reagan was not strongly motivated to abolish the Endowments. As an actor himself, the President had many friends in the arts, including Charlton Heston, Reagan's successor as president of the Screen Actors Guild and an early member of the National Council on the Arts. In addition, the Heritage Foundation, an intellectual redoubt of the Reagan revolution, in its first *Mandate for Leadership* volume (1980), endorsed the purposes of the Arts and Humanities Endowments, while urging greater adherence to those purposes and better management of Endowment programs.

In response, the Reagan White House established a presidential task force to study whether the National Endowment for the Arts and the National Endowment for the Humanities should continue. Headed by Hannah H. Gray, president of the University of Chicago; Daniel J. Terra, art collector and ambassador-at-large for cultural affairs; and Charlton Heston, the task force held hearings and ultimately recommended keeping the Endowments alive and well funded. In accepting the report of the task force, President Reagan pointed out that the two Endowments, beginning in 1965, "account[ed] for only 10 percent of the donations to the arts and scholarship. Nonetheless, they have served an important role in catalyzing additional private support, assisting excellence in arts and letters, and helping to assure the availability of arts and scholarship." The task force eventually became the President's Committee on the Arts and the Humanities, established by Executive Order in 1982.

Hodsoll asked to be considered for the chairmanship of the Arts Endowment. "Everyone said I was nuts," he later recalled, as President Reagan agreed to name him NEA chairman. Frank Hodsoll was sworn in as the fourth Arts Endowment chairman by Chief Justice Warren E. Burger on November 13, 1981, with the three former NEA chairmen—Roger Stevens, Nancy Hanks, and Livingston Biddle—present at the ceremony. By the time he assumed the post in November 1981, however, a number of discipline directors had resigned. Hodsoll had ample opportunity to reappoint existing program directors or select new ones.

Hodsoll expressed optimism about his mission. In 1981, the final year of the Biddle chairmanship, the NEA's budget rose to nearly $160 million. The following year Hodsoll had to contend with a cut of 10 percent, to $143.5 million in 1982—the first budget cut in the Arts Endowment's history—but the reduction was far less than the 50 percent proposed by Stockman, and more favorable momentum was gathering. "The arts in America are alive and well," Hodsoll wrote. "Our country continues to have the greatest variety of excellence of any country in the world. There are dozens of regional theaters . . . there are painters and sculptors everywhere. Post-modern architecture begins here. [There is] a greater variety of first-class orchestras than in any other single country. We are a world center for ballet and modern dance. There are great museums. And artists from around the world continue to flock to this country. This is a tribute to the nation."

The NEA Jazz Masters Program

The year 1982 saw the inauguration of one of the NEA's most significant programs, the NEA Jazz Masters Fellowship, a lifetime achievement award honoring outstanding exponents of an art form that is undeniably unique in its American origins and character. The award was conceived in April 1980 when Aida Chapman, then assistant director of Music, wrote a position paper in which she posed several ideas for honoring the jazz field, including establishing a Jazz Hall of Fame. By the time the NEA acted, it was 1982 and the first NEA Jazz Masters Fellowships were awarded under Adrian Gnam's leadership as director of Music.

The first trio of NEA Jazz Masters, named in 1982, represented distinct traditions and levels of experimentation in music: Roy Eldridge (1911–89), Sun Ra (1914–93), and Dizzy Gillespie (1917–93). Eldridge, a trumpeter, was a leading representative of the transitional generation between Louis Armstrong's Dixieland, the big-band era, and the bebop style. Eldridge had played in the Teddy Hill band with saxophonist Leon "Chu" Berry, a brilliant performer whose career ended when he died in a car accident at age 33.

Sun Ra, originally known as Herman "Sonny" Blount, was a remarkable innovator famous for his cosmic spirituality and "space alien" persona, as well as his startling improvisations and pioneering use of electronic music. He moved from issuing and selling his own albums in the 1950s to producing a multimedia show, the Sun Ra Arkestra, which included singers, dancers, martial artists, film, and original costumes.

John Birks "Dizzy" Gillespie was an authentic giant of the bebop era; he and Charlie "Bird" Parker were its two leading figures. The impact of Gillespie's innovations is heard in the work of every jazz trumpeter who followed him, and his compositions have been played and replayed. In the 1940s, Gillespie formed a big band, and fellow musicians included such future stars as Yusef Lateef and John Coltrane; his rhythm section brought together John Lewis, Milt Jackson, Kenny Clarke, and Ray Brown. The latter four went on to organize the Modern Jazz Quartet, and all were later selected as NEA Jazz Masters.

In the years that followed, the NEA Jazz Masters Fellowship became America's most prestigious honor in the field. In 1991, when jazz biographer D. Antoinette Handy was Music director, the NEA enhanced the program by having the recipients collect their award during a concert ceremony. The first ceremony was held at the Sheraton Hotel in Washington, DC, with support from Chevron (USA) and the

Dizzy Gillespie was one of the first recipients of the NEA Jazz Masters Award in 1982. (Photo by Martin Cohen)

Yamaha Music Corporation. The events were coordinated by the Charlin Jazz Society in conjunction with the 18th Annual International Association of Jazz Educators (IAJE) conference, and the evening celebrated all 27 previous NEA Jazz Masters along with four new inductees: Danny Barker, Buck Clayton, Andy Kirk, and Clark Terry. Wynton Marsalis served as master of ceremonies.

In 2008, Arts Endowment Chairman Dana Gioia noted with satisfaction that in the 26 years since the NEA Jazz Masters program began, not only has the award's prestige grown, but also the individual stipend has reached $25,000, and the number of awards given each year has risen from three to six. One of these awards, the A. B. Spellman NEA Jazz Masters Award for Jazz Advocacy, named for the veteran agency official and jazz historian, is presented to a non-performing jazz advocate who has made major contributions to the field. Cultural critic Nat Hentoff received the first NEA jazz advocate award in 2004.

Since 1982, the NEA Jazz Masters award has encompassed outstanding talents across the generational span, from Count Basie to Cecil Taylor, from Ahmad Jamal to Dave Brubeck, from Ella Fitzgerald to Tony Bennett. The extraordinary variety of jazz idioms reflected what A. B. Spellman called "the old jazz principle that 'you've got to make it new.'" For many years, the NEA Jazz Masters award had been presented at a concert held during the annual conference of IAJE. Working with Jazz at Lincoln Center, and with funding from the Verizon Foundation, the NEA also produced an online curriculum for high school students called NEA Jazz in the Schools.

NATIONAL MEDAL OF ARTS ESTABLISHED

In 1984, President Reagan signed legislation establishing the National Medal of Arts as the nation's highest award to artists and art patrons. This presidential award was

President Ronald Reagan presenting the National Medal of Arts to visual artist Romare Bearden in 1987. (Photo by Mary Anne Fackelman-Miner, White House)

destined, like other NEA honors, to become a hallmark of American creative excellence. Drawing from nominations by private citizens, members of Congress, and arts groups, the National Council on the Arts makes recommendations and submits them to the President. The medal itself was designed by sculptor Robert Graham following a public competition.

The National Medal of Arts was first presented at a White House luncheon on April 23, 1985. The first set of recipients included a stellar group of American artists and patrons:

- Elliott Carter, composer
- Ralph Ellison, novelist
- José Ferrer, actor
- Martha Graham, dancer and choreographer
- Lincoln Kirstein, dance impresario
- Louise Nevelson, sculptor

- Georgia O'Keeffe, painter
- Leontyne Price, opera singer
- Dorothy Chandler, patron
- Alice Tully, patron
- Paul Mellon, patron

Another recipient was not an individual, but a corporation, Hallmark Cards, Inc., for its longstanding support of the arts.

National Medal of Arts recipients in the second Reagan Administration included film directors Frank Capra and Gordon Parks, composers Aaron Copland and Virgil Thomson, painters Willem de Kooning and Romare Bearden, choreographers Agnes de Mille and Jerome Robbins, folklorist Alan Lomax, philosopher and critic Lewis Mumford, fiction writers Eudora Welty and Saul Bellow, and poets Howard Nemerov and Robert Penn Warren—a constellation of the nation's most creative talents.

Twentieth Anniversary

In 1985, the NEA celebrated its twentieth anniversary. On March 25, the Academy of Motion Picture Arts and Sciences awarded a special Oscar to the NEA for its service to the arts, and six months later, the Academy of Television Arts and Sciences awarded the Arts Endowment an Emmy. Frank Hodsoll was renominated as NEA chairman, and President Reagan declared September 23–29 of that year National

Arts Week. First Lady Nancy Reagan served as honorary chairman of the Twentieth Anniversary Committee, headed by Charlton Heston. Widespread public support for the Arts Endowment was manifested in more than 800 NEA anniversary events around the country. Additionally, the NEA's budget rose to $164.7 million.

As another marker of its twentieth anniversary, the Arts Endowment sponsored *Buying Time,* edited by Scott Walker, an anthology of work by recipients of the NEA Literature Fellowships over the years. Published by Graywolf Press in St. Paul, Minnesota, the volume comprised an anthology of America's best poets

NEA Chairman Frank Hodsoll (right) shares the agency's Academy Award with President Reagan. (NEA File Photo)

and short-story writers. The poets in *Buying Time* included John Ashbery, John Berryman, Louise Bogan, Lucille Clifton, Robert Duncan, Allen Ginsberg, Louise Glück, Galway Kinnell, Etheridge Knight, Stanley Kunitz, Philip Levine, W. S. Merwin, Kenneth Rexroth, Muriel Rukeyser, May Sarton, and Charles Wright. Fiction was represented by Paul Bowles, Raymond Carver, Louise Erdrich, John Gardner, John Hawkes, Maxine Hong Kingston, Grace Paley, Marge Piercy, Isaac Bashevis Singer, and Tobias Wolff. The playwriting section featured the work of Maria Irene Fornes. It was an extraordinary roster of literary talent and a fitting tribute to two decades of NEA support of literature.

GRANT PATTERNS CONTINUE

At the onset of the Reagan Administration, the NEA's grants, based on peer review, generally followed the patterns previously established. Many of the same institutions continued to appear on lists of grantees, prompting concern about the rigor—or lack of it—in the application review process.

Determined to ensure that the panels forwarded only artistically worthy applications for funding, Chairman Hodsoll personally reviewed hundreds of applications, including supporting materials and panel notes. Applications which he believed failed to meet the standard of artistic excellence, lacked adequate support for funding, or raised policy issues were selected for additional review and discussion by the National Council on the Arts at its quarterly meetings. In some instances, a majority of council members agreed with the chairman's judgment and recommended that the applications be rejected. In accordance with the NEA legislation, Chairman Hodsoll made the decisions himself, after considering the recommendations from panels and the National Council on the Arts.

Hodsoll was assisted in this regard by Associate Deputy Chairman for Programs Ruth Berenson, whom he had brought to the Arts Endowment from her earlier work as art critic and writer for the *National Review*. The panels were required to document more fully, and for the record, their recommendations—not just reasons for rejections, but their rationales for funding, reinforcing Hodsoll's resolve to support only the most artistically meritorious among the 20,000 or more applications received each year.

In 1982, Hodsoll emphasized that private donations for the arts would remain the most important component of arts support in a "pluralistic system . . . in which no one sector dominates." But he also called for new practices needed to address devel-

Cowboy Poetry

If asked for an example of cowboy poetry, many Americans might only know Dr. Brewster Higley's lyrics for "Home on the Range." Cowboy poetry, however, is a vibrant and beloved genre, with fans across the United States. Influenced by the rhythms of gospel, hymns, and other musical genres, its ballad style—characterized mostly by rhyme and authentic detail— has roots that stretch back to the 1860s. Since then, wranglers and buckaroos have entertained each other in bunkhouses and on trail drives with poems they have memorized or made up on the spot.

The year 1985 marked the beginning of the National Endowment for the Arts' contribution to this unique art form with support for the first annual Cowboy Poetry Gathering, held in the railroad town of Elko, Nevada, and sponsored by the Western Folklife Center. To prepare for the event, folklorist Hal Cannon and his colleagues surveyed ranchers to explore the heritage of contemporary cowboy poetry and determine its popularity. The reach of cowboy poetry surprised them all when attendance at this first gathering of cowboy poets in the middle of winter exceeded five times the expected number. Within five years, dozens of similar festivals emerged across the Western United States, and by the mid-1990s, that number had increased to over 150, followed by numerous poetry books, CDs, magazines, and anthologies. Several of the more famous cowboy poets, including Baxter Black, Wally McRae, and Waddie Mitchell made numer-

Cowboy poet Wallace McRae, also an NEA National Heritage Fellow, has been performing at the National Cowboy Poetry Gathering in Elko, Nevada, since its inception in 1984. (Photo by Tom Pich)

ous appearances on radio and television.

Today, the week-long Elko festival attracts 8,000 enthusiasts and adds more than $6 million to the local economy. Women, too, are now participating in droves. Cannon remembers that more than 50 corporations and funders turned him down for help, but the Arts Endowment's support was steadfast: "The NEA support was a very important indicator of trust, and helped us to get cowboy poetry off the ground."

Idaho Shakespeare Festival, here performing Shakespeare's play *The Comedy of Errors*, has benefited from support by the NEA and the Idaho Commission on the Arts over its more than 30 years. (Photo courtesy of Idaho Shakespeare Festival)

opments such as the acquisition of film companies and publishing houses by business conglomerates, the increasing predominance of "blockbuster" exhibitions at museums, and a decline in adventurous repertoires produced among performing arts institutions. His approach demonstrated a far-reaching economic and institutional understanding of the arts in America, one that recognized new financial pressures on arts organizations and the need for a different kind of public support.

Hodsoll developed a six-part strategy for the NEA:

• Providing long-term institutional assistance to the best of the arts organizations, big or small;

• Encouraging broader audiences for advanced and diverse art forms;

• Increasing efficiency in grantmaking by promoting anticipatory planning by arts institutions;

• Reinforcing links among federal, state, local, and regional arts organizations;

• Stimulating broader private support;

• Initiating a system of arts information delivery.

Efficiency, stability, partnership, and sustainability—these new concepts took

their place beside the traditional ideals of artistic excellence and artistic heritage, and they were reflected in several accomplishments during the decade.

A noteworthy instance of two of those goals, long-term assistance and federal-state-local links, is the Idaho Shakespeare Festival (ISF). In the words of the managing director and later member of the National Council on the Arts, Mark Hofflund, "ISF is the product of *modest and steady* federal support over many years through a highly scrutinized, professional and publicly engaged process of federal leadership at a statewide level. There is nothing immediately notable or sexy in this. It generates no medals or headlines or sound bites. In 30 years, this organization has progressed from an annual budget of $4,500 to $2,500,000—with assets of $5,000,000 from a campaign to build an amphitheater situated among 12 acres of riverside habitat." Furthermore, the success resulted from two parties: "The greatest cumulative source of support for ISF, during these decades, was none other than the Idaho Commission on the Arts—as supported by the NEA." Indeed, Hofflund adds, Idaho "likely would not have an arts agency had the NEA not encouraged its creation 40 years ago."

CONGRESSIONAL CONTROVERSIES AND INFLUENTIAL CRITIQUES

In 1984, while the agency was reforming its grants process and expanding into new programs, another controversy erupted when Representative Mario Biaggi (D-NY) stepped forward to protest the funding of a production by the English National Opera company of Verdi's opera *Rigoletto* at the Metropolitan Opera in New York. This version of *Rigoletto*, advertised as being set among Mafiosi in New York's Little Italy, was judged by some as demeaning to Italian-Americans. Biaggi was joined in his complaint by Rudolph Giuliani, then associate U.S. attorney in New York, and various Italian American advocacy groups. Representative Biaggi called Chairman Hodsoll to testify at a special Congressional hearing. The *Rigoletto* uproar eventually died down, but the episode demonstrates the sharp scrutiny applied to the Arts Endowment whenever an organization it funded produced art that verged on controversial topics and touched on edgy themes.

The battle heated up again in 1985, when Congressmen Tom DeLay (R-TX) and Dick Armey (R-TX) declared that the Arts Endowment had violated its mandate by awarding grants to authors of poetry that the two legislative critics described as "pornography." As reported in the *New York Times*, Representative Armey argued that authors of obscene verse continued to benefit from Arts Endowment grants as a

The Mayors' Institute on City Design

The Mayors' Institute on City Design is a partnership between the National Endowment for the Arts, the U.S. Conference of Mayors, and the American Architectural Foundation. In 1986, Mayor Joseph Riley of Charleston, South Carolina, proposed the idea of a program that would give mayors a better understanding of how design can improve their cities. He presented this idea to the NEA's then-director of Design, Adele Chatfield-Taylor, who secured funding to form the Mayors' Institute on City Design. Now in his eighth term, Mayor Riley notes: "Mayors come to the Institute as regular people but, I promise you, they leave as zealous apostles of good urban design. You can see the light bulbs go off in their minds."

The structure of the Institute has remained the same since its inception: eight mayors and eight designers, all locked in a room for two-and-a-half days—no staff, no media, no sound bites or grandstanding—just 16 men and women talking about design. Each mayor brings his or her city's most critical urban design challenge to discuss, and following the case-study method, the teams generate creative solutions. As of 2008, a Mayors' Institute takes place somewhere around the country every 60 days. In addition to more than 750 mayor alumni, the institute can also claim more than 400 designers, who have often commented on learning as much from the mayors as the mayors have learned from them.

Mayors who have attended credit the experience as transforming the way they look at their cities. As one alumnus, U.S.

New Orleans Mayor Ray Nagin (at podium) leads a press conference for the Mayors' Institute on City Design's special session on the 2005 Gulf Coast hurricanes. (Photo by Aaron Koch)

Representative Kay Granger, former mayor of Fort Worth, Texas, said, "Throughout my three terms, I kept coming back to what I had learned at the Institute and applying it to my city. I can think of three specific success stories that were the direct result of my participation. These included the creation of the grand boulevard in the place of a torn-down overpass, the rebuilding of our downtown library, and the reorientation of the city toward its waterfront. Honestly, in terms of what will last beyond me and into the future, the Mayors' Institute had greater influence than anything else I did while in office."

As of 2008, more than 750 mayors have participated in the NEA's Mayors' Institute on City Design. The program's success also led to the 2005 creation of the Governors' Institute on Community Design, a spinoff initiative intended to help governors practice good community design and innovative planning.

consequence of cronyism within the NEA. By this he implied that former grantees, who had become panel members judging the appropriateness of applications, would then reward those whose work resembled, supported, or justified their own.

Such allegations constituted a legitimate area for Congressional oversight. Indeed, a public agency distributing funds in a competitive process must avoid even the suspicion of inside dealing or unfair practices. In 1979, the *Washington Post* commented, "The charge that a 'closed circle' of acquaintanceship runs the [Arts] Endowment through overlapping appointments to panels and committees is a serious one, and one both the Arts and Humanities [Endowments] have been guilty of for a long time. Beside the obvious wrong of creating situations where friends make grants to friends, or friends of friends, there is also the patently unhealthy set-up in which stale ideas recycle like so much dead air."

The Armey-DeLay criticism also had been anticipated in a number of articles about the Arts Endowment in literary and political journals. Hilary Masters, fiction author and son of the distinguished American poet Edgar Lee Masters, published a critical examination of the Arts Endowment's Creative Writing Fellowships in *Georgia Review* in 1981. Titled "Go Down Dignified"—a phrase from a Robert Frost poem "Provide, Provide" about securing wealth and fame—the article noted the charge of cronyism directed against panelists, and also observed that most grants went to writers in New York and California. "Few found their way to Middle America or to the South. States like Oklahoma, Michigan, Georgia, and Indiana received only two grants each. Louisiana, Kansas, Tennessee, and Mississippi got only one each. Both West Virginia and Utah received only one fellowship each, and theirs were given to writers with no permanent residence in those states. Missouri received none," Masters observed, adding that a disproportionate amount of grant money had been awarded to writers connected with certain small presses. In one case, seven writers associated with Big Sky Press were among the 267 winners of fellowships out of a pool of 3,750 submissions—evidence to Masters of an interlocking relationship among publishers, authors, and panelists. The *Georgia Review* printed a "Restrained Response" to Masters by NEA Literature Director David Wilk, who asserted that Masters misrepresented the grants review process and cherry-picked from the statistical data. Nevertheless, Masters's scathing essay caused much commentary in the literary world.

Armey and DeLay were joined by Representative Steve Bartlett (R-TX), who proposed an amendment to the NEA's 1985 funding bill prohibiting awards to artists whose work could be considered "patently offensive to the average person." Though

none of the cited poems were written when any of the authors were NEA grantees, the objections were powerful nonetheless. Congressional staff members even came to the Arts Endowment facility and searched through Literature grant archives looking for more controversial material.

Led by Chairman Hodsoll, the NEA repudiated the challenge to its grantmaking by issuing a firm defense against attempts to impose federal regulations on literary content. Professor Cleanth Brooks, a surviving member of the influential "New Critics," a group of literary critics and scholars whose methods dominated mid-century American literary study, came forward to declare Congressional censorship a "cure worse than the disease." He also suggested, "A properly educated public should be able to act as their own censors." On the other hand, John Illo, a professor of English at Shippensburg University of Pennsylvania, soon responded in the letters column of the *New York Times,* finding it "surprising" that Brooks "should not know the difference between the right of publishing without restraint and the privilege of being subsidized." After he left the Arts Endowment, Hodsoll expressed agreement with Illo's position, noting, "I make a fine distinction (some would argue too fine) between content standards and administrative common sense that respects the expectation that taxpayers have that their taxpayer dollars will not be used to offend them."

Nevertheless, internal notes on the political debate, written by NEA Congressional Liaison Anne Marie Barnes and circulated to NEA staff, included the statement, *"The Endowment would not have been established if there were any suggestion that the Federal government, or any instrumentality of it, would in any way influence the content of supported art.* [Emphasis in original] The Endowment was not to become a Soviet art czar or Ministry of Culture." Clearly, the Arts Endowment was still struggling with the general problem of how to negotiate the competing demands of artistic freedom and public standards, and soon the NEA would undergo much more severe attacks.

New Programs

In summing up the situation of the NEA at the close of its second decade, Hodsoll pointed out a new economic constraint in the arts: "Notwithstanding increasing overall support for the nonprofit arts, it is important to note that, especially in the performing arts, expenses are increasing, in some cases even faster than revenues. We need a better sense of how great these difficulties are. We also remain concerned about the reluctance in many quarters to produce, present, or exhibit programs that

lack the drawing capacity of 'stars' or 'blockbusters.' The tension between marquee value for its own sake and artistic excellence remains; the only question is whether that tension is producing greater imbalances today than previously. Most important-ly, we are concerned that 61 percent of American adults do not participate in most of the arts we support; hence, our priority for arts education and television program-ming in the arts." Both were essential to sustaining future audiences for the arts.

In 1986, the promise of television's creative engagement would be partly fulfilled by funding of the Public Broadcasting Service series on American artists, *American Masters*. The first season included documentary profiles of critical figures in the his-tory of American culture, including the architect Philip Johnson, author Katherine Anne Porter, actor Charlie Chaplin, singer Billie Holiday, conductor James Levine, composer Aaron Copland, painters Thomas Eakins and Georgia O'Keeffe, and play-wright Eugene O'Neill. The series also included a collaborative project among playwright Arthur Miller, German director Volker Schlöndorff, and the cast of the cinema version of Miller's *Death of a Salesman*, a classic of the modern theater.

The concluding years of the Reagan era saw many other positive developments in the Arts Endowment's support of media arts. The NEA had supported the founding of the National Center for Film and Video Preservation as a subsidiary of the Ameri-can Film Institute. The center is an archive for film and television products whose holdings are at the Library of Congress and other archives. Its mission, to advance technology for rescuing and reproducing film and television originals, has resulted in the transfer of black and white products from fragile and hazardous nitrate-based stock to acetate, research to resolve a range of separate problems associated with the degradation of acetate stock itself, the application of special technologies for the preservation of color films, and research on the preservation of videotape. In 1986, AFI initiated a two-year national moratorium on the disposal of television program-ming and began preparing comprehensive national guidelines for the selection of television programs for retention and preservation. The center held the first national conference for local television news archives in 1987, and the guidelines were dis-tributed to the nation's television networks, broadcast groups, and production companies in 1988.

The Dance Program supported a landmark event when the Joffrey Ballet pro-duced *The Rite of Spring* in 1987. Led by the choreographer and historian Millicent Hodson and her husband, Kenneth Archer, the Joffrey Ballet reconstructed the cho-reography of ballet genius Vaslav Nijinsky, set to the score of Igor Stravinsky. *The Rite of Spring* had not been staged with the complex Nijinsky directions since its

The NEA supported the reproduction of *The Rite of Spring* by the Joffrey Ballet of Chicago, which used the original sets, costumes, and choreography from the 1913 production. (Photo by Herb Migdoll)

tempestuous premiere in 1913 in Paris, when it sparked a riot. The 1987 revival featured the original sets and costumes designed by the Russian mystic philanthropist and painter Nicholas Roerich. The event proved to be notable in the history of ballet. The reconstructed version of *The Rite of Spring* has been adopted into the repertory of the Kirov Ballet in Russia and presented many times since. In supporting the project, the Arts Endowment demonstrated its crucial role in maintaining artistic legacies, making a famous episode in the history of ballet accessible to a broad American audience.

A NEW PRIORITY: ARTS EDUCATION

Chairman Hodsoll's commitment to arts education resulted in an ambitious research study published by the Endowment in 1988, entitled *Toward Civilization*. The study sounded a grave and dignified warning about the decline of arts instruction in the K–12 curriculum. In the foreword, Hodsoll wrote, "We have found a gap

between commitment and resources for arts education *and* the actual practice of arts education in classrooms. Resources are being provided, but they are not being used to give opportunities for all, or even most, students to become culturally literate. The arts in general are not being taught sequentially. Students of the arts are not being evaluated. Many arts teachers are not prepared to teach history and critical analysis of the arts."

This statement articulated a new theme of arts education at the NEA. Whereas previous efforts had focused on placing artists in the schools and exposing children to arts activities, *Toward Civilization* emphasized learning and study, with the great traditions of art and culture at the center of the curriculum. In this sense, it accorded with the broader movements of education reform in the 1980s signaled by documents such as the Department of Education's influential report, *A Nation at Risk* (1983), and the National Endowment for the Humanities' controversial study of higher education, *To Reclaim a Legacy: A Report on the Humanities in Higher Education* (1984). These reform documents emphasized content knowledge and basic skills, and they helped inspire the standards movement in K–12 education, but they didn't take the arts much into account. *Toward Civilization* insisted the arts be an essential part of a regeneration of elementary and secondary education, and the call was heard throughout the arts education community. The report would be answered a decade later with the establishment of National Standards for Education in the Arts.

CLOSING ACHIEVEMENTS

The close of Hodsoll's tenure saw other efforts to survey the arts in U.S. society. Hodsoll initiated the *Arts in America* reports, which offered inventory and analysis of America's artistic resources and issues. He also helped create the National Task Force on Presenting and Touring the Performing Arts. Administered by the Association of Performing Arts Presenters, the task force aimed to strengthen arts presentation and to reinforce the networks of presenting organizations, performers, audiences, and communities—

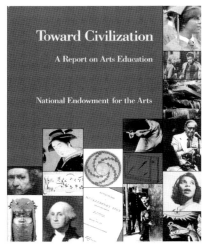

The 1988 NEA report *Toward Civilization* explored the lack of arts education in the nation's schools.

once again underscoring Hodsoll's emphasis on the infrastructure of arts support.

President Reagan summarized the importance of the Arts Endowment's work at the National Medal of Arts presentation in 1987: "Why do we, as a free people, honor the arts? The arts and the humanities teach us who we are and what we can be. They lie at the very core of the culture of which we're a part, and they provide the foundation from which we may reach out to other cultures so that the great heritage that is ours may be enriched by, as well as itself enrich, other enduring traditions. We honor the arts not because we want monuments to our own civilization but because we are a free people. The arts are among our nation's finest creations and the reflection of freedom's light."

As Arts Endowment chairman, Frank Hodsoll had demonstrated strong leadership and management skills, securing budget increases, setting a new agenda for arts education, and addressing serious criticisms originating from inside and outside the federal government. The NEA's programs and awards were going strong, and the National Medal of Arts, the NEA National Heritage Fellowships, and the NEA Jazz Masters awards had become distinguished honors. The Arts Endowment appeared to be primed for even further growth and success.

John E. Frohnmayer, NEA Chairman 1989–92. (Photo by Michael Geissinger)

Culture Wars

I N SEPTEMBER 1987, the Southeastern Center for Contemporary Art (SECCA) in Winston-Salem, North Carolina, received a grant of $75,000 from the NEA to support the seventh annual Awards in the Visual Arts program, known as AVA-7. The idea for AVA began under Chairman Hanks as a model for public-private partnership programs. The NEA grant was matched by a total of $75,000 from the Equitable Foundation and the Rockefeller Foundation. These grants enabled the SECCA jury to meet and select ten artists, including photographer Andres Serrano, to showcase their art in a traveling exhibition. The Arts Endowment played no part in the selection process. Nearly a year later, in July 1988, the University of Pennsylvania's Institute of Contemporary Art (ICA) received an NEA grant of $30,000 for a retrospective of works by another photographer, Robert Mapplethorpe, who soon after died in 1989.

The AVA-7 exhibition opened at the Los Angeles County Museum of Art in May 1988. It continued through the middle of July, then traveled without incident to the Carnegie-Mellon University Art Gallery in Pittsburgh before being displayed, again without protest, at the Virginia Museum of Fine Arts in Richmond from mid-December through January 1989. AVA-7 included a photograph by Serrano that showed, in a blurred focus, a crucifix as seen through a golden liquid. The title of the work was *Piss Christ*.

The Mapplethorpe exhibition, entitled *The Perfect Moment,* was an extensive retrospective of Mapplethorpe's career, which opened at the ICA in Philadelphia in December 1988. Unlike Serrano's image, *Piss Christ,* which was hazy in appearance

Richard Serra's sculpture *Tilted Arc* in New York City in the 1980s. (Photo by David Aschkenas)

but provocative in title, the Mapplethorpe exhibit included graphic sexual images under a mild title. The Mapplethorpe show was installed at the Museum of Contemporary Art in Chicago from February to early April, and was then scheduled for the Corcoran Gallery of Art in Washington beginning July 1, 1989. These appearances were to be followed by stops at the Wadsworth Atheneum in Hartford, the University Art Museum in Berkeley, and the Institute for Contemporary Art in Boston, to conclude at the end of August 1990.

In November 1988, national elections were held, and President Reagan was succeeded by another Republican, George H. W. Bush. The themes raised by these two exhibitions seemed a far cry from the dominant foreign and domestic policy issues of the campaign—the Cold War, the Middle East, violent crime—but they soon erupted into a controversy that would affect national politics through to the next presidential election.

The furor over the Serrano and Mapplethorpe images began just as another heated controversy was winding down. In 1981, a massive steel sculpture by Richard Serra, *Tilted Arc,* was placed on the plaza in front of a federal office building in Manhattan by the General Services Administration (GSA). An Arts Endowment panel had recommended Serra for the commission through its advisory role in the GSA's "Art in Architecture" program. Although the work was intended to improve the aesthetics of its location, workers who used the space claimed that the sculpture was obstructive and discomforting. For years they complained loudly about the work. In spring 1989, it was removed in the middle of the night at the orders of a regional administrator of the GSA.

The *Tilted Arc* affair principally involved people who made daily contact with the artwork, and the impact of the incident was largely confined to local citizens and people in the art world. News of the Serrano and Mapplethorpe exhibits, however, would spread far beyond the art world to become a major political story across the nation. After the AVA-7 exhibition closed, the Reverend Donald E. Wildmon, executive director of the American Family Association in Tupelo, Mississippi, saw the catalogue containing Serrano's *Piss Christ.* He condemned both Serrano and his work, initiating a public campaign against the show and the agency that helped make it possible. Thousands of like-minded citizens across the country flooded Congress with protests. Wildmon called for the dismissal of the "person at the National Endowment for the Arts responsible for approving federal tax dollars."

At the time, the Arts Endowment was in transition. Frank Hodsoll had departed, and the Bush Administration had not yet nominated a successor. The acting chairman, Hugh Southern, had served as deputy chairman under Hodsoll. On April 25, 1989, Southern issued a statement intended to moderate the growing tumult. It said, "The involvement of the National Endowment for the Arts as a funder of the Southeast Center for Contemporary Art follows Endowment panelists' advice, and that of the National Council on the Arts. The Endowment is expressly forbidden in its authorizing legislation from interfering with the artistic choices made by its grantees. The National Endowment for the Arts supports the right of grantee organizations to select, on artistic criteria, their artist-recipients and present their work, even though sometimes the work may be deemed controversial and offensive to some individuals. We at the Endowment do, nonetheless, deeply regret any offense to any individual."

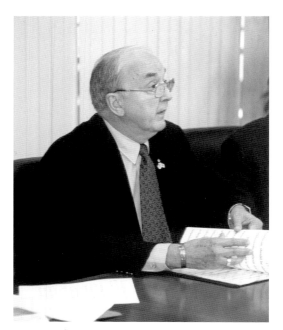

Senator Jesse Helms was a frequent opponent of the NEA. (Photo courtesy of Senator Jesse Helms Senate Papers, Jesse Helms Center Archives, Wingate, NC)

The statement did nothing to blunt the hostile reactions. Criticism of the Arts Endowment in Congress was led by Senators Jesse Helms (R-NC) and Alfonse D'Amato (R-NY), and echoed in the *Washington Times*. Joined by 22 other Senators—including several Democratic standard-bearers such as Bob Kerrey (D-NE), Dennis DeConcini (D-AZ), Harry Reid (D-NV), and Tom Harkin (D-IA)—they released a letter in May denouncing Serrano's work as "trash" and demanding a review of the Arts Endowment's award procedures.

Telephone calls and letters poured into the agency complaining about Serrano's work. In a June broadcast, televangelist Pat Robertson added his voice to the chorus attacking Serrano and the Arts Endowment. Southern replied to the protesting senators with a letter on June 6, 1989, to Senator D'Amato stating that he "personally found [Serrano's photograph] offensive," but pointed out that the selection of the art had been made by SECCA's jury, not by the Arts Endowment itself. Southern said that the Arts Endowment and the National Council on the Arts promised a review "to ensure that Endowment processes are effective and maintain the highest artistic integrity and quality." However correct they were, his communications did not give the angry legislators what they wanted—a guarantee that the NEA would not support projects containing works that outraged public taste.

The battle heightened as columnist Patrick Buchanan and theologian Jacob Neusner—a member of the National Council on the Arts—weighed in, each in a distinct venue and with considerable differences of style and tone. Buchanan used the *Washington Times* editorial page as a forum to blast offensive artworks, many of which were not funded by the Arts Endowment. He cited the commercial film, *The Last Temptation of Christ,* and a mural of revolutionary icons Lenin and Castro on a private building in Manhattan. Buchanan called on newly elected President George H. W. Bush to purge the Arts Endowment.

From his position at the program of Judaic studies at Brown University, Neusner wrote a letter to Senators Helms and D'Amato, "I wish the Endowment leadership would simply say . . . we goofed and we're sorry. Because we did goof and I for one am sorry and also, I personally am enormously chagrined." Within days of Neusner's letter, on May 31, 1989, Senator Slade Gorton (R-WA) called on the Arts Endowment to cut off funds to SECCA for five years.

MAPPLETHORPE CONTROVERSY AND CONGRESSIONAL REACTION

At almost the same time, the Mapplethorpe exhibit began to generate controversy, beginning with the show's cancellation by the Corcoran Gallery of Art in Washington, DC, in June 1989. As a demonstration of approximately 60 people outside the Corcoran ensued, the decision caused a huge uproar in arts circles throughout the country. The Washington Project for the Arts exhibited the work in July–August 1989. The clamor over Mapplethorpe became noticeably louder just as Congress began debating H.R. 2788, the appropriations bill for the Interior Department and Related Agencies, which provided funding for the Arts Endowment. Four critical amendments were offered. Three of these were defeated: one to eliminate the Endowment's entire appropriation for fiscal year 1990, another to cut its grants and administration appropriation by 10 percent, and another to reduce its budget by 5 percent.

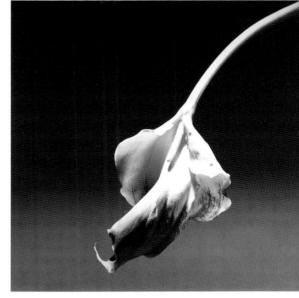

A fourth amendment, offered by Representative Charles Stenholm (D-TX), called for a reduction of Arts Endowment funding by $45,000—representing the $30,000 NEA grant that had been awarded to ICA for the Mapplethorpe show and the $15,000 that had gone to AVA-7 to exhibit Serrano. The Stenholm amendment carried, and the bill passed the House.

When the Senate took up the NEA's appropriation bill, Senator Helms inserted language prohibiting the Arts Endowment from using any appropriated funds for materials deemed

Robert Mapplethorpe's *Calla Lily*, 1986, part of *The Perfect Moment* exhibition that toured in 1988–90. (© Robert Mapplethorpe Foundation, used by permission)

"obscene or indecent," including those denigrating belief in a religion or non-religion, or debasing any person on the basis of race, creed, sex, handicap, age, or national origin. "Obscenity" was defined as works which include "sadomasochism, homoeroticism, the sexual exploitation of children, or individuals engaged in sex acts and which, when taken as a whole, do not have serious literary, artistic, political, or scientific value." Other amendments were introduced to ban for five years all direct grants to SECCA and to the ICA at the University of Pennsylvania, and to shift $400,000 from the agency's Visual Arts Program to other Endowment programs in the areas of folk arts and community arts—even though the Mapplethorpe grant came from the Museum Program, not Visual Arts.

When the final version of the bill emerged, the Senate had provided $250,000 to create an independent commission to review the Arts Endowment's grantmaking operation. The amendments to take funds from the Visual Arts Program and to place a ban on SECCA and ICA grants were not included. Thus, at that point, the controversies had not resulted in reduction of the NEA's budget. Conservatives in public life and several Republicans in Congress, however, maintained their suspicion of the Arts Endowment, and to many the names Serrano and Mapplethorpe were now tokens of moral corruption inside the agency. Into this heated and confusing climate, new Arts Endowment leadership arrived.

FROHNMAYER'S CHAIRMANSHIP

In July 1989, President George H. W. Bush appointed John E. Frohnmayer to head the Arts Endowment, and in November he was sworn in as the agency's fifth chairman. The moment of Frohnmayer's arrival could not have been less auspicious, but the new chairman displayed an attitude of optimism.

A *Washington Post* writer characterized the reaction to one of Frohnmayer's public appearances in Oregon, his home state, directly after his nomination to the chairmanship, as "giddy applause." Frohnmayer was a successful lawyer—specializing in the First Amendment—an art collector, and chairman of the Oregon State Arts Commission. He had studied for the ministry before choosing law as a profession.

In his memoir, *Leaving Town Alive* (published in 1993), Frohnmayer wrote that before accepting his appointment he had considered the Arts Endowment chairmanship to be "the best job in the country," one which he "had always wanted." In fact, he had unsuccessfully lobbied for the post at the beginning of the Reagan era. As a state arts leader in Oregon, he had experienced the benefit of NEA assistance to

John E. Frohnmayer is sworn in as NEA Chair on November 13, 1989, by President George H. W. Bush. (Photo courtesy of George Bush Presidential Library)

the state agencies, writing that Oregon had received "money to help fund full-time directors for local arts councils, and this small amount of assistance increased these councils from three to 14 over a two-year period." In his pre-appointment interviews, he argued that the "Endowment could be extraordinarily helpful to the President [George H. W. Bush] as he sought to bring the country together."

Frohnmayer also wrote in his memoir that he had been asked in his pre-appointment interview by White House staff what he would do if the Administration had a different point of view about a particular program from his own. He responded, "I would try my best to persuade the Administration that my point of view was right, but that I was a team player, and if I failed to persuade, I would do the Administration's will." As he soon realized, however, it would prove difficult to balance the competing demands of different constituencies as the culture wars came to Washington.

Frohnmayer remembered being "hopeful that Serrano and Mapplethorpe would be history by the time I got to the Endowment." But Serrano and Mapplethorpe were history only in the sense that they had become permanent symbols. Indeed, at the time of this publication the grants and the controversy are nearly two decades old, yet the two names have been incessantly repeated by critics of the Arts Endowment, though to ever-diminishing effect. Likewise, the reputations of both artists have become inseparable from the NEA controversy.

The NEA's Rural Arts Initiative

For more than two decades, the National Endowment for the Arts had focused on bringing the arts to underserved communities—including minority and inner city communities—through its Expansion Arts Program. In 1989, the NEA expanded that focus of underserved communities to include rural areas with the development of the Rural Arts initiative. Designed "to assist rural arts organizations that have considerable potential to develop artistically and administratively," the program lasted three years, and state arts agencies typically received grants of up to $40,000 to support two to five rural arts organizations.

In 1991, arts councils in Alabama, Alaska, Iowa, Louisiana, Montana, New Mexico, North Carolina, North Dakota, Pennsylvania, South Carolina, and Wisconsin received nearly $400,000 to help "exemplary rural arts organizations with institutional potential." Overall, Rural Arts enabled arts agencies in 22 states to augment existing initiatives or to develop new ones. Projects supported under the initiative included Virginia's artist residency program at rural community colleges, Idaho's Arts in Rural Towns that trained performers and presented arts events for communities of fewer than 5,000 people, Oklahoma's self-directed study and practice guide for older adults, and Arizona's Tribal Museum program that assisted the state's many Native American tribes

Musician Phil Baker enjoys a laugh with students in a concert in Clear Lake, South Dakota, as part of the 1989 Touring Arts Teams, a rural arts initiative funded by the Arts Endowment. (Photo courtesy South Dakota Arts Council)

in documenting and preserving their cultures.

Although the Expansion Arts Program no longer exists as a separate division, the Arts Endowment has continued to bring the arts and arts education to rural areas through direct grants and partnerships with state, local, and regional arts agencies. Later national initiatives strengthened this mission with programs such as American Masterpieces, a touring and arts education initiative that as of 2008 has supported more than 200 projects in various disciplines across the country.

Fighting on Two Fronts

To comply with Congressional mandates, the new chairman inserted the wording of the obscenity clause into the terms and conditions governing all NEA grants. His decision satisfied the Administration but evoked virulent attacks from a new group of dissenters: artists and arts administrators who had previously looked to the agency for support. The arts community began accusing the NEA of failing to defend freedom of expression, and soon the outcry became a complaint of censorship. The arts community also accused Chairman Frohnmayer of "selling out" to censors. Composer Leonard Bernstein refused the 1989 National Medal of Arts as a protest against the chairman's policies, and New York theater director Joseph Papp denounced Frohnmayer as "out-Helmsing Helms" and as "a person not to be trusted." Papp put his denunciation into action in 1990 when he turned down two NEA grants totaling $323,000, one a $50,000 award to support the Shakespeare Festival's annual Festival Latino. Another organization, the Bella Lewitzky Dance Foundation, won a grant that year, but when it submitted a request for payment, the company manager refused to comply with the new terms and conditions of the grant. When the Arts Endowment insisted the grantee abide, as required by law, the company filed suit.

The Arts Endowment now found itself fighting a war on two fronts. Some arts advocates labeled the new wording in the grants' terms and conditions a "loyalty oath." Frohnmayer later claimed that he had adopted the language as "an invitation to a lawsuit, which I hoped would lead to a finding that the language was unconstitutional." Because of the obscenity clause, a number of artists regarded the Arts Endowment's grant contracts as "a symbol of repression," and many artists and arts organization directors refused to serve on panels. In 1992, no fellowship awards were granted for sculpture because the members of a Visual Arts panel had resigned in protest.

In his memoir, Frohnmayer continued, "My course was set and I wasn't going to change it." After the insertion of the new language into grant terms and conditions, he stated his opposition to the politicization of art, while expressing surprise when protests grew among the artists opposed to his policies. Joseph Wesley Zeigler, in his book *Arts in Crisis,* identified the cause of Frohnmayer's dilemma: "His failure to understand the [Washington political] system led him to overreact to Congressional moves, while at the same time he underestimated the anger in the arts world at the NEA's refusal to support cutting-edge works. . . . This inflamed artists while failing to assuage the conservatives."

The difficulty in defining a consistent policy in this polarized climate was visible within a month of Chairman Frohnmayer's confirmation. His first direct conflict with artists involved Artists Space, a nonprofit New York gallery. Artists Space was opening a show, with $10,000 in Arts Endowment funds, about the impact of AIDS on the arts community. The exhibit included depictions of sexual activity, as well as a catalogue replete with highly polemical statements. Examining the catalogue, Frohnmayer consulted with National Council on the Arts member Jacob Neusner, who informed him the catalogue included violent attacks on public figures—including fantasies by artist David Wojnarowicz of setting Senator Helms on fire with gasoline and throwing another conservative legislator from a high building—that had not been included in the original funding proposal submitted for the show. Chairman Frohnmayer decided to suspend financing for the exhibit, on the grounds of its political nature. A week later, however, he reversed his decision, and restored the $10,000 grant with the proviso that the funds would not pay for the catalogue. His decision only inflamed the situation, and Zeigler observed, "For the next two years, 1990 and 1991, Frohnmayer was caught in the middle of the crisis."

The "NEA Four"

The next chapter in the saga started with the performance art of Karen Finley. Zeigler explained, "In the world of 'underground' culture, Karen Finley was a darling: admired by the cognoscenti, and unnoticed by the wider public." A performance in which she poured chocolate sauce on her naked body brought her to national attention when it was the subject of a column by Washington journalists Rowland Evans and Robert Novak, who offered an unattributed description of the performance, by "an Administration insider," as "outrageous." At a stormy meeting in May 1990 in Winston-Salem, North Carolina, that would be long remembered, the National Council on the Arts voted to defer for four months a group of 18 grants for Finley and other performance artists, that had been recommended by the Arts Endowment's Theater panel. Of the 18 grants delayed, 14 were eventually recommended for funding by the National Council and awarded by Chairman Frohnmayer. Along with Finley, the remaining artists not recommended were John Fleck, Holly Hughes, and Tim Miller. These individuals sued the Arts Endowment and came to be known in the arts community as the "NEA Four."

In his memoir, Frohnmayer described these individuals as "boldly and confrontationally taking on social issues about which there was tremendous societal debate."

While Evans and Novak claimed that "White House sources" had said that Frohn-mayer was "adamantly against disapproving any of the recommended applications," Frohnmayer later protested this was untrue, and that he did not have a planned course of action. But, Frohnmayer had already written to White House aides Andrew Card and David Bates about an upcoming Finley performance, which the Arts Endowment had previously funded, that from all appearances the performance "was defensible on its artistic merit."

The ferocious public debate over the Arts Endowment's grants approval process and a lawsuit by several newspapers led the agency to change its policy on National Council meetings. In August 1990 the National Council on the Arts opened its grant review sessions, which had previously been closed, to the public.

ONGOING ACCOMPLISHMENTS

Although the controversies persisted, the regular business of the Arts Endowment proceeded apace. As in every previous year, the agency reviewed thousands of applications, awarding grants to arts organizations and artists. Thirteen distinguished artists living in Hawaii, South Dakota, and Puerto Rico, among other places, received NEA National Heritage Fellowships. Composer George Russell, pianist Cecil Taylor, and bandleader Gerald Wilson were honored as NEA Jazz Masters.

The Arts Endowment continued to offer crucial support to significant projects. Visual Arts grants funded artist residencies at state universities in Colorado, Illinois, New Jersey, New Mexico, Utah, Virginia, and Washington. The Art in Public Places program, which helped local governments and organizations place art in public spaces, supported commissions at Duke University Medical Center, Las Vegas City Hall, and the

Snake Path, 1992, by Alexis Smith at the University of California, San Diego, was funded through the NEA's Art in Public Places program. (Photo by Philipp S. Ritterman)

Luis Jiménez, 1977 and 1988 NEA Visual Arts Fellowships

Visual Arts Fellowships were awarded from 1966 to 1995, providing financial support for American artists, often at crucial points in their careers. One of those artists assisted by the program was Luis Jiménez, who received fellowships in 1977 and 1988. Mostly working in large fiberglass sculptures, Jiménez was building a reputation as an important American artist at the time he received his grants.

Jiménez was born July 30, 1940, in a barrio of El Paso, Texas. His artistic interests began in his father's custom sign

Luis Jiménez's statue *Vaquero* stands in front of the Smithsonian American Art Museum in Washington, DC. (Photo by Don Ball)

shop, where he learned the techniques of welding and spray-painting. Jiménez later built upon these metalworking and painting skills with work influenced by Diego Rivera and other Mexican muralists. Graduating from the University of Texas at Austin, he moved to New York City in 1969, where he held his first exhibition. After moving back to El Paso in 1972, he created large fiberglass sculptures celebrating Mexican-American culture and myths.

Jiménez cited the 1977 NEA fellowship as being crucial to his success as an artist: "This grant helped me develop the concepts I used to create my first public work, *Vaquero*, for the City of Houston, an NEA Art in Public Places commission." A cast of that piece stands in front of the Smithsonian American Art Museum in Washington, DC.

He received another NEA grant in 1988, helping him to finance a new workspace and to travel to La Napoule, France. "The contact with artists from other countries, specifically the Africans, was enormous— for them making art is literally a life and death struggle," Jiménez said about the experience. "In addition, the distance actually enabled me to focus on my projects back home, and I worked on sketches and working drawings."

Luis Jiménez died on June 13, 2006, after an accident in his Hondo, New Mexico, studio involving one of his large sculptures.

Wyoming Game and Fish Department, and for highway overpasses in San Diego.

Preservation remained a central focus of the Arts Endowment funding to museums. The conservation grants in 1990 numbered 73 and totaled $1,169,800 in program funds. The Currier Gallery of Art in Manchester, New Hampshire, for example, received money to conserve furniture and woodwork designed by Frank Lloyd Wright in his Zimmerman House. The Toledo Museum of Art won a grant to conserve a collection of Islamic ceramics, while Oberlin College received funds to support work on Gustave Courbet's *Castle of Chillon*, and the Detroit Institute of Arts received a grant to conserve three monumental stained glass windows by John La Farge.

These were not unusual awards. Each represented the thousands of worthy projects evaluated and supported by the agency at the same time that media attention and political pressure focused only on a tiny group of controversial works of art.

RESEARCH STUDIES

Amid the din, the Arts Endowment continued to carry out some remarkable research projects with significant impact on different arts fields. One of the most important was the publication *Survey of Public Participation in the Arts: 1982–1992 (SPPA)*. The *SPPA* was the third in a series of national population surveys designed by the NEA research staff to collect data on the U.S. population's engagement in the arts. Data on the consumption side of the arts was thin. Until 1982, little reliable information could be found regarding how many and how often American adults visited museums, attended theater, listened to opera, read poetry, and in various other ways participated in the arts. The Arts Endowment's Research Division set out to increase the knowledge base by designing a questionnaire and commissioning the U.S. Bureau of the Census to compile a sample of respondents and conduct the survey. More than 17,000 people were interviewed in 1982, making it the largest single survey of U.S. arts participation ever. In 1985, another statistical survey was conducted, providing the first opportunity to draw comparisons and explore trends in arts participation among the American public.

The 1992 *SPPA* followed the same basic procedures, but used more clearly articulated definitions and more sophisticated data collection. With a ten-year gap between it and the first survey, and with the respondent pool broken down by age, income, race, education level, and gender, the 1992 report signaled important trends in arts participation and supplied arts organizations with invaluable informa-

tion on audiences. Among the findings:

 • From 1982 to 1992, the attendance rate at art museums and galleries rose almost five percentage points.

 • Audiences for opera, classical music, and jazz on radio increased by 49 percent, 60 percent, and 71 percent, respectively.

 • Literary reading rates (fiction, poetry, drama) fell by three percentage points.

The 1992 *SPPA* generated a front-page article in the *New York Times* on February 12, 1996. Written by Judith Miller and titled "Aging Audiences Point to Grim Arts Future," the article was the first of several to profile a troubling trend, the "graying of the arts" phenomenon documented in the *SPPA* results; that is, younger age groups were not participating in the fine arts at the rate their parents did when they were young. Future surveys would be conducted in 1997 and 2002, confirming the "graying" pattern while building a uniquely broad and consistent database on arts participation for researchers, educators, journalists, and policymakers, as well as arts organizations.

The data from the first surveys in 1982 and 1985 also provided material for another significant report, *Arts in America 1990*. This was the second in a series of reports requested by Congress on the status and condition of the arts in the United States. *Arts in America 1990* gave the agency the opportunity to reflect upon changes in the arts during the 25 years of the agency's existence. The report recounted dozens of projects and artworks funded by the Arts Endowment, but perhaps most impressive, given the political climate, were the trends in arts production and participation. The United States had experienced a remarkable growth in the number of arts organizations and artists, amount of public and private support, and size of audience:

 • In 1965, there were five state arts agencies with combined appropriations of $2.7 million. By 1990, there were arts agencies in all 56 states and jurisdictions with total appropriations of $285 million.

 • In 1990, local arts councils numbered around 3,000, with 600 having full-time staff.

 • Private sector giving for the arts, humanities, and culture grew from $44 million in 1965 to $7.5 billion in 1989.

 • Performing arts attendance from 1965 to 1988 rose from nine to 24 million for symphony orchestra concerts, three to 18 million for opera, and one to 15 million for nonprofit professional theater.

The Arts Endowment's impact on generating non-federal support for the arts was demonstrated by other statistics, cited in *Arts in America 1990*:

• In 1989, the NEA's $119 million in organizational grants generated $1.4 billion in non-federal funds.

• By 1990, the NEA's Challenge Grants totaling $237 million had been matched by more than $2 billion in new non-federal funds.

• In 1990, all four Pulitzer Prize recipients in poetry, fiction, drama, and music had been recognized earlier in their careers with NEA fellowships.

Arts in America 1990 contained testimonials from arts leaders about the benefits of an Arts Endowment grant, not only providing money, but something far more valuable in the long term—recognition. Joan Myers Brown, founding artistic and executive director of the Philadelphia Dance Company, Philadanco, explained it well: "The impact the National Endowment for the Arts has made on predominantly African-American dance organizations since its inception can be exemplified by the history of the success of organizations such as Dayton Contemporary Dance Company of Ohio, Dallas Black Dance Theatre in Texas, Cleo Parker Robinson Dance Company in Denver, Colorado, and Philadanco in Philadelphia, Pennsylvania. Being able to move into the main or national funding stream because of the approval of the Endowment opened doors to local agencies, foundations, and community-based funding in our areas. This ability to compete for grants, often given only to the more established cultural institutions, allowed what were often considered 'grassroots' or 'community-based' to secure a stronger footing in the field."

The Arts Endowment also reported in *Arts in America 1990* on the economics of working as an artist in the United States. A 1989 Columbia University study of 4,000 artists found that three-fourths of them earned no more than $12,000 annually from their art. Rising medical costs hit hard during the 1990s, affecting artists not only because they tend to be self-employed but also because of the physical hazards to

The Philadelphia Dance Company (Philadanco) performing *White Dragon*, choreographed by Elisa Monte. (Photo by Lois Greenfield)

which many in the arts are exposed. Another NEA research study, which was later published in 1993 as *Dancemakers,* found that the average annual income choreographers earned from their artistic work in 1989 was $6,000, while their professional expenses totaled $13,000. Including money earned in other pursuits, a dancer's average income reached only $22,000. *Dancemakers* was, recalls Andrea Snyder, executive director of Dance/USA and former NEA Dance Program assistant director, "the first study of its kind to reveal the true economic life of today's choreographers. It quickly became one of the most important references for the dance field as it made the case for increasing resources and services to artists making dances."

Arts in America 1990 concluded on a triumphant note: "Over the past 25 years, the National Endowment for the Arts has been most effective at helping to create a diverse network for public support of the arts and increasing the number and quality of arts institutions." The figures provided a strong argument for federal support for the arts, demonstrating the public's responsiveness to public funding and the enduring impact of grant awards.

THE INDEPENDENT COMMISSION

In the middle of 1990, an Independent Commission mandated by Congress to study the National Endowment for the Arts began its work. Comprised of 12 members, plus a staff of eight, the commission was co-chaired by John Brademas, the former Indiana Democratic Congressman and co-sponsor of the 1965 legislation creating the Endowments, and Leonard Garment, who, as an assistant to Richard Nixon, had played a leading role in increasing the Arts Endowment's budget under Nancy Hanks. Soon after the Independent Commission held its first meeting, the "NEA Four" sued the Arts Endowment, alleging that their grant applications had been denied illegally.

The mandate of the Independent Commission was twofold. First, it was charged with reviewing the Arts Endowment's grantmaking procedures, including the panel system. Second, the commission was to consider whether standards for publicly funded art should be different from those for privately funded art. These issues reflected the primary criticisms leveled at the Arts Endowment; namely, that its grantmaking process was afflicted by cronyism, and that it had funded works too far from the mainstream of public taste.

The commissioners identified the fundamental cause of the Arts Endowment's crises as a deep change in the national sensibility. They wrote, "Today, twenty-five years

Former Indiana Congressman John Brademas co-chaired the 1990 Independent Commission reviewing the NEA's grantmaking procedures. (Photo courtesy of NYU Photo Bureau)

after its creation, the system no longer works as it once did, for reasons that the NEA's founders could not have foreseen. On certain social and cultural issues, the nation has become more polarized. As with other federal agencies, these developments affect the NEA and the environment in which it operates.... The Independent Commission believes it is time to restate what the founders of the NEA took for granted: The National Endowment for the Arts is a public agency established to serve purposes the public expresses through its elected representatives."

The Independent Commission went on to state, "While the artists and the arts institutions receiving NEA funds are indispensable to the achievement of the purposes of the agency, the NEA must not operate solely in the interest of its direct beneficiaries. As with every federal agency, the Endowment must do its part in pursuing worthy social objectives but the agency cannot let such goals take precedence over its primary task of strengthening the role of the arts in American life."

In its most substantial comments, the introduction included the following: "Publicly funded art . . . should serve the purposes which Congress has determined for the Endowment. It should be chosen through a process that is accountable and free of conflicts of interest. . . . Insuring the freedom of expression necessary to nourish the arts while bearing in mind limits of public understanding and tolerance requires unusual wisdom, prudence, and most of all, common sense."

Reconciling freedom of expression and public acceptance, however, is a delicate process, especially when voices from both sides become extreme and antagonistic. Few public agencies had to contend with clashing cultural forces as intensely and sensationally as the Arts Endowment did in these days. The commission's call for NEA leadership to exercise wisdom and prudence was not an easy task with so many in the government, the press, and the art world making conflicting demands.

Regarding grant panels, the Independent Commission pointed out a similar diffi-

culty, noting that "making decisions about awarding grants to the arts is not an objective activity, subject to quantitative measures or improved by formulaic prescriptions. Professional expertise, aesthetic discernment, and an awareness that federal funds are being expended—all these qualities are essential to the successful grant making by the NEA."

ASSESSING THE NEA'S RECORD

In examining the record of the Arts Endowment, the commission took testimony from arts professionals, NEA employees, and prominent figures in the arts and public life. Individuals testifying included Theodore Bikel, then-president of Actors' Equity and former member of the National Council on the Arts; Samuel Lipman, pianist, publisher of the conservative *New Criterion* monthly, and also a former council member; theater director, teacher, and critic Robert Brustein; free speech litigator Floyd Abrams; and constitutional expert Theodore B. Olson, who later served as U.S. Solicitor General under President George W. Bush from 2001 to 2004.

Drawing from the same data that went into *Arts in America 1990,* the Independent Commission determined that the NEA had "helped transform the cultural landscape of the United States." When the Arts Endowment was founded, the number of symphony orchestras in the nation totaled no more than 110, but in 1990 the number had risen to 230. Opera companies had increased from 27 to 120, while state folk art programs had exploded from one to 46. Dance companies jumped from 37 to 250, and art museums from 375 to 700. The number of artists in the United States had tripled. The commission report summarized the work of the Arts Endowment by affirming that "a relatively small investment of federal funds has yielded a substantial financial return and made a significant contribution to the quality of American life."

The commission also determined that "although there are deficiencies in the operation of the Endowment and some mistakes are inevitable, these problems can be ameliorated, if not eliminated, by a combination of Congressional guidance and oversight, significant reforms in grant-making procedures and prudent administration of the Endowment. These goals can be achieved while at the same time assuring both freedom of expression and accountability for expenditure of public funds."

The Independent Commission developed a series of recommendations concerning publicly funded and privately funded art, grantmaking and panel procedures, the role and responsibilities of the National Council on the Arts, private-public partnerships, and obscenity.

The commission found that the standard for selecting publicly funded art "must go beyond" that for privately funded art. With regard to "aesthetic or artistic qualities," both should be judged only on the basis of excellence. Government support, however, must bring with it criteria beyond artistic worth; publicly funded art must not ignore the conditions traditionally governing the uses of public money, and must serve "the purposes which Congress has defined for the National Endowment for the Arts." These must include meeting professional standards of authenticity, encouraging artists to achieve wider distribution of their works, and reflecting the cultures of minority, inner-city, rural, and tribal communities.

The commission recommended that the preamble of the legislation authorizing the establishment of the Arts Endowment "be amended to make clear that the arts belong to all the people of the United States." Next, the Independent Commission recommended reforming the grants application process. The commission called for the strengthening of the authority of the chairperson; for the National Council on the Arts to be more active in the grants process; for the elimination of "real or perceived conflicts of interest"; for the evaluation of grant applications to be "fair, accountable, and thorough"; for advisory panels to be broader and more representative in terms of aesthetic and philosophical views; and for it to be made "clear that the National Endowment for the Arts belongs not solely to those who receive its grants but to all the people of the United States."

On the issue of obscenity, the commission affirmed that "freedom of expression is essential to the arts," but also that "obscenity is not protected speech," and that the Arts Endowment "is prohibited from funding the production of works which are obscene or otherwise illegal." It also declared, however, that the Arts Endowment is an "inappropriate tribunal for the legal determination of obscenity, for purposes of either civil or criminal liability." It also recommended that Chairman Frohnmayer rescind the requirement that grantees certify that the works they proposed would not be obscene.

The commission concluded with an affirmation: "Maintaining the principle of an open society requires all of us, at times, to put up with much we do not like but the

bargain has proved in the long run a good one." The report was a major factor in the ongoing status of the Arts Endowment. While it was prompted by the immediate controversies, the commission took the occasion as a moment to reflect the different pressures and viewpoints in American life and culture. Its recommendations marked a serious attempt to renegotiate the competing demands from artists, arts institutions, journalists, politicians, and the public that had affected the Arts Endowment from the start.

DISCORD CONTINUES

Unfortunately, the Independent Commission report did not dispel the atmosphere of conflict that had become attached to the Arts Endowment. While worthy grants continued to be awarded, uncertainty characterized its policymaking. In November 1990, the Endowment approved, "without opposition and almost without discussion," in the words of the *Washington Post,* grants to two of the NEA Four, Karen Finley and Holly Hughes, only two months after the group had filed their suit against the Endowment. In December 1990, Chairman Frohnmayer announced that he would approve a fellowship to New York visual artist Mel Chin, one he had previously turned down.

By then, the presidential primary campaigns had begun. For the first time in its history, the NEA became an issue in a national election. Republican contender Patrick Buchanan, who as a newspaper columnist had castigated the NEA, was running on a "culture war" platform that combined virulent attacks on the Arts Endowment with the threat to close it down (and "fumigate the building," he added in a *New York Times* article). The negative public perception of Frohnmayer as an ineffective leader increased with these assaults, and the agency's situation worsened. With few supporters, Frohnmayer submitted his resignation to the President on February 21, 1992, becoming the only NEA chairman to resign under political pressure. Soon after, Buchanan unveiled a campaign advertisement claiming that the sitting Administration had "invested our tax dollars in pornographic and blasphemous art too shocking to show." Administration spokesmen denounced the ad as "demagoguery," but a great amount of damage had been done to the image of the National Endowment for the Arts. The agency had lost support in Congress, the White House, the media, and from the public.

Jane Alexander, NEA Chairman 1993–97. (Photo by Martha Swope)

What Is to Be Done?

I N 1993 the Arts Endowment's budget was largely intact. The scars of the previous four years were civic and political, but in financial terms the NEA had remained unaffected. In 1987, its budget had stood at $165 million, and in 1992, with a Democratic majority in Congress and George H. W. Bush in the White House, the Arts Endowment's budget was at a historic high of $176 million.

John Frohnmayer had been gone for almost a year when William Jefferson Clinton was inaugurated as president. From May 1992 to January 1993, Dr. Anne-Imelda Radice had served as acting chairman. (Radice would go on to posts in the Department of Education and the National Endowment for the Humanities during the presidency of George W. Bush, and would eventually become director of the Institute of Museum and Library Services in May 2006.) During the transition Madeleine Kunin, deputy secretary of Education, held the position of acting chairman of the Arts Endowment, while the day-to-day operations of the agency were managed by Acting Senior Deputy Chairman Ana Steele, the only NEA staffer remaining who had been employed by the agency from its inception.

On October 8, 1993, Jane Alexander was sworn in by Supreme Court Justice Sandra Day O'Connor as the Arts Endowment's sixth chairman. The first artist to occupy the position, Jane Alexander was born in Boston in 1939 and educated at Sarah Lawrence College and the University of Edinburgh. She had never been involved in party politics, although she had been active in the protest movements of the 1960s and 1970s. She was an accomplished stage and screen actress who had won a Tony Award in 1969 for her performance in *The Great White Hope* by Howard

Sackler, a production mounted at Washington's Arena Stage with Arts Endowment support. Alexander had also received an Oscar nomination for the movie version of the same work, released in 1970, and an Emmy in 1981 for her performance as a concentration camp prisoner in the network television movie *Playing for Time*. Another Emmy would come in 2005 for her performance in *Warm Springs*.

Alexander came to the Arts Endowment at an extremely difficult point in its history. As reported in the *New York Times,* Alexander testified at her Senate confirmation hearing in September 1993 that her priorities would include informing the country that the great majority of the projects financed by the Arts Endowment were non-controversial. Over the next four years she traveled to all 50 states and Puerto Rico to examine the status of the arts and to improve understanding of the role of the Arts Endowment and its work. Despite her leadership, the agency underwent massive budget cuts and compulsory changes. Through this crisis, Alexander managed to keep the agency operating, and oversaw the reorganization necessitated by the reduction of appropriations. By the time she left the Endowment in 1997, the immediate threat to the agency's existence had passed. Its budget had been drastically reduced, its regulations had been tightened, and its operating freedom had been narrowed. However, media scrutiny was still heavy, conflicts with artists were unresolved, and Congressional disapproval remained firm.

ALEXANDER'S BEGINNING

In her memoir, *Command Performance* (2000), Alexander recalled being handed a briefing book intended to prepare her for "questions about controversy." Shortly after being nominated, she noted that she "was fortunate that [she] had seen none of the works in question and could respond noncommittally when asked about them." The briefing book suggested that she declare she was "not thoroughly knowledgeable about the actions taken by the former Administration . . . nor . . . about current controversies. In the future I look forward to working with the Senate on those issues and all other issues regarding the Endowment."

In her written statement submitted at her Senate confirmation hearing, Alexander stated: "I believe strongly that the sound and fury of the past few years over [a] handful of controversial grants must end . . . I cannot promise that under my chairmanship the arts will be free of controversy. The very essence of art, after all, is to hold the mirror up to nature . . . I can, however, assure Congress that I will follow the statutory guidelines on funding to the very best of my ability to ensure that grants

Chairman Alexander being interviewed by Maine reporter Felicia Knight (later director of Communications at the NEA). (Photo by Harold Ulmer, Maine College of Art)

are given for the highest degree of artistic merit and excellence. . . . My goal for the arts is that the best reaches the most."

Yet, disputes over content continued to bedevil the Arts Endowment. The lawsuit filed by the NEA Four had progressed through the court system and, in fact, changed its focus as changes were made in the Arts Endowment's legislation. The initial complaints by the artists were, one, that their applications were rejected for political reasons; and two, that the contents of their applications were released to the public—a violation of the Privacy Act. When the "standard of decency" provision was included in the NEA's 1990 legislation, however, the plaintiffs added a First Amendment count to their case. A district court found in favor of the NEA Four in 1992, and the Ninth Circuit Court of Appeals upheld the lower court ruling. In June 1993, at the recommendation of the Department of Justice, the Arts Endowment settled the complaint of Finley, Hughes, Miller, and Fleck, who had claimed their rights had been abridged when Frohnmayer rejected their grants in 1990. The NEA followed the Justice Department's recommendations on the basis that Chairman Frohnmayer had failed to follow "legal procedures" in the case. This was only a partial resolution, however, pertaining only to their specific applications. The artists continued their

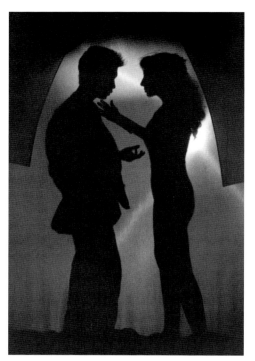

The Bond Street Theatre's collaboration with the Theatre Tsvete of Sofia, Bulgaria, on a production of *Romeo and Juliet* for audiences in Kosovo was made possible through the NEA international program ArtsLink. (Photo by Marko Georgiev, courtesy of Bond Street Theatre)

lawsuit, joined by the National Association of Artists' Organizations, challenging the constitutionality of the "decency" provision. The months-old Clinton Administration appealed the decision to the Supreme Court, which would later rule in favor of the Arts Endowment in 1998.

Amid these disputes, however, Alexander found much cause for optimism in the agency's programs. In her first annual chairman's statement in the 1993 *Annual Report,* Alexander wrote with satisfaction about "the transformation of the old Office of International Activities as the full-fledged International Program . . . One of the new program's first concrete achievements was creation of the United States/Canada/Mexico Creative Artists' Residencies, the first trilateral exchange program of its kind." She also reported on the expansion of ArtsLink, supporting exchange by U.S. artists and arts administrators with their peers in Eastern and Central Europe.

During Alexander's tenure, the publication *Dancemakers,* a study warning of under-financing of "the very creators of America's great cultural export, dance," which Alexander described as "an endangered species," was issued. Other noteworthy outcomes of her term included a new grant to the American Heritage Center and Art Museum at the University of Wyoming in Laramie, and two projects supported by the Challenge Grants Program: the expansion of *Black Culture on Tour in America,* run by the Carter G. Woodson Foundation, to include a Mid-Atlantic and New England touring circuit; and the establishment of a filmmaking academy at the North Carolina School of the Arts. Innovative music initiatives included Chamber Music Rural Residencies, in Georgia, Iowa, and Kansas, while a Media Arts grant supported a 26-episode radio series *Wade in the Water: African American Sacred Music Traditions.*

In 1994, the Arts Endowment hosted in Chicago the first federally sponsored national conference on the arts, "Art-21: Art Reaches into the Twenty-first Century." Underwritten by 18 corporations and foundations, the event brought together more than 1,000 participants to discuss national arts policy, with four topics: the artist in society, lifelong learning in the arts, the arts and technology, and expanding resources for the arts.

The conference opened with an address by Secretary of Housing and Urban Development Henry Cisneros, who spoke about expanding resources for the arts and concentrated on an issue the Arts Endowment had made central to its work for decades: outreach to distressed communities. "The arts can help fight violence, crime, and gang problems in our inner cities," Cisneros affirmed. The *Washington Post* described Art-21 as a convocation that "wrestled with doing innovative programs with less funding." Noting that the "buying power" of the agency had declined 46 percent in the previous decade, the *Post* noted that for "Cisneros and others . . . the only way to justify increased arts funding is to broaden the role of arts in society." Addressing the gathering by video broadcast, President Clinton said that the mission of the NEA was "to enliven creative expression and to make the arts more accessible to Americans of all walks of life."

Art-21 was one of the significant projects of Alexander's chairmanship. She defined federal policy as chiefly about guidance and assistance, emphasizing that art starts at the local level. She stated, "Open up the doors to your institutions and to your workshops . . . We then begin person by person, child by child, to build a new America."

The sentiment was ambitious. One logical place for making such a great change, especially at a time of political crisis, was in the field of education. In 1994, with the support of the Endowment, the *National Standards for Education in the Arts,* which detailed basic requirements for "what every young American should know and be able to do in dance, music, theater, and the visual arts," was published. The report, which included benchmarks for each major arts field from kindergarten through high school, appeared simultaneously with other Clinton Administration reforms in education. Later it helped educators at the state level to draft content and skill standards for curricula for grades K through 12.

At the same time, the Arts Endowment Research Division released *Trends in Artist Occupations: 1970 to 1990,* which described the rising popularity of the arts as a

career path. The report analyzed data from the U.S. Census to reveal a 127 percent increase in people identifying themselves as artists over the two decades.

In her second chairman's statement, in 1994, Alexander quoted Walt Whitman, who had declared, "The United States themselves are essentially the greatest poem." Among other things, she stressed the emerging use of technology to "share art and ideas" and linkages between donors, arts organizations, and communities. The federal government was already beginning to plan Millennium Projects in anticipation of 2000, and Alexander endorsed a statement by President Clinton that "our dedication to the arts today will shape our civilization tomorrow."

THIRTIETH ANNIVERSARY—AND A DECISIVE BUDGET BATTLE

In 1995, the Arts Endowment celebrated its thirtieth anniversary. In the two previous fiscal years, Congress had trimmed the NEA's budget from $174 million to $170 million, and then from $170 to $162 million. Agency staff was also reduced. These small cuts, however, reflected only the beginning of a shift in Congressional support. A major restructuring of the NEA had begun, and the most severe and debilitating cuts would come in 1996.

The budget and staff cutbacks reflected the impact of an aggressive strategy directed against the very existence of the Arts Endowment by a group of Republican legislators under the leadership of Speaker of the House Newt Gingrich. During the 1994 election campaign, many Republicans ran on a political platform called the "Contract with America" that included a call for the elimination of the Arts Endowment. The Republicans had won and were now in the majority in both the House and Senate for the first time in 40 years. As part of the new political reality, chairmanship of the House Interior Appropriations Subcommittee—with authority over funding of the Arts and Humanities Endowments—transferred from Sid Yates (D-IL) to Ralph Regula (R-OH).

In a January 8, 1995, op-ed in the *Washington Post,* columnist George Will exhorted Republican legislators to "Give Them the Ax," referring to the two Endowments and the Corporation for Public Broadcasting. Will wrote, "Because government breeds more government and develops a lobbying infrastructure to defend itself, every state now has a humanities council." While leaders in the arts regarded it as the expansion of public support for culture throughout the land, Will labeled the Arts Endowment a pork-barrel scheme. Will concluded, "If Republicans merely trim rather than terminate these three agencies, they will affirm that all three perform

Chairman Alexander at one of the many Congressional hearings on NEA funding, with Senator Alfonse D'Amato to the right. (Photo by Ann Burrola)

appropriate federal functions and will prove that the Republican 'revolution' is not even serious reform."

The threat facing the Arts Endowment was no longer simply more budget cuts, but the threat of total elimination. The agency had not been authorized since 1993, leaving it vulnerable. Authorization committees gave advocates and critics an additional playing field in both chambers. In May 1995, Representatives William Goodling (R-PA) and Randy "Duke" Cunningham (R-CA) introduced legislation that would reduce appropriations for the Arts Endowment and its sister agency, the National Endowment for the Humanities for fiscal years 1996, 1997, and 1998 with complete elimination of funds by October 1998. Although the authorization bill was voted out of the House Committee on Economic and Educational Opportunities, it was never voted upon by the full House. A similar bill introduced by Representative Phil Crane (R-IL) gained 33 co-sponsors but failed to be considered by a committee.

Meanwhile in the Senate, the Committee on Labor and Human Resources, chaired by Senator Nancy Landon Kassebaum (R-KS) took up reauthorization supported by Senators James Jeffords (R-VT), Edward Kennedy (D-MA), Christopher Dodd (D-CT), and Al Simpson (R-WY). At one of four hearings, Chair Kassebaum declared, "There is support for the work of the National Endowment for the Arts" and added "Clearly we have to answer some constituent concerns that really do still question

whether this is a function of federal government." Kassebaum was among several Republican lawmakers to offer legislative proposals in the debate over the NEA. She introduced an amendment that would trim NEA money by 5 percent per year and used the opportunity to speak out against a grant to a California arts center that ran performances on sexual themes.

The NEA remained intact but with lower funding levels. The House Appropriations Committee had slashed the agency's FY 1996 budget by 39 percent from $162 million to $99 million. A thorough reorganization followed, which required severe cuts in staffing. Eighty-nine employees were let go through the Reduction in Force (RIF) process, and 11 who were eligible chose to retire. In total the Arts Endowment's staff shrunk by more than half.

Michael Faubion, later to become NEA's director of Council Operations and deputy director of Government Affairs, recalled the difficulties of the drastic downsizing, "During this time, there were constant rumors of what would happen if the agency's budget was cut in half, or worse. The potential for layoffs was very troublesome. A few staff members left before this could happen to them, knowing that the last to have begun work would be the first to go. Once the decision was made about who had to go and who had to stay, all of us still had to work side by side for three months—very uncomfortable." The reductions took effect in late 1995 and early 1996. Simultaneously, the federal government was shut down for the month of January. Faubion remembers, "Those of us who still had jobs were instructed not to come into work. Then, the worst snowstorm to hit Washington in years came at the same time. When we finally returned to work, we had completely different offices and jobs, and different people to work with. It was a surreal experience."

SURVIVING THE BUDGET CUT AND CONGRESSIONAL REFORMS

The budget cut was much larger than any previously imposed, but at the same time the agency earned national honors. January 1995 saw the premiere of *American Cinema,* a new series on public television, supported by the Arts Endowment as part of the millennium celebration of twentieth-century American art. Chairman Alexander accepted a Tony Award on behalf of the agency, which recognized the significant work of the Arts Endowment in the expansion of American regional theater. Further, in 1995, for the first time, the NEA National Heritage Fellowships were presented at the White House with First Lady Hillary Rodham Clinton presiding.

In her Congressional testimony that year, Alexander defended the Arts Endow-

ment. She declared, "A great nation supports and encourages the education of *all* its people. A great nation recognizes that the life of the spirit, of the human mind, is what endures through the passing on from generation to generation of a heritage that says: this is who we are, this is who we were, and this is who we will be in days to come. That heritage is manifested through the arts, the humanities and the sciences. That heritage is what we seek to keep alive at the Endowment for the Arts."

Later, in the NEA's 1995 *Annual Report,* Alexander stated "the most poignant of all our partnerships came about in response to tragedy." Following the 1995 bombing of the Oklahoma City federal building, the Arts Endowment led a design initiative to foster community reconstruction.

First Lady Hillary Rodham Clinton (left) presented the NEA National Heritage Fellowships at the White House to bluegrass musicians Jim and Jesse McReynolds. (Official White House photo)

A design workshop convened entitled "We Will Be Back: Oklahoma City Rebuilds."

In 1996, a Rockefeller Foundation report showed that, notwithstanding the cuts, the Arts Endowment remained the largest single financial supporter of the arts in America. Still, the chairman was forced to face the new reality that "with fewer dollars, we must become more resourceful." And so Alexander instituted several "sweeping changes" to restructure the agency:

• Reduction of 17 discipline-based grant programs to four funding divisions: Heritage and Preservation, Education and Access, Creation and Presentation, Planning and Stabilization;

• Addition of combined arts panels—a new layer of review—over the new four funding divisions;

• Establishment of Leadership Initiatives to give the agency programmatic flexibility.

Of the grant-making changes undertaken during her tenure, none was more painful for Chairman Alexander than the Congressional mandate to eliminate all individual artist grants, with the exception of the Literature Fellowships. This change would remain an ongoing point of controversy in the artistic community for the next decade.

Over the next three years (1996–1998), Congress instituted a series of dramatic reforms affecting the agency's operations and grantmaking policies including:

• Elimination of grants to individuals with the exceptions of the field of literature and honorific fellowships for jazz musicians and folk and traditional artists;

• Elimination of grants to organizations for the purpose of sub-granting to other organizations or artists, except for regional, state, and local arts agencies;

• Elimination of seasonal or general operating support grants to organizations;

• Authority for the NEA to solicit, accept, receive, and invest gifts or bequests of money, property, and services;

• Capping of agency funding to any one particular state at 15 percent (excluding multi-state projects);

• Reduction of the National Council on the Arts from 26 to 14 private members appointed by the President and confirmed by the Senate, and the addition of six ex-officio seats for members of Congress appointed by the House and Senate leadership;

• Increased percentage of program funds allocated to state arts agencies from 35 percent to 40 percent.

The Congressional reforms strengthened language contained in the agency's 1990 authorization that funding priority be given to underserved populations. Congress also required that the NEA establish a separate grant category for projects that are national in scope, or that provide access to the arts in communities in underserved states.

The Arts Endowment had previously functioned as a compartmentalized grant-making body, with financing awarded through specific arts disciplines. Under the old structure, for example, symphony orchestras competed with each other for grants from the NEA's symphony budget. Under the new reforms, a symphony orchestra would compete against a dance company or a literary magazine, whose project fell in the same division, such as Education and Access.

According to Alexander, the new structure would ensure equitable opportunities for support, but would be more rigorous. In addition, the new structure would more accurately reflect cross-fertilization among disciplines. She pointed out that "contemporary art often marries genres—poetry and song, digital art with film, design and drama," adding that "one of the outcomes that we hope for is collaboration among arts organizations, not only for fiduciary reasons, but for aesthetic growth and experimentation." (This new arrangement proved temporary, however, and by 2005 grants were awarded again for projects in specific disciplines.)

As the severe cutbacks were implemented, the Arts Endowment continued generating fresh and exciting projects. In 1996, the American Canvas project began, with meetings in cities such as Charlotte, North Carolina; Columbus, Ohio; Los Angeles, California; Miami, Florida; Rock Hill, South Carolina; Salt Lake City, Utah; and San Antonio, Texas. American Canvas hosted discussions of arts support in these cities and improved strategies for arts integration into communities. Open Studio, a project for free Internet access to arts organizations in all 50 states, along with a mentoring program for ten sites to be used by artists on the World Wide Web, also began in 1996 in partnership with the Benton Foundation.

American Canvas analyzed and discussed the major issues faced by those in the nonprofit arts, compiled from public forums in seven different communities.

The Battle Continues

In 1997, the NEA faced multiple efforts to abolish it. Although Congress had imposed enormous budget cuts, House Speaker Gingrich once again targeted the Arts Endowment for liquidation. In April, Gingrich told a Washington news conference that rich celebrities and entertainment executives should donate their own funds to establish a private endowment, or "tax-deductible private trust." Hollywood personalities including actor Alec Baldwin, speaking for the Creative Coalition, an entertainment industry lobby, rebuffed the suggestion. Baldwin commented, "Arts belong at the national table." But public intellectuals of a free-market bent, such as economics professor Tyler Cowen of George Mason University, backed the proposal for a private arts endowment, which Cowen argued would "decentralize taste and promote diversity."

On June 26, 1997, the FY 1998 appropriations bill for the Interior and related agencies was voted out of the House Appropriations Committee with $10 million for the NEA, just enough money to shut the agency down. Before the House floor debate on the bill occurred, a rule was passed, by a vote of 217–216 that allowed both a point of order against the unauthorized agency and for the presentation of an

Arts Education Partnership

One of the National Endowment for the Arts' major accomplishments in the field of arts education is the Arts Education Partnership (AEP), a collaborative project of the U.S. Department of Education, the National Assembly of State Arts Agencies, the Council of Chief State School Officers, and the NEA. Established in 1995, the AEP serves as a meeting ground for organizations and researchers to explore how to promote and sustain the arts in the school curriculum. Under Chairman Jane Alexander and Senior Deputy Chairman Scott Shanklin-Peterson, the partnership was formed to support and enhance arts education in the schools.

Richard Deasy was the founding director of the AEP. For more than a decade, he led this coalition of more than 100 arts, education, business, philanthropic, and

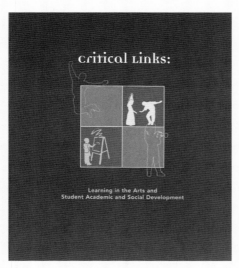

The Arts Education Partnership created reports such as *Critical Links*, which explored the role of arts in a child's cognitive development and academic performance.

government organizations to promote the essential role of the arts in the learning and development of every child and in the improvement of America's schools. Each year, the coalition convenes national meetings with unique themes such as "Arts Education and Standardized Tests." Hundreds attend, and experts in arts pedagogy, child development, and education policy present the latest research to teachers, foundation leaders, and arts organization personnel.

The AEP also issues reports based on the coalition's meetings, activities, and research in the field. The topics of the reports include the arts and academia, the arts and social development, assessing arts education, and training educators in the arts. One report, *Critical Links: Learning in the Arts and Student Academic and Social Development* (2002), is recognized as a seminal document in understanding the role of the arts in a child's cognitive development and academic performance. Another AEP publication is *Third Space: When Learning Matters* (2005), a study of the positive impact of arts education in underserved schools. The AEP collaborated with the National Assembly of State Arts Agencies on *Critical Evidence: How the Arts Benefit Student Achievement* (2005). This booklet provides policymakers, educators, parents, and advocates with non-technical language on current research on the value of arts learning experiences. The AEP also offers online resources, including a directory of participating organizations, publications, and other arts education advocacy resources.

amendment to provide block grants to the states for arts education. The deciding vote was cast when Representative John McHugh (R-NY) switched sides. McHugh insisted that while he "always felt the government has a role in arts funding," he was "looking for a way to do it more effectively."

When the House took up the appropriations bill on July 11, Congressman Phil Crane (R-IL) raised the point of order against the NEA and it was automatically accepted, leaving the agency with zero funding. Congressman Vern Ehlers (R-MI) offered the block grant amendment giving $80 million to state arts agencies, as well as local school boards to subsidize arts education. The Ehlers amendment was defeated by a vote of 191 to 238, leaving zero funding for the NEA.

As the bill moved to the Senate, President Clinton came to the Arts Endowment's defense, promising to veto the appropriations bill if it did not contain at least $99.5 million for the Arts Endowment. But the fight had just shifted to a different chamber. Champions of the NEA appeared on both sides of the aisle in the Senate, including the Chairman of the Senate Interior Appropriations Subcommittee, Slade Gorton (R-WA). Senator Gorton kept his pledge to defend the agency and restored $100 million for the NEA in the Interior bill.

More attempts were made in the Senate to abolish the NEA. One attack focused on sexual content in artistic expression led by Senator Jesse Helms (R-NC) and by a new proponent of eliminating the agency, Senator John Ashcroft (R-MO). Senator Spencer Abraham (R-MI) put forth a plan to privatize both the National Endowment for the Arts and the National Endowment for the Humanities over a five-year period declaring the Endowments were "out of touch with the public." Other Senators registered objections to the non-democratic distribution of federal funding. Senator Tim Hutchinson (R-AR) assailed what he perceived as the centralization of federal arts grants in six cities to the exclusion of the rest of America, and Senator Kay Bailey Hutchison (R-TX) attempted to redirect more funds to the states.

Finally on October 18, the Senate passed by a vote of 93 to 3 an appropriations bill containing $100 million for the NEA and a new provision for the agency to solicit and accept private funds. When the bill moved to conference, Interior Appropriations Chairmen Senator Gorton and Representative Ralph Regula (R-OH) brokered a compromise that successfully assuaged Congressional critics. For FY 1998, the National Endowment for the Arts would receive $98 million and instructions from Congress that permanently altered the agency's mission and operations well into the next decade.

The number of total grants awarded by the NEA dropped from 4,000 in 1995 to 1,100 in 1997. Yet the Arts Endowment had survived, despite strong Congressional opposition. Alexander had completed four years in the chairmanship, and she remained a strong advocate for federal funding of the arts. Soon after her swearing-in, she began touring the country, reintroducing the Arts Endowment and its mission to communities large and small. No previous chair had traveled so extensively across America. Alexander became a nationally visible spokesperson for public support of the arts—something none of her predecessors had ever attempted. In House testimony in 1997, she had declared, "We are the engine that drives other public and private investment in the arts, and we are not a drain on the economy by any standard of measurement."

During Alexander's chairmanship, the NEA suffered severe budget cuts as well as reductions in staff, programs, and resources. Interest groups and political leaders of diverse ideologies continued to target the Arts Endowment for elimination. According to the *Washington Post,* Alexander had "regained solid support from a broad swath of political moderates." She announced that she would leave the chairmanship at the end of her four-year term in October 1997. She called the respite "a chance to breathe," and the *Post* concluded that she also had "won that for the Arts Endowment." In her final judgment she said, "It is a testament to the citizens of America who love the arts in their community that the Endowment is alive. . . . These citizens are a pure force in an impure world and our society needs more of them."

Bill Ivey, NEA Chairman 1998–2001. (Photo by Marion Ettinger)

Broadening the Agency's Reach

I N HIS SEARCH for a successor to Jane Alexander in December 1997, President Clinton turned to the director of the Country Music Foundation in Nashville, Bill Ivey, as the seventh chairman of the Arts Endowment. Ivey was born in Detroit in 1944 and grew up in the Upper Peninsula of Michigan. He received his education at the University of Michigan and Indiana University, earning history, folklore, and ethnomusicology degrees. In 1994, Ivey had been named to the President's Committee on the Arts and the Humanities. He also served two terms as president of the National Academy of Recording Arts and Sciences, as a senior research fellow at the Institute for Studies in American Music at Brooklyn College, and as a faculty member of the Blair School of Music at Vanderbilt University.

Ivey was known primarily as an advocate for the preservation of country, folk, and popular music. The Country Music Foundation operated with an annual budget of $4 million, and through it, Ivey administered the Country Music Hall of Fame from 1971 to 1998, while publishing a journal and directing a record label.

After being unanimously confirmed by the Senate, Ivey was sworn in as chairman in 1998. A populist, Ivey represented a new sort of federal arts leader. While public and political support for the agency remained low, and the agency's budget had been cut by 40 percent, his profile was helpful in reassuring Congressional critics who believed that the Arts Endowment's programs catered to cultural elites.

The *Washington Post* quoted Ivey on the announcement of his pending appointment, affirming that the Arts Endowment was "a very important agency, particularly in its role of nurturing excellence in all the arts . . . it would be an ultimate job for

me." The same newspaper cited praise of Ivey as "an amazing generalist" by Michael Greene, president of the National Academy of Recording Arts and Sciences. Greene endorsed Ivey as one who knew "a tremendous amount about the visual arts and folklore," and who "in terms of arts advocacy . . . had always gone down the center. He hasn't jumped into any camp."

Ivey's first annual message as chairman was short. He noted that since its creation in 1965, the Arts Endowment had awarded 110,000 grants, supported museum shows and theater companies of varying size, established arts classes for youth, televised concerts and folk festivals, and developed innovative public-private partnerships. With the budget at $98 million, grants in 1998 emphasized diversity, including support to a theater group for a play about African-American performer Paul Robeson, a Hispanic performing arts series, a country music program in Nashville, folk art instruction in Nevada, and Alaskan native authors and storytellers.

Less than a month after Ivey's confirmation, the Arts Endowment claimed a major victory when the Supreme Court affirmed on June 25, 1998, by a vote of eight to one, the constitutionality of the statutory provision requiring the agency to consider "standards of decency and respect for the diverse beliefs and values of the American public" in its application review process. The sole dissenting Justice was David H. Souter. Justice Sandra Day O'Connor, writing for the majority, held that the Congress had the right to be vague in setting criteria for spending money, and the decency clause did not, on its face, discriminate on the basis of viewpoint. In a separate opinion, but one that joined the majority, Justice Antonin Scalia declared, "It is the very business of government to favor and disfavor points of view on innumerable subjects, which is the main reason we have decided to elect those who run the government, rather than save money on making their posts hereditary."

NEA Chairman Bill Ivey was a champion of folk artists, such as bluegrass guitarist/singer Doc Watson, seen here receiving the National Medal of Arts from President Bill Clinton. (Official White House Photo)

Theatreworks/USA's production of *Paul Robeson, All-American* was supported by a 1998 NEA grant. (Photo by Jean-Marie Guyaux)

BROADENING LOCAL APPEAL

Chairman Ivey demonstrated a deep understanding of the infrastructure and public policy needs of American cultural enterprises. Furthermore, Ivey built on Alexander's reorganization with further reforms—for example, engaging program directors more in the grant-making process, specifically, in determining grant amounts. Ivey, having previously served on NEA panels, believed that some panelists had too narrow a focus, and welcomed the discipline directors' expertise and broad perspective.

With the NEA budget remaining essentially flat for two more years, Ivey nevertheless introduced strategies for enhancing American cultural life, including the development of a broad initiative called Continental Harmony. Administered by the St. Paul, Minnesota-based American Composers Forum, the program placed composers-in-residence with local chamber music ensembles to develop new musical

During her residency in David City, Nebraska, composer Deborah Fischer Teason learns about the community's Czech heritage from local accordionists as part of an NEA ArtsREACH project. (Photo by Ruth Nichols)

works reflecting the sensibilities and traditions of local communities. Many of the compositions premiered on July 4, 2000. Continental Harmony exemplified a new approach in Arts Endowment programming that also included ArtsREACH, a program launched in 1998 that funded arts projects in states identified as "under-represented" in the agency's grant count. ArtsREACH answered Congressional demands that NEA funding reach underserved areas. States that received special attention and grants workshops under ArtsREACH included Alabama, Indiana, Iowa, South Carolina, and South Dakota. In 1999, ArtsREACH increased the agency's grantmaking in 20 targeted states by more than 350 percent. It served as a prototype for another program, Challenge America, which also emphasized out-reach and arts education for previously underserved areas.

That year, in his *Annual Report* message, Chairman Ivey outlined his vision. Con-forming to the requirements of Congress, Ivey developed a strategic plan for the years 1999–2004, and named it "An Investment in America's Living Cultural Her-itage." The plan included a revised mission statement: "The National Endowment for the Arts, an investment in America's living cultural heritage, serves the public good by *nurturing* the expression of human creativity, *supporting* the cultivation of community spirit, and fostering the recognition and appreciation of the **excellence** and **diversity** of our nation's artistic accomplishments" (emphasis original). The goals of the five-year strategic plan reinforced the sense that the NEA under Ivey would broaden participation and local appeal in Arts Endowment activities.

Save America's Treasures Program

In 1998, the White House Millennium Council partnered with the National Trust for Historic Preservation to establish Save America's Treasures, an effort to protect "America's threatened cultural treasures, including historic structures, collections, works of art, maps, and journals that document and illuminate the history and culture of the United States." Each year, Congress appropriates funds for the program. Since its inception, more than $216 million has been appropriated; the awards are distributed through a direct designation by Congress or through competitive grants.

The National Park Service partnered with three federal agencies—the National Endowment for the Arts, the National Endowment for the Humanities, and the Institute of Museum and Library Services— to administer Save America's

Preservation of acetate negatives of photography sessions by illustrator and painter Norman Rockwell, here working on *The Art Critic*, 1955, is one of the projects supported by Save America's Treasures. (Photo by Bill Scoville, courtesy of Norman Rockwell Museum)

Treasures funds. The President's Committee on the Arts and the Humanities coordinates the process. The NEA awards these grants for preservation of art works, artifacts, and collections.

The Save America's Treasures program is one of the largest and most successful grant programs for the protection of our nation's irreplaceable and endangered cultural heritage. It is also the only grant program that supports both the preservation of historic sites and structures as well as intellectual and cultural artifacts.

The conservation treatment supported by Save America's Treasures frequently allows previously endangered work to be exhibited to the public. For example, Thomas Sully's massive painting *The Crossing of the Delaware* was conserved in public view at the Museum of Fine Arts, Boston, allowing museum visitors a chance to see a side of collections care that is usually invisible to the public. The museum's new American wing was designed with a place of prominence where the painting, reunited with its original frame, will be on permanent exhibition.

Performing arts organizations, such as dance companies, are sometimes unable to fund documentation of their work. For instance, the George Balanchine Foundation found itself in danger of losing the world-renowned choreographer's ballets with the passing of his original dancers. With funding from Save America's Treasures, the older generation of dancers was videotaped teaching the works to young dancers, thereby ensuring that his work would survive.

In his chairman's statement accompanying the plan, Ivey highlighted his populist bent: "Today, art is no longer confined to paintings in museums—or dances, plays and symphonies in concert halls and theaters. . . . It's in large cities and in the smallest, most remote towns. Besides anchoring communities, growing the economy, and increasing jobs, the arts give communities a sense of identity, shared pride, sound design that affects how we live, and a way to communicate across cultural boundaries." Echoing the agency's enabling legislation, the introduction stated, "It is vital to democracy to honor and preserve its multi-cultural artistic heritage as well as support new ideas; and therefore it is essential to provide financial assistance to its artists and the organizations that support their work."

The expansion of Arts Endowment grants to more communities remained a touchstone of the Ivey chairmanship. In the area of design, he instituted four Leadership Initiatives to improve design standards across the country. The initiatives focused on government facilities, obsolete suburban malls, schools, and the stewardship of rural areas. Another NEA program during this period, the YouthARTS project, brought the Arts Endowment together with the Department of Justice to address crime by minors. This partnership helped establish arts programs inside juvenile justice facilities and in "at-risk" neighborhoods.

Thirty-Fifth Anniversary

The Arts Endowment celebrated its thirty-fifth year in 2000 by organizing "America's Creative Legacy: An NEA Forum at Harvard," cosponsored by the Kennedy School of Government. The conference was held with the participation of Chairman Ivey and all his living predecessors—Jane Alexander, John Frohnmayer, Frank Hodsoll, and Livingston Biddle. The forum reflected the arrival of the millennium and the roll-out of millennium projects developed by the Arts Endowment over several years. The White House Millennium Council's Final Report on these efforts, which was issued in January 2001, included a section titled "Imagining America: Artists and Scholars in Public Life," which declared, "The arts and the disciplines of the humanities have a real effect on individuals, institutions, and communities. But too often, artists and scholars are separated from public involvement, precluding valuable collaboration."

Chairman Ivey laid out the accomplishments of the Endowment over 35 years by restating his belief that "the agency strengthens American democracy at its core." The Arts Endowment's support assisted in the growth of local arts agencies from

From left to right: Chairman Bill Ivey with former chairs Jane Alexander, John Frohnmayer, Livingston Biddle, and Frank Hodsoll at the NEA Forum on America's Creative Legacy at Harvard University in 2000. (Photo by Mark Morelli)

400 to 4,000, nonprofit theaters from 56 to 340, symphony orchestras from 980 to 1,800, opera companies from 27 to 113, and dance companies multiplied by 18 times since 1965.

In the 2000 *Annual Report* chairman's statement, Ivey pointed out that the Arts Endowment had bipartisan support in Congress, and he proposed a "Cultural Bill of Rights" for Americans, comprising:

1. **Heritage:** The right to fully explore America's artistic traditions that define us as families, communities, ethnicities, and regions.

2. **A Creative Life:** The right to learn the processes and traditions of art, and the right to create art.

3. **Artists and Their Work:** The right to engage the work and knowledge of a healthy community of creative artists.

4. **Performances, Exhibitions, and Programs:** The right to be able to choose among a broad range of experiences and services provided by a well-supported community of cultural organizations.

5. **Art and Diplomacy:** The right to have the rich diversity of our nation's creative life made available to people outside of the United States.

6. **Understanding Quality:** The right to engage and share in art that embodies overarching values and ideas that have lasted through the centuries.

Finally, Ivey stated, "As we move into a new millennium, the NEA is committed to citizen service." Although never adopted in any broader public sense, this "Cultural Bill of Rights" provided a vivid snapshot of Chairman Ivey's vision for the Arts Endowment.

CHALLENGE AMERICA

The agency's 2000 budget stood at its lowest in a quarter-century, totaling only $97.6 million. Chairman Ivey gained a $7.4 million increase for the Arts Endowment budget for fiscal year 2001, raising the agency's annual appropriation to $105 million. After an attempt by the bipartisan House Arts Caucus to increase the NEA's budget failed, Senator Slade Gorton (R-WA) led a successful effort through the Senate to increase the NEA's budget. The increase was ultimately maintained in the final version of the bill agreed upon by both the House and Senate in conference.

The new funding was earmarked exclusively for the Challenge America Arts Fund to provide grants for outreach and arts education projects in remote and previously neglected communities. This important program represents Ivey's major legislative triumph. After almost a decade of cuts, it marked the first increase in the Arts Endowment's budget since 1992. The following year, Congress raised the Endowment's budget to $115.2 million, again with the increases going to the Challenge America program.

Under Ivey, Challenge America began as a short-term mechanism for enhancing the arts, arts education, and community activities in underrepresented areas. The program was expanded and under future Chairman Dana Gioia, the NEA achieved national reach through Challenge America by awarding a direct grant to every U.S. Congressional district. The program's popularity with Congress also continued to grow. In July 2003, Representative Lynn Woolsey (D-CA) stated, "NEA programs such as Challenge America are using art as a means to bring communities together. Along with the United States Department of Housing and Urban Development and the National Guild of Community Schools, Challenge America has started a program that offers arts instruction to children living in public housing. When we deprive the NEA and NEH of the funds it needs, we deprive this entire nation of an active cultural community." Support for the program continued throughout the Administration of President George W. Bush, who requested $17 million for Challenge America for fiscal year 2004.

ARTS AND ACCESSIBILITY

The NEA's Office of AccessAbility, originally named Special Constituencies Office, was created under Chairman Nancy Hanks in 1976 in response to an appeal by National Council on the Arts member Jamie Wyeth. Wyeth and his wife, who uses a

wheelchair, were often unable to attend cultural events as the venues were not accessible. The National Council resolved that "No Citizen, regardless of physical and mental condition and abilities, age or living environment, should be deprived of the beauty and insights into the human experience that only the arts can impart."

The NEA became a leader in the field of accessibility, and was the third federal agency to publish its Section 504 Regulations in the federal register. The AccessAbility Office, in addition to serving as an advocate for those who are older, disabled, or living in institutions, established a series of initiatives to advance the Arts Endowment's access goals: Universal Design, Careers in the Arts for People with Disabilities, Arts in Healthcare, and Creativity and Aging.

In a 1998 speech to the National Forum on Careers in the Arts for People with Disabilities, Chairman Ivey reiterated the importance of the work of the Arts Endowment in the field of accessibility. "Most Americans will experience disability at some time during their lifespan, either themselves, or, like me, within their families. As with aging, it is an experience that touches everyone. Thus working towards a fully accessible and inclusive culture is important to all Americans."

IVEY MOVES ON

The end of 2000 brought a presidential election and the victory of Republican George W. Bush. The new First Lady, Laura Bush, made her vigorous support for culture and the arts clear from the beginning of her residence in the White House. Bill Ivey remained in charge of the Arts Endowment, and—like Nancy Hanks two decades earlier—wondered whether the NEA chairmanship could become a nonpartisan appointment.

Bill Ivey served nine months under the new Republican Administration. In April 2001 he announced that he would resign in September of that year, six months before the expiration of his term. Before his departure, he championed the NEA's FY 2002 budget request before Congress and expressed his hope that "the new Administration will be able to move efficiently to choose new leadership for the Arts Endowment." But the controversies that had plagued the agency remained vivid, and the public image of the Arts Endowment continued to be dictated largely by its critics.

Michael Hammond, NEA Chairman 2002. (NEA File Photo)

CHAPTER 9

In Dark Hours

BEFORE A SUCCESSOR to Chairman Bill Ivey could be appointed, America underwent the frightful experience of September 11, 2001, stunned by the horror of the attacks on New York and Washington, DC. Federal employees close to the Capitol, and in tall buildings such as the Old Post Office, were especially alarmed. On the day of the attacks, panelists reviewing fellowship applications for literature projects gazed out the windows as smoke rose from the Pentagon across the river. Evacuated from the building, they decided to assemble in a nearby hotel and continue to work.

Because New York City, the main target of the terrorists, is the nation's arts center, the impact of September 11 on artists and cultural institutions was felt nationwide. Immediate action was taken by the Heritage Emergency National Task Force to assess structures and collections in the areas of the 9/11 attacks. Within hours, the American Association of Museums reported that all New York museum staff were accounted for and museum collections safe.

However, on the 105th floor of the North Tower of the World Trade Center, the Cantor Fitzgerald investment firm had suffered the horrific loss of hundreds of employees. The world's largest corporate collection of works by sculptor Auguste Rodin and numerous works by Alexander Calder, Roy Lichtenstein, and Louise Nevelson were destroyed. Next door in the South Tower, the National Development and Research Institutes Library was completely wrecked, as were the offices of the Lower Manhattan Cultural Council. The Broadway Theater Archive, with 35,000 photographs, that stood a block from the World Trade Center was also lost, and 13

other historically or architecturally significant structures, including the Federal Hall National Memorial, were damaged.

In the days and weeks immediately following September 11, Americans turned to the arts, especially to music and poetry, to express their grief. Media focused on the dark stages of Broadway and paid little attention to the blight of the nonprofit arts community. Congress debated how to expedite relief to New York City while arts groups navigated eligibility requirements to secure loans from the Small Business Administration and aid from the Federal Emergency Preparedness Agency.

The economic impact of the terrorist attacks on each of the arts fields was assessed by the NEA. There was a dramatic downturn in year-end giving to nonprofit arts organizations as donors directed giving to 9/11 charities. Revenues were lost from cancelled performances and low attendance at arts events. The general economic slump, decline in tourism and travel, and reduction in state tax revenues brought about cuts in state and local arts budgets. New York City announced a 15 percent across-the-board cut in funding for cultural organizations. Insurance costs rose, in part because of increased security needs at public performances.

The Arts Endowment issued a Chairman's extraordinary action grant through the New York State Council on the Arts to help artists in Lower Manhattan begin the process of cleaning and repairing offices and purchasing equipment. Over the years, the Endowment had provided similar emergency disaster grants to arts organizations devastated by floods, earthquakes, and hurricanes, and help after the bombing of the Oklahoma City Federal Building.

More substantial help for New York's cultural organizations came from private foundations. The Andrew W. Mellon Foundation created a special $50 million fund to benefit those museums, libraries, and performing arts organizations most directly affected. Several years later President Bush presented the Mellon Foundation with the nation's highest award to artists and arts patrons, the 2004 National Medal of Arts for "civic leadership in the aftermath of the September 11 attacks."

HAMMOND APPOINTED

Eight days after September 11, President George W. Bush announced his intention to nominate Michael Hammond, dean of the Shepherd School of Music at Rice University in Houston, as chairman of the Arts Endowment.

Hammond was a conductor and composer, but he also brought vast educational and arts administration experience to the agency. A Wisconsin native, he attended

Michael Hammond signing papers to become the new NEA chairman in January 2002. (Photo by Ann Guthrie Hingston)

Lawrence University and Delhi University, India, and earned a Rhodes Scholarship to Oxford University where he received degrees in philosophy, psychology, and physiology. Before joining the Shepherd School in 1986, Hammond directed the Wisconsin Conservatory of Music in Milwaukee, and then moved to New York State to become the founding Dean of Music at the State University of New York at Purchase. Subsequently, he served as president of the college. While in New York, he founded the celebrated international arts festival at Purchase, known as Pepsico Summerfare. The new chairman, at 69, had long been active in orchestral and vocal music, but his biography was so diverse that it also included lecturing in neuroanatomy to medical students in Wisconsin.

In a statement reflecting the somber mood of the country in those days and weeks, Hammond declared, "I am deeply honored by President Bush's confidence in me. . . . The arts can help heal our country and be a source of pride and comfort." As Hammond prepared for his Senate confirmation, he further articulated his vision for the Arts Endowment, "Our heritage embodies all the efforts that have gone before us, what we imbibe, and what we wish we could say but cannot put into words." He cited the *Guide to Kulchur* by Ezra Pound as "a primer for American poets" that "begins with words and gestures, and finds new metaphors." Western civilization is "a conversation," he said, influenced by new voices and cultures. For Americans to join that conversation wisely, they must be trained in it, and so he saw his primary mission to be arts education. "We have never made a serious effort in the United States to engage our youth with the arts," he lamented. "We can make the greatest impact on preschool children, and then move onward with technique-based, prolonged involvement with the arts. This will help formulate good taste and deepen understanding."

Hammond compared the task before him to the moon-landing mission brought forth by President Kennedy, which took nearly a decade to accomplish. "What use is creating awareness of the arts," Hammond asked, "if it is not a long-term, crucial task?" Hammond anticipated the agency's Shakespeare in American Communities program,

Dr. Robert S. Martin was acting chairman for the National Endowment for the Arts in 2001. (Photo courtesy of Institute of Museum and Library Services)

proposing that ten Shakespeare touring groups be selected for funding, "with two or three of them on the road most of the time." He also called for a renewal of interest in representational painting and for attention to classical music on radio.

With Chairman Ivey gone and Michael Hammond not yet in place, Robert S. Martin was designated acting chairman of the Arts Endowment on October 1, 2001. While serving as acting chairman of the NEA, Martin was also director of the Institute of Museum and Library Services, a sister agency of the Arts and Humanities Endowments. Formerly, Martin had been a professor and interim director of the School of Library and Information Studies at Texas Woman's University in Denton, Texas, and Texas State Librarian. He served until January 23, 2002, when Hammond was sworn in.

On his third day in office, Chairman Hammond called an all-agency staff meeting and spoke eloquently about art and the creative process. Those in attendance were moved by the promise of his remarks and looked forward to his inspirational tenure, but Hammond served as chairman for only seven days—from January 23 to January 29. On Tuesday, January 29, he did not report for work.

Hammond had felt ill over the weekend and had gone to the hospital for a series of tests on January 28. That night he attended a gala at the Shakespeare Theatre Company with Michael Kahn, the theater's artistic director, and Queen Noor of Jordan, followed by a performance of *The Duchess of Malfi* by John Webster. Hammond left the performance early and returned home in a taxicab. The next morning, when he did not show up for work, police were called to his home. There they found Michael Hammond, dead of natural causes at age 69.

"There was great sadness among the staff," Senior Deputy Chairman Eileen Mason recalled. "They had waited four months for a new chairman and were excited about the breadth of Hammond's intellect, his passion for the arts, and his lifelong work in music education. On January 23, they had welcomed him with food and

song at an all-agency reception, and had heard about his love of the arts and his vision for the agency." Now the agency needed a new leader, and Mason assumed the post of acting chairman.

THE MASON INTERIM

Eileen Mason came to the agency with a background in education, publishing, and governmental service. A native New Yorker, she began studying the violin in grade school, and continued her lifelong commitment to symphonic and chamber music under the tutelage of composer and conductor Karel Husa at Cornell University. With a Bachelor of Arts from Cornell, where she studied English and music, she worked as a book editor at Little, Brown in Boston, editing college textbooks in literature and the social sciences. In Washington, DC, she served as a manager at two federal energy agencies, and earned a master's degree in public administration from American University. She became vice president for grants on the Arts and Humanities Council of Montgomery County, Maryland, before joining the Arts Endowment in 2001.

Mason served for 13 months as acting chairman, focusing on honoring Hammond's memory, strengthening relations with Congress, supporting arts education, and extending access to quality arts programs in underserved communities. In April 2002 she joined members of the Congressional Arts Caucus led by Representative Louise Slaughter (D-NY) and Representative Steven Horn (R-CA) to visit 16 New York City arts organizations significantly affected by the destruction of buildings, closing of performance venues, and decrease in tourism after the attacks of 9/11. As the group, hosted by the New York State Council on the Arts, traveled from Times Square theaters to the Brooklyn Museum of Art and Brooklyn Academy of Music to El Museo del Barrio in Harlem, it was clear that the arts industry in

Senior Deputy Chairman Eileen Mason became acting chairman of the NEA for 13 months between Chairmen Michael Hammond and Dana Gioia. (NEA File Photo)

Grants Workshops

Improving relations with Congress remained a priority for Acting Chairman Eileen Mason. In April 2002, Senator Charles Schumer (D-NY) wrote to the National Endowment for the Arts to alert the agency to the funding crisis for arts organizations in Buffalo, New York. Schumer cited "the dismal fiscal outlook facing Buffalo and Western New York. By increasing the strain on the state budget and imposing new security needs on the region, the September 11 terrorist attacks exacerbated the budget problems facing Buffalo." Working with NEA Government Affairs Director Ann Guthrie Hingston, Mason organized a grants workshop with Senator Schumer and U.S. Representative Jack Quinn (R-NY) in Buffalo on July 8 at the Erie County Historical Society.

More than 80 representatives of arts organizations listened to Mason describe the Arts Endowment's grant programs and application process. Applications increased from the Buffalo area throughout the next year, and many applicants became grant recipients. For 40 years, the NEA has been doing grants workshops and participating in federal workshops but never before had a chairman participated in one with a member of Congress. Mason, and later NEA Chairman Dana Gioia, continued the new grants workshop model, which became an effective instrument for broadening the agency's geographical coverage. Throughout the next five years more than 60 workshops were conducted in nearly 30 states.

Acting NEA Chairman Eileen Mason and U.S. Representative Jack Quinn at a grants workshop in Buffalo, New York, on July 8, 2002. (NEA File Photo)

2001 National Medal of Arts recipient Rudolfo Anaya with President and Mrs. George W. Bush at the White House ceremony. (Photo by Neshan Naltchayan)

New York was determined to rebound, but financial aid was direly needed.

During their visit to the Dance Theatre of Harlem, Artistic Director, National Medal of Arts recipient, and former National Council on the Arts member Arthur Mitchell greeted the group. Mitchell recounted how he had started with a small company years before, believing that every child in Harlem deserved the opportunity to learn how to dance. "If it weren't for the National Endowment for the Arts," he declared, "Dance Theatre of Harlem would not be here today."

A few days later, Mason represented the NEA at a meeting of the President's Committee on the Arts and the Humanities, with First Lady Laura Bush in attendance. Carrying forth the vision of Michael Hammond, Mason stated that the Arts Endowment's mission "is to acquaint Americans with their rich and diverse artistic heritage." Two initiatives she put forward anticipated things to come. First, she called for an examination of the state of classical music on nonprofit radio, which would evolve into a full-scale project of the NEA's Office of Research and Analysis, and, second, she announced a plan to bring professional performances of Shakespeare's plays into every corner of the country. This idea would later grow under Chairman Dana Gioia into the major Shakespeare in American Communities initiative.

When President and Mrs. Bush presented the 2001 National Medal of Arts and the National Humanities Medals to a distinguished group of artists and scholars, emotions ran high. Only six months after the attack on the World Trade Center, a packed audience sang "The Star Spangled Banner" with reverence and new meaning. Among the Medal of Arts recipients were painter Helen Frankenthaler, film director Mike Nichols, singer Johnny Cash, novelist Rudolfo Anaya, and cellist Yo-Yo Ma. The highlight of the ceremony was Yo-Yo Ma's cello performance, accompanied on the piano by National Security Advisor Condoleezza Rice.

In 2002, the National Endowment for the Arts, in partnership with the Appalachian Regional Commission, sponsored a regional conference to demonstrate the positive economic impact that the arts can have on local communities. More than 300 artists and arts administrators shared information about model programs and best

practices. Two Republican North Carolina legislators, Congressman Charles Taylor, a member of the House Appropriations Subcommittee on Interior and Related Agencies, which has jurisdiction over the Arts Endowment's budget, and Congressman Cass Ballenger, a nonvoting member of the National Council on the Arts, attended and endorsed the concept.

In July 2002, the House of Representatives voted for an amendment sponsored by Representative Louise Slaughter (D-NY) for a $10 million budget increase for the Arts Endowment. Representative Slaughter's amendment was supported by 191 Democrats, 42 Republicans, and one Independent. The tally indicated that momentum was slowly building in the House, as Republicans were showing signs of support for the agency. The Senate, however, voted for only a modest increase. When a final omnibus bill was passed in February 2003, with rescissions across the board for all agencies, the agency received $115.7 million for 2003—a disappointing increase of only $500,000.

In the aftermath of the September 11 attacks on the World Trade Center in New York and the Pentagon, arts organizations were facing serious shortages in the availability of private and public funding. The eighth chairman of the National Endowment for the Arts, Michael Hammond, had begun his long-awaited tenure on January 23, 2002, laid out his vision for the agency, and passed away a week later. Despite the upheaval of Chairman Hammond's death, the NEA began to receive growing support from a bipartisan coalition in Congress and established a renewed commitment to extending access to quality arts programs throughout the country.

Dana Gioia, NEA Chairman 2003–09. (Photo by Vance Jacobs)

Building a New Consensus

T HE NINTH CHAIRMAN of the National Endowment for the Arts, poet Dana Gioia, was nominated by President George W. Bush to succeed Michael Hammond on October 23, 2002. The U.S. Senate unanimously confirmed the nomination on January 29, 2003.

Chairman Gioia, 52 at the time of his confirmation, was an intellectual figure of national importance. He had published three collections of poetry, including *Interrogations at Noon,* which won the 2002 American Book Award. His 1991 essay "Can Poetry Matter?" stimulated a major debate in the literary world, and a subsequent book, *Can Poetry Matter?: Essays on Poetry and American Culture,* was short-listed for the National Book Critics Circle Award in criticism. He co-edited several best-selling literary textbooks with the poet X. J. Kennedy, and he had attained further distinction as a translator from Latin, Italian, and German. Also trained in music, Gioia had worked as a music critic and composed two opera libretti, *Nosferatu* and *Tony Caruso's Final Broadcast.*

Born to a working-class family of Italian and Mexican descent in Los Angeles and the first member of his family to attend college, Gioia graduated from Stanford University and received a master's degree in comparative literature from Harvard, where he studied under the poets Robert Fitzgerald and Elizabeth Bishop. He returned to Stanford to attend business school and earned an MBA. Beginning in the late 1970s, he spent 15 years in New York working for General Foods while writing in the evenings. He eventually became a vice-president before leaving business in 1992 to write full-time.

Gioia inherited an Arts Endowment that showed some progress in increasing its budget and devising promising new programs. Still, the impact of the 1990s culture wars hung heavily over the NEA, and the severe cuts in funding and staffing remained a burdensome legacy. In spite of more than 100,000 grants given in every state and U.S. territory, the Arts Endowment remained best known for a few controversial grants given nearly a decade prior. Many members of Congress continued to criticize the agency, and anti-NEA legislation was regularly introduced. The media remained alert for potentially contentious grants, artists and arts organizations were bitter over the cutbacks, and public perception was mixed at best.

Gioia approached his new position with the aim of first changing the national conversation about the rationale for federal funding for the arts. In a speech delivered to the National Press Club in Washington, DC, on June 30, 2003, he asked, "Can the National Endowment for the Arts matter?" The speech was a sober statement of philosophy, and a sharp overview of the public standing of the agency. He began by observing that, "If the Chairman of the National Endowment for the Arts had spoken to this forum ten years ago, the topic might well have been 'Should the NEA Exist?' At that time a serious cultural and political debate existed in Washington about whether the agency served a legitimate public function." Gioia observed that this question had become moot, at least as a policy matter. Congress had saved the agency. The Arts Endowment had undergone severe budget cuts and a reduction in staff, but its continuing existence was assured. The question, to Gioia, was not should the NEA exist, but how could the NEA best serve the nation?

Gioia outlined his goal for the agency succinctly as "bringing the best in the arts and arts education to the broadest audience possible." His vision stressed, first, that the agency needed to serve all Americans, including tens of millions in rural areas, inner cities, and military bases who had historically been ignored by the NEA. Second, the agency must enhance culture and enrich community life, especially by connecting "America with the best of its creative spirit." To meet those goals, and do so in a way that would win over critics and change public perception, Gioia realized, would require more than funding strong applicants. It demanded a radical change in the still largely negative public perception of the agency, and these changes needed to be embodied in visible, national programs.

A New Approach Is Needed

The controversies of the previous decade showed that, in the media and political spheres, a single questionable grant could outweigh a thousand meritorious ones. Historically, the Arts Endowment's successes tended to be seen merely at a local level. Only when a grant became controversial did it and the NEA receive national attention. Likewise, most arts organizations mounted programs that had only local impact, even though the larger issues they faced such as sustainability, funding, media coverage, and audience development transcended their local reach. Gioia concluded that the American arts might benefit from a different model than the NEA's traditional piecemeal approach of awarding single grants to individual organizations for specific projects. Stronger national leadership was needed. Properly designed and executed, an expanded funding model could link local arts organizations to broader networks and partnerships in fruitful ways.

Chairman Dana Gioia at the Shakespeare in American Communities celebration on Capitol Hill in 2003. (Photo by Steven Purcell)

And so the Arts Endowment developed an ambitious new method of supporting the arts that would have unprecedented impact. In addition to continuing its numerous direct grants, the Arts Endowment created large initiatives designed to incorporate local organizations into broader national partnerships. These national initiatives improved both the efficiency and effectiveness of arts programs. By creating large national partnerships, these programs could achieve enormous economies of scale while also gaining publicity no individual organization could generate independently. Arts organizations were invited to apply for the opportunity to deliver a program to communities around the country, especially those in which opportunities to experience the arts were limited. These national initiatives served both artists' need for employment and arts organizations' need for funding, educational outreach, and affordable programming. In addition to reaching an unprecedentedly large and diverse public, the new initiatives provided the public—including the media and government officials—with tangible examples of the Arts Endowment's achievements.

Shakespeare in American Communities

In April 2003, Chairman Gioia announced the launch of the first national initiative, Shakespeare in American Communities, a project designed to bring Shakespeare to audiences and schools all across the U.S. and unite players in the arts and arts education systems. It also focused on reviving theatrical touring of serious drama, a once thriving practice that had become unaffordable for most companies. In its initial phase, the program organized regional tours of Shakespeare plays by six distinguished theater companies. First Lady Laura Bush and Motion Picture Association of America President Jack Valenti served as honorary chairs and Arts Midwest as partner.

The first phase of the program began in autumn 2003 and ran to November 2004. In that year, six companies visited 172 communities—mostly small and midsized towns—and 500 schools across all 50 states. As the initial phase gained momentum, an unexpected new dimension of the program began as the Department of Defense supported the NEA to expand the Shakespeare program to visit military bases and neighboring schools. It was the first time the National Endowment for the Arts had received funding from the Defense Department, and the first significant program that the Arts Endowment had ever offered to the millions of Americans in the military or their families. This surprising partnership signaled to the arts world, the press, and the general public that something new was happening at the agency.

Over the next four school years, Shakespeare in American Communities grew into the largest Shakespeare tour in history. Focusing increasingly on providing students with the opportunity to see a professional production of Shakespeare, the program eventually sponsored performances and tours by 77 theater companies, reaching more than 2,300 municipalities in all 50 states. The program also provided free education materials for teachers, including an audio CD and two award-winning films that featured Tom Hanks, William Shatner, Martin Sheen, Harold Bloom, Julie Taymor, Mel Gibson, and James Earl Jones, among other talented artists. By late 2008, the Shakespeare kits had been distributed to teachers and librarians across the country and reached more than 24 million students. In addition to its vast educational impact, the program gave 2,000 actors paying work performing classic theater—a great boon to professionals so often underemployed.

Through its vast reach and broad appeal the Shakespeare program soon became the Arts Endowment's signature initiative. Widely covered by the press, it signaled a

Aquila Theatre Company's production of *Othello,* starring Lloyd Notice and Kathryn Merry, kicked off the national tour of the NEA's Shakespeare in American Communities initiative in September 2003. (Photo by A. Vincent Scarano)

resolve at the NEA to bring the best of art and arts education to communities that had previously been overlooked. It also demonstrated a new concern for improving arts education in U.S. high schools. As more theater companies, actors, presenters, teachers, and students participated, the program developed a large constituency of supporters, including many members of Congress, who appreciated major theater companies visiting their districts. The Shakespeare program also represented a substantial new investment in American theater since the Arts Endowment was able to create this historical tour without cutting existing grant support for the theater field, continuing to support a huge variety of other projects including approximately 135 new works each year.

Operation Homecoming: Writing the Wartime Experience

As the events of 9/11 plunged the United States into a new era of geopolitics, the Arts Endowment leadership envisioned another, entirely new national initiative. In 2003, Connecticut Poet Laureate Marilyn Nelson and Chairman Gioia discussed a class on poetry Nelson had recently taught at the U.S. Military Academy at West Point. "The cadets had really eaten up the experience of writing and reading poetry," Nelson said. "Now some of them are e-mailing me from the war. I wish we could do something more—something tangible—for them."

The conversation became the seed of Operation Homecoming: Writing the Wartime Experience, which began in 2004. Under the direction of NEA Counselor to the Chairman Jon Parrish Peede, the Arts Endowment sponsored a series of writing workshops at military installations led by a group of distinguished and diverse writers, including Mark Bowden (*Black Hawk Down*), Tobias Wolff (*In Pharaoh's Army*), Jeff Shaara (*Gods and Generals*), Tom Clancy (*The Hunt for Red October*), Bobbie Ann Mason (*In Country*), Stephen Lang (*Beyond Glory*), and Joe Haldeman (*Forever War*). As with the Shakespeare program, the Department of Defense and the military services became valuable partners, and The Boeing Company agreed to support it.

The New Yorker from June 12, 2006, with excerpts from the Operation Homecoming anthology. (Image by Owen Smith/*The New Yorker* © 2006 The Condé Nast Publications)

The response to the program was massive. Phone calls, letters, faxes, and e-mails poured into the NEA as military personnel and their families asked to participate, some calling from Baghdad and Kabul. Vietnam War veterans also sent emotional letters of support, stating that they wished they had been offered a similar opportunity decades earlier.

During the next two years, teams of writers led workshops at 25 military bases in the U.S. and overseas for 6,000 service members and their spouses. Participation was so enthusiastic that the Arts Endowment decided to compile their best work in an anthology edited by Andrew Carroll. By the end, more than 12,000 pages of poems, memoirs, short stories, and letters were submitted by military personnel and their families and evaluated by an inde-

NEA Jazz Master Chico Hamilton performing at the 2005 NEA Jazz Masters awards ceremony and concert in Long Beach, California. (Photo by Vance Jacobs)

pendent editorial panel of writers. As Gioia assured in the preface to the volume, "The Arts Endowment gave the visiting writers total freedom in conducting their workshops. They were not told what to teach, and they in turn gave the participants complete freedom on how and what to write."

Essays written by service members and their families were published in *The New Yorker* in June 2006. In September 2006, the release of the anthology, *Operation Homecoming: Iraq, Afghanistan, and the Home Front, in the Words of U.S. Troops and Their Families,* published by Random House, was celebrated at the Library of Congress. The project also inspired two documentary films: *Muse of Fire,* directed by Lawrence Bridges, and *Operation Homecoming,* directed by Richard Robbins. *Muse of Fire* premiered at the National Archives in Washington, DC in March 2007. *Operation Homecoming* was broadcast on PBS in April 2007, eventually winning two Emmys in 2008, as well as becoming a finalist for a 2008 Academy Award.

NEA Jazz Masters Initiative

In 2004, Chairman Gioia took a small but venerable NEA program of fellowships to jazz musicians and expanded it to become the largest jazz program in the agency's history. Renamed the NEA Jazz Masters Initiative, it stood at the center of an ambitious effort to recognize the distinctive American musical form and expand the audience for jazz in the United States. Gioia increased the number of fellowship winners

and the dollar amount for the award. A category for "jazz advocate"—eventually named after A. B. Spellman—was added.

All components—including the NEA Jazz Masters on Tour, a series of presentations featuring performances, educational activities, and speaking engagements by NEA Jazz Masters in all 50 states—were united into the new initiative in partnership with Arts Midwest. With the expansion came NEA Jazz in the Schools, an educational program for high school teachers that combined a Web-based curriculum produced in partnership with Jazz at Lincoln Center. The Verizon Foundation provided early support for the school initiative, and the Verizon Corporation along with The Doris Duke Charitable Foundation donated funds to support NEA Jazz Masters on Tour. Meanwhile, the Arts Endowment worked with XM Satellite Radio to feature the NEA Jazz Masters on a daily radio segment across 13 news, talk, and music stations. Donating their radio time, XM broadcasted these popular jazz features as often as 120 times a day.

Mrs. Laura Bush speaking at the 2004 event announcing the American Masterpieces initiative. (Photo by Jim Saah)

American Masterpieces

In January 2004, First Lady Laura Bush made an historic appearance at the Old Post Office Pavilion. At a news conference there, she announced the Arts Endowment's new national initiative, American Masterpieces: Three Centuries of Artistic Genius, along with a Presidential request to Congress for an $18 million budget increase for FY 2005.

American Masterpieces brought exhibitions, concerts, dance performances, and broadcasts of great American art to large and small communities in all 50 states. Each grant was accompanied by an educational component that involved seminars, learning projects, and curricular materials, a feature that led Mrs. Bush to say, "I'm especially pleased at the program's focus on arts education, as it is crucial that the knowledge and appreciation of our cultural legacy begins in our schools. The Endowment would support touring, local presentations, and arts education in order to acquaint Americans, especially students with the best of the nation's artistic achievements." By the end of 2005,

Congress appropriated $10 million for American Masterpieces, and support was firmly in place for the Visual Arts Touring, Musical Theater, Dance, Choral Music, and Literature components of the program. The art forms were remixed slightly each year. In 2006 Choral Music was added to the program, and in 2008 the chamber music and presenting fields received funding.

American Masterpieces has sustained an enormous number of tours, exhibitions, and festivals. Over 50 dance grants were awarded in the first three years of the program enabling companies like Alvin Ailey, Martha Graham, Luna Negra, Pilobolus, Trisha Brown, and José Limón to tour the nation. Meanwhile, over the past four years, 47 visual arts exhibitions from institutions such as the Georgia O'Keeffe Museum, Phillips Collection, George Eastman House, American Folk Art Museum, and Olana Partnership toured 200 venues across 39 states.

The University of Michigan's University Dance Company perform Martha Graham's *Primitive Mysteries* as part of American Masterpieces. (Photo by Peter Smith Photography, courtesy of University Dance Company)

Research about Reading

Gioia placed great importance on careful research as a means to determine the public agenda for arts and arts education. In the early months of his chairmanship, the Arts Endowment's Office of Research and Analysis began to analyze the results of the latest *Survey of Public Participation in the Arts*. As with previous surveys administered in 1982 and 1992, the Arts Endowment designed the 2002 questionnaire in consultation with survey experts and arts professionals, then commissioned the U.S. Bureau of the Census to collect a sample and conduct the survey.

The 1992 Arts Participation survey had offered reasons for optimism, with access to the arts and audiences on the rise in most art forms. In 2002, however, the trends reversed, with audience participation in the arts going down. Broken down by age groups, the findings proved even more troubling. The youngest group (18 to 24-year-olds) showed the steepest declines of all in numerous art forms. The percentage of young adults who listen to jazz on radio dropped by 11 points, while young listeners of classical music dropped by nine points. A major problem had clearly emerged in the

American arts that would deeply influence NEA planning and programming—the decline of audiences in almost every art form, a decline steepest among the young.

One art form, however, underwent an especially daunting decline—literature. The rate of adults who read any fiction, poetry, or drama in the preceding 12 months—any imaginative writing of any length or quality in any medium—slid from 54 percent in 1992 to 46.7 percent in 2002. In addition, during this period, access to books and the arts expanded, with more libraries, museums, historic sites, performing arts spaces, and after-school programs in the United States every year. For literature, the portion of young adults who engaged in literary reading was 9.5 percentage points lower than ten years before—an astonishing drop in such a fundamental activity.

The reading declines called for further study, and Gioia commissioned an expanded analysis of the literary reading segment of the survey. The result was *Reading at Risk: A Survey of Literary Reading in America,* which turned out to be one of the most discussed and debated cultural stories of 2004. Created under then-Research Director Mark Bauerlein, *Reading at Risk* showed literary reading rates falling precipitously in every demographic group—all ages, incomes, education levels, races, regions, and genders. Librarians, publishers, editors, writers, and educators weighed in on what Gioia termed "a national crisis," and more than 600 stories and commentaries appeared in the first few weeks after its release. A serious national debate about the causes and extent of the reading decline had begun and would continue for years with the Arts Endowment taking the lead.

In 2007, the Arts Endowment's research division, headed by Sunil Iyengar, issued an influential follow-up study, *To Read or Not to Read: A Question of National Consequence.* The report compiled reading data from other government agencies, private foundations, and university research centers, all of which reached a consistent finding. This comprehensive report reinforced and expanded the earlier conclusions. All Americans, especially young people, read less and read less well, and these declines had serious educational, economic, and civic consequences. These reports have remained the definitive reference point for treatments of the field of literary culture and publishing in America.

Re-Investing in Reading: The Big Read

Gioia acknowledged that no single program or government agency by itself could reverse the decline in reading. As the leading arts agency in the United States, however, the Arts Endowment assumed the task of developing a national initiative to encourage literary reading.

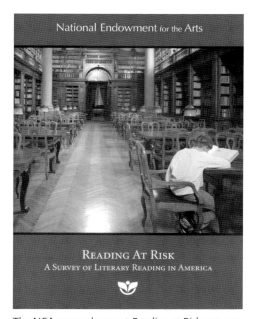

National Endowment for the Arts

READING AT RISK
A SURVEY OF LITERARY READING IN AMERICA

The NEA research report *Reading at Risk* was one
of the most discussed and debated cultural
stories of 2004.

On May 9, 2006, the agency unveiled a new program, The Big Read. Building on ideas from existing "City Reads" programs, the National Endowment for the Arts created a partnership of public, private, nonprofit, and corporate entities—Arts Midwest, the Institute for Museum and Library Services, The Boeing Company, and the W. K. Kellogg Foundation—to support and administer an ambitious national reading program. The Big Read offers citizens the opportunity to read and discuss a single book within their communities, as well as provides comprehensive resources for discussing the work, including readers guides, teachers guides, CDs, and publicity material as well as a national public service campaign and an extensive Web site with comprehensive information on authors and their works.

For a pilot program, the Arts Endowment selected ten municipalities from across the country to receive grants to conduct and promote four- to six-week community-based programs aimed at both teens and adults. From January through June 2006, these diverse communities—ranging from rural Enterprise, Oregon (population 1,895) to metropolitan Miami-Dade, Florida (population 3,900,000)—took part in the pilot phase. Each community created unique events, activities, and literary programs around one of four classic novels: *The Great Gatsby* by F. Scott Fitzgerald, *Their Eyes Were Watching God* by Zora Neale Hurston, *Fahrenheit 451* by Ray Bradbury, and *To Kill a Mockingbird* by Harper Lee.

To introduce public officials to the program, the NEA held a celebration of The Big Read on July 20, 2006, at the Library of Congress. Ray Bradbury participated vivaciously, greeting the capacity audience via a video recording. Members of Congress, including Senator Norm Coleman (R-MN), Representative Louise Slaughter (D-NY), and Representative Charles Taylor (R-NC) read passages from their favorite books. Mrs. Laura Bush, who enthusiastically joined The Big Read as its Honorary Chair,

remarked, "In ten cities and towns across the United States, thousands of Americans are being introduced—or reintroduced—to the joys of reading literature. They're learning how characters in our favorite stories become close friends that we can visit, just by reopening dog-eared volumes. They're discovering how we can escape to another world by losing ourselves in a good book—only to find truths about humanity that lead us right back to our own lives."

In its third year, The Big Read reached all 50 states as well as Puerto Rico and the District of Columbia. By 2009, more than 400 towns and cities will have hosted a Big Read program, with over 21,000 local and national organizations supporting the initiative. Indeed, The Big Read has become the largest federal literature program since the World War II Armed Services Editions project. Organizers choose from 27 books, ranging from classic novels such as Willa Cather's *My Ántonia* and Mark Twain's *The Adventures of Tom Sawyer* to contemporary works such as Tobias Wolff's *Old School* and Tim O'Brien's *The Things They Carried*. The Arts Endowment also helped produce a weekday show on XM Satellite Radio focusing on The Big Read books. Broadcast three times daily, each book was read in half-hour segments. (All of

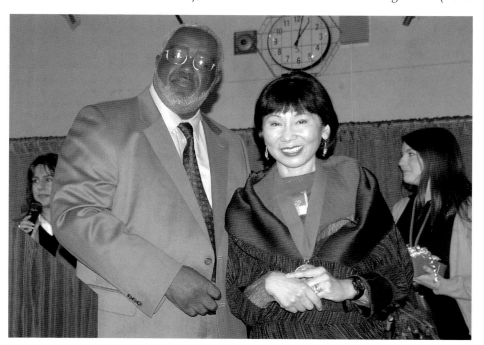

Fresno City College President Ned Doffoney with Amy Tan, author of *The Joy Luck Club*, at a Big Read book discussion in the Fresno, California. (Photo by Roberta Barton/Fresno County Public Library)

the broadcast time was donated by XM Radio.) Among the many celebrated figures who volunteered their time and talents were Robert Duvall, Ed Harris, Robert Redford, Ray Bradbury, Nadine Gordimer, Edward Albee, Alice Walker, and Sandra Day O'Connor. The Arts Endowment, with Lawrence Bridges, also developed special introductory films presenting interviews and commentary by the living authors of The Big Read.

In late 2007, the Arts Endowment added an international component to The Big Read that included exchange programs with Egypt, Russia, and Mexico. In Egypt, partnerships were created in Cairo and Alexandria to bring American novels to readers (including the first Arabic translation of *Fahrenheit 451*). Meanwhile, American audiences read *The Thief and the Dogs* by Egyptian Nobel Laureate Naguib Mahfouz. Russia featured *To Kill a Mockingbird* in

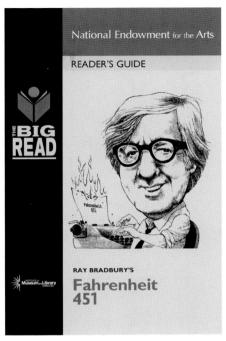

The Big Read Reader's Guide for Ray Bradbury's *Fahrenheit 451*.

the Ivanovo and Saratov regions while selected American cities read Leo Tolstoy's *The Death of Ivan Ilyich*. For the U.S./Mexico Big Read the NEA and the Fondo de Cultura Económica jointly produced an anthology of classic Mexican short stories, *Sun, Stone, and Shadows,* published in both Spanish and English editions to be read in both U.S. and Mexican cities. Each of these international titles became permanent selections for the U.S. Big Read.

CLEANING UP THE OLD POST OFFICE

Not all of Dana Gioia's initiatives were national. Some of them were downright homey and domestic. When Gioia visited the Old Post Office in November of 2002, he was surprised and dismayed by the Arts Endowment's cluttered corridors. The stately marble hallways had long served as storage for excess files, old books, office furniture, and an assortment of supplies and materials, for the agency was short on space. Although Gioia's own desk sets no high standard for neatness—always piled high with books, documents, journals, and CDs—he felt a need for the NEA public

spaces to portray the agency's accomplishments. Laurence Baden, deputy chairman for Management and Budget, gradually secured more office and storage space in the Old Post Office. This expansion not only improved working conditions; it also allowed staff that had been dispersed around the building to enjoy a common working space with their colleagues.

Today the corridors of the Old Post Office are clear of clutter. Those who visit the NEA enjoy viewing framed portraits of NEA Jazz Masters and stylish caricatures of American authors featured in The Big Read program. The staff also rescued its 1984 Oscar from storage to display as one more symbol of the agency's achievements. Portraits of former chairmen now greet visitors to the chairman's office, and striking paintings loaned by living American artists decorate the office walls.

THE CONVERSATION CHANGES

By January 2004, the public conversation about the Arts Endowment had changed markedly. Discussing the proposed budget increase, Roger Kimball, conservative intellectual and previous critic of the NEA, now found the Arts Endowment "a vibrant force for the preservation and transmission of artistic culture." Indeed, he added, "the NEA has become a clear-sighted, robust institution intent on bringing important art to the American people." Kimball's summary appeared in *National Review Online,* which had taken a different attitude toward the agency only a few years earlier. Meanwhile, veteran columnist William Safire of *The New York Times* likewise commended on the new programs, citing their bipartisan spirit. "The NEA has raised a banner of education and accessibility to which liberal and conservative can repair," he said. The *Wall Street Journal* joined in the praise, too. In response to the new NEA Jazz Masters initiative, Nat Hentoff wrote, "No one with government funds to dispense has done more to bring jazz to American audiences than Dana Gioia."

In a long piece in *The New York Times,* Bruce Weber wrote that the NEA under Chairman Gioia "has won the Congressional approbation that eluded his predecessors. And [Gioia] has done so without alienating artists, who tend to resist all restraints on their independence." Michael Slenske's 2,700-word profile of *Operation Homecoming,* published in 2005 in The *Boston Globe,* referred to the program as an "innovative" model that not only serves an important historical purpose, but "promises to be helpful" in the recovery of war veterans.

Growing public support for Arts Endowment programs extended to Capitol Hill.

Poetry Out Loud

One of Chairman Dana Gioia's national initiatives was an innovative partnership with the state arts agencies to create a national poetry recitation contest. Co-sponsored by the Poetry Foundation of Chicago, Poetry Out Loud revived the old-fashioned practice of memorizing and reciting poems combined with contemporary excitement of poetry slams. Students choose poems from an extensive library of selections and then compete in a series of contests—first in the classroom, then the school, followed by local, regional, state, and ultimately national meets. Performances are measured on elements such as accuracy, projection, interpretation, and understanding of the poem. Winners receive scholarships for college and cash awards for their school libraries.

Poetry Out Loud launched nationally in 2006 with more than 50,000 students participating. Teachers received materials including a poetry anthology, lesson plans, and an audio CD featuring writers and actors including James Earl Jones, Anthony Hopkins, Alyssa Milano, Richard Rodriguez, and Kay Ryan. State arts agencies organized the program in the high schools in each state capital area. In 2008, student enrollment in the program reached a quarter of a million. The competition garnered unprecedented media attention, including a front-page story in *USA Today,* an in-depth follow-up article in the *Washington Post,* and even as a clue in *The New York Times* crossword puzzle.

With more than 250,000 participants in

The first Poetry Out Loud National Champion in 2006, Jackson Hille, from Columbus Alternative High School in Ohio. (Photo by James Kegley)

2008, Poetry Out Loud continues to enjoy immense popularity and its national finals have been judged by luminaries such as *Writer's Almanac*'s Garrison Keillor, activist and anthologist Caroline Kennedy, memoirist Azar Nafisi, and poet Luis Rodriguez. As one teacher commented, "This was easily one of the greatest experiences of my teaching career. It was the level of intellectual confidence and enthusiasm that we as teachers usually only fantasize about."

In September 2004, Senator Jeff Sessions (R-AL), who had previously been highly critical of the NEA, wrote to the *Montgomery Advertiser* to praise the Shakespeare initiative. "In my view," he said, "these are the kinds of programs the National Endowment for the Arts should be sponsoring—taking the best of American art and culture and making it available, in this case, to our service men and women and their families. . . . I'm proud that the Alabama Shakespeare Festival was chosen to participate in the program." In floor debates in the House of Representatives on May 18, 2006, Rush Holt (D-NJ) argued that an increase in NEA funding "will build programs that use the strength of the arts and our nation's cultural life to enhance communities in every state and every county around America." One month later, Representative Jerrold Nadler (D-NY) told his colleagues, "Funding for the arts is one of the best investments our government makes. In purely economic terms, it generates a return that would make any Wall Street investor jealous."

Fortieth Anniversary

On March 10, 2005, when Chairman Gioia appeared before the House Appropriations Subcommittee on Interior, Environment, and Related Agencies, he summarized the situation of the Arts Endowment: "As the National Endowment for the Arts approaches the fortieth anniversary of its founding legislation, the agency enjoys a renewed sense of confidence in its public mission, reputation, and record of service." Chairman Gioia also noted that the "Arts Endowment now reaches both large and small communities as well as rural areas, inner cities, and military bases—successfully combining artistic excellence with public outreach."

At public events throughout 2005 and 2006, the 40-year history of the Arts Endowment was noted and celebrated. In September 2005, the Lyndon B. Johnson Library and Museum at the University of Texas at Austin convened a three-day conference to commemorate the signing of the legislation establishing the National Endowment for the Arts and the National Endowment for the Humanities. At panel discussions and receptions, the founding and evolution of the Arts Endowment were remembered. Among the many notable speakers was former Congressman John Brademas, who discussed the original legislation creating the Arts Endowment.

In November 2005, President and Mrs. Bush hosted a black-tie dinner at the White House to celebrate the fortieth anniversary of the NEA and NEH. Artists, scholars, and patrons attended, as did Lynda Bird Johnson Robb, daughter of President Johnson. President Bush paid tribute to NEA Chairman Gioia and the agency's "support

for music and dance, theater and the arts across our great country." The NEA, he said, "has helped improve public access to education in the arts, offered workshops in writing, and brought artistic masterpieces to underserved communities."

The capstone anniversary event was a symposium on arts and culture held at American University's striking, new Katzen Arts Center in May 2006. It was an educational symposium for graduate students and young professionals to learn about the Arts Endowment and the dramatic growth of the arts during the last 40 years.

Highlights of the two-day conference were the individual sessions convened by every discipline director to discuss the impact of the Arts Endowment on his or her field. Other events included a plenary session on international cultural exchange and a panel discussing public funding and private giving. Finally, graduate students from colleges and universities throughout the country presented papers on diverse topics relative to the arts in the public sector. The NEA's fortieth anniversary celebrations, including this symposium on arts and culture, provided ample opportunities for gleaning lessons from the past to shape the next 40 years.

GIOIA'S SECOND TERM

On December 9, 2006, Dana Gioia was unanimously confirmed by the U.S. Senate for his second term as NEA chairman. During his second term, Chairman Gioia expanded the international activities of the NEA. Under the leadership of Pennie Ojeda, the agency created literary exchanges with Russia, Pakistan, Egypt, Northern Ireland, and Mexico. The Arts Endowment also streamlined its grants process and simplified its application categories. In its fortieth year, the NEA staff handled more applications (a 30 percent increase from Fiscal Year 2000 to 2004) and more grants (a 12 percent increase in the same period) without an increase in staff. While operating on a reduced administrative budget, the Arts Endowment also managed the substantial workload of Challenge America grants in order to reach every congressional district consistently each year.

Gioia continued to spend considerable time refining and expanding national initiatives. Believing that consistency of support and excellence of execution were essential to their success, he urged the NEA staff to look for ways to improve the programs with each new grants cycle. Application procedures were adjusted, teaching materials updated, Web sites revised and redesigned, and partnerships expanded.

Gioia also observed that arts organizations benefitted from being able to repeat programs. A theater company whose first tour was challenging gained the necessary

experience to make subsequent tours go more smoothly. A school district modestly involved in one year's jazz, poetry, or Shakespeare programs would greatly expand its participation the next time around. In a second Big Read program, a municipality coordinated its many partners more easily than in its first effort. Consistent NEA investment not only sustained the specific initiatives; it also helped build the expertise, confidence, and credibility of all the organizations involved. As the number of partners involved in these initiatives reached into the thousands, the widespread impact of this long-term planning and support became visible.

Historic Budget Increase

Congress noted the NEA's progress with growing enthusiasm. In December of 2007, the NEA received a $20.1 million budget increase—the Arts Endowment's largest increase in 29 years. The NEA's $144.7 million budget for 2008 marked a 16 percent increase over 2007. This dramatic budget increase was not only a testament to Congress's confidence in Gioia's leadership, but a concrete example of the impact of the work of the NEA staff, including Senior Deputy Chairman Eileen Mason, Government Affairs Director Ann Guthrie Hingston, Communications Director Felicia Knight, and Congressional Liaison Shana Chase, in rebuilding the agency's relationship with Capitol Hill and the media.

The NEA also helped secure historical legislative changes in the Arts and Artifacts Indemnity Program of the Federal Council on the Arts and the Humanities. The new legislation authorized a substantial increase, with the international indemnity ceiling reaching $10 billion along with an additional $5 billion to support the creation of a domestic component to the program. In a period of skyrocketing art values and high insurance rates, it would be hard to exaggerate the importance of this legislation, which made major museum shows financially possible across the nation. As John E. Buchanan, Jr., director of museums with Fine Arts Museums of San Francisco noted, "It is one of the greatest things that the government can do for American art museums."

The same legislation also created the NEA Opera Honors, the first new class of federal arts awards in 26 years. Like the Arts Endowment's Jazz Masters awards, the NEA Opera Honors are lifetime achievement awards celebrating artists and advocates who have earned the highest distinction and made irreplaceable contributions to their field. The new program reflected Gioia's conviction that the U.S. government needed to do more to recognize and celebrate the contributions of its artists.

NEA Chairman Gioia (left) with Plácido Domingo, Washington National Opera general director, at the May 2008 announcement of the inaugural class of NEA Opera Honors, the first new NEA lifetime achievement award in 26 years. (Photo by Fadi Kheir)

The first NEA Opera Honors recipients were soprano Leontyne Price, conductor James Levine, composer Carlisle Floyd, and director Richard Gaddes. Administered by OPERA America, the awards were greeted with enormous enthusiasm by the American classical music world.

SERVING ALL AMERICANS

In September 2008, Gioia announced his intention to resign the following January—two years before the end of his term—to return to writing. "I have given up six years of my creative life," he remarked. "I want to return to poetry while I have the stamina and spirit to pursue the art seriously." This announcement caused regret on both sides of the aisle. Congressman Patrick Tiberi (R-OH) wrote that Gioia "had successfully worked across party lines to bring broad support and enthusiasm to the arts and arts education." Meanwhile Representative Betty McCollum (D-MN) praised Gioia's democratization of the Arts Endowment, which "brought the arts to many new communities and demonstrated to Congress how the NEA's work touches every corner of the country."

As he prepared to leave office in late 2008, Gioia received what he termed "the best farewell gift imaginable." American literary reading had risen for the first time in 26 years. After the universal declines charted in earlier NEA surveys, reading trends reversed among virtually every group measured. Best of all, young adults (age 18–24), who had shown the most drastic declines over the previous decades, now registered the largest increase of any group (+21 percent). Although the survey did not establish cause and effect, it seemed no coincidence that these young adults had been in high school when the NEA launched the national literary initiatives (Shakespeare in American Communities, Poetry Out Loud, and The Big Read) that had reached millions of teenagers during the previous six years. Likewise the NEA's influential reading surveys had helped ignite national concern about the decline of reading and its effects. While these new positive trends reflected the work of countless teachers, librarians, writers, and parents, the NEA had played a catalytic role—demonstrating that well-focused federal investment could make a difference in American society.

A Great Nation Deserves Great Art

OVER THE PAST FOUR DECADES, the National Endowment for the Arts has established itself as a unique institution in American culture. As the official arts agency of the U.S. government, supported by yearly appropriations from Congress, the NEA has not only become the nation's largest supporter of arts and arts education, but also, by its special position as the nexus between the public and private sectors, an irreplaceable institution. In addition to distributing thousands of grants each year, including critical funding to the state arts agencies, the Endowment also convenes panels that set standards of artistic quality, publishes research reports that guide informed discussions of cultural trends and policies, and creates institutional partnerships that now reach every community in the nation. The NEA's direct financial influence has been enormous. To date, it has awarded more than 126,000 grants totaling over four billion dollars, a sum that has generated matching funds many times larger than the initial investment. As a result, American culture has been enlivened, enlarged, and democratized.

Such impressive results were surely in the minds of the legislators who first called the agency into existence in 1965 at a moment of cultural optimism in which the government's vision of a great nation included a commensurably great artistic culture. Although these legislators might have been surprised by some of the subsequent debates involving the agency, they understood that the NEA represented a bold innovation in federal policy. How could such great innovation occur without incident? In retrospect, it seems inevitable that the growth of federal arts policy would involve debate, challenge, and change as the nation defined the new agency's proper role. Guided by nine chairmen with diverse outlooks and leadership styles,

the Arts Endowment has lived through an often turbulent period of cultural transformation. The agency has not merely survived these challenges; its work has been strengthened and clarified by them.

Today, the National Endowment for the Arts enjoys high regard for its commitment to bring the best of arts and arts education to all Americans. Supporting excellence in the arts—both new and traditional—across all of the disciplines, it fosters the nation's creativity and brings the transformative power of the imagination into millions of lives, reaching many who would have no easy access to the arts without government funding. Having created a new national consensus for federal support of the arts, with strong bipartisan support from Congress and wide public approval, the agency has moved decisively into a positive new era. As a new Administration arrives in Washington, led by President-elect Barack Obama, who has voiced his belief in the federal cultural agencies, the Arts Endowment seems poised for continued growth. Under future chairmen, the agency will surely pursue new ideas and opportunities, but one thing will remain constant, the Endowment's commitment to serve all Americans by bringing the arts into their lives, schools, and communities.

The IMPACT *of the* NEA

Dancer Fanny Elssler performing in *La Volière,* drawn on stone by M. Gauci from a drawing by J. Deffett Francis, printed by P. Gauci. (Lithograph courtesy of New York Public Library for the Performing Arts, Jerome Robbins Dance Division)

Dance

DOUGLAS C. SONNTAG
Dance Director

INTRODUCTION

The story of American dance and the federal government begins, appropriately enough, with a tale set in Washington. In 1840, at the same time that Ralph Waldo Emerson, Alexis de Tocqueville, and others were complaining about the lack of a national culture in the United States, one of the great ballerinas of the Romantic Era, Fanny Elssler, embarked upon a multi-city tour of the young republic. "I am about to cross the Atlantic and proceed to America!" she had written in her diary. "I cannot look upon this strange intention as other than a mad freak that has seized my fancy in a thoughtless moment. . . . My sober judgment could never have brought me to such a resolution."

Her fears proved unfounded. The performances she gave in New York, Philadelphia, Baltimore, and Richmond created a sensation. Crowds of fans packed the theaters every night to watch her dance, and lithographs showing her costumed for exotic solos sold in the thousands. In Washington, President Martin van Buren and his cabinet gave her an official audience. At a formal banquet in the Capitol, the nation's highest legislators toasted her health by drinking champagne from a satin dance slipper. What was to have been a three-month stay extended into two years of performances and travel. Fanny Elssler returned to Europe more celebrated than ever, dancing for several more years before retiring at age 41, still beautiful and quite wealthy.

Elssler's success, however, had no lasting impact on dance in America, and for another century the art and business of professional dance struggled to survive. There were no academies for training dancers and no state-supported companies to employ them. There were few professional choreographers and only tiny urban

audiences accustomed to the theatrical conventions of the elite European art form.

In the decades following Elssler's visit, concert dance was slow to develop. It was not until the beginning of the twentieth century that the first stirrings of an artistic awakening were detectable. Early pioneers of modern dance, including Loïe Fuller, Isadora Duncan, Ruth St. Denis, and Ted Shawn, planted the seeds that would bear fruit in subsequent decades. The second generation of modern dance choreographers included Martha Graham, Doris Humphrey, Helen Tamiris, Charles Weidman, Katherine Dunham, and Pearl Primus. These artists laid a foundation that would support a national dance movement.

Ballet was also beginning to evolve. Early tours by such companies as the Ballet Russe de Monte Carlo began the arduous task of building and educating audiences across the nation. In 1933, George Balanchine, a rising choreographic star who had left the Soviet Union to work in Europe, arrived in New York and expertly mined the considerable resources that would sustain American ballet through the century.

THE NEA ENTERS THE FIELD

When President Johnson signed the National Foundation on the Arts and the Humanities Act of 1965, a small and important collection of dance companies, artists, and presenting organizations comprised the American concert dance field. These included the Martha Graham Dance Company, Merce Cunningham Dance Company, the San Francisco Ballet, the New York City Ballet, the American Dance Festival, and Jacob's Pillow Dance Festival. Not one of them was more than 40 years old, and the audiences they attracted were passionate but drawn from only a few large cities. Nationally, the dance field itself seemed confined.

Nobody foresaw how much the field of dance would prosper in the coming four decades, or the catalytic role the Arts Endowment would play. The American dance field was artistically rich but lacked the resources to expand basic activities, such as increasing the number of performances, the number of dancers on contract, and their weeks of rehearsal and performance time. Arts Endowment support began to make it possible for dancers, choreographers, and administrators to work full-time on their craft.

From the start, the Arts Endowment fostered an intimate relationship with the dance field in all its elements. The NEA gave critical assistance to choreographers across the range of dance expression and helped build networks facilitating regional and national tours so that newly created work could reach audiences in all parts of the

Studio portrait of dancer/choreographer Martha Graham. (Photo by Chris Alexander)

country. The NEA also supported the development of regional ballet companies and dance-related educational tools for school children. Later, the NEA sponsored research studies on the state of the field. The Arts Endowment's national perspective allowed it to address the needs of the entire discipline and to respond broadly to changing conditions in the dance world. The agency's financial support helped ignite what many termed the "dance boom," a period of unequalled growth in American concert dance that lasted from the mid-1960s through the late-1980s.

EARLY ENDOWMENT SUPPORT FOR DANCE

The first panel convened by the Arts Endowment, in January 1966, was the dance panel. The first-ever NEA grant went to the American Ballet Theatre in December 1965, presented by Vice President Hubert Humphrey and amounting to $100,000,

an enormous sum at the time. In 1966, the Endowment awarded its first-ever individual fellowships, totaling $93,000, to choreographers Alvin Ailey, Merce Cunningham, Martha Graham, José Limón, Alwin Nikolais, Anna Sokolow, and Paul Taylor.

In the Arts Endowment's first two years, with the dance and theater disciplines under the supervision of Ruth Mayleas, dance grants totaled more than $750,000. These grants fostered the following accomplishments:

• American Ballet Theatre and the Martha Graham Dance Company went on national tours. For the Graham Company, and for choreography recipient Martha Graham, these grants were decisive not only in keeping the company in the United States (several other countries were inviting them to move out of the U.S. to more hospitable financial climes), but also in enabling thousands of Americans across the country to experience the work of this artistic genius.

• The Joffrey Ballet mounted new work and conducted a seven-week residency in the Pacific Northwest with Arts Endowment, Washington State Arts Commission, and local private funds.

• With a $5,000 technical assistance grant, the Association of American Dance Companies, predecessor to today's Dance/USA, was formed to serve and represent the entire field of American dance.

The Arts Endowment, in 1968, began a groundbreaking effort to support dance touring under then-Dance Program Director June Arey. With $25,000 of Arts Endowment money, matched many times over by state and local funds, the Illinois Arts Council sponsored four modern dance companies for residencies in six Illinois cities. In addition to performances, the companies conducted lecture demonstrations, seminars, master classes, and teacher institutes for several thousand people within a 50-mile radius of the host cities.

Following evaluation of this pilot effort, interstate circuits were developed in 1968 to support nine dance companies for residencies in Connecticut, Illinois, Indiana, Minnesota, Missouri, New Hampshire, New Jersey, North Carolina, Ohio, Rhode Island, Vermont, and Wisconsin. The program reached new audiences in communities of all sizes, identified new performance space for dance, and, importantly, provided employment for dance artists.

This Coordinated Residency Touring Program, as it was originally titled, grew year after year, adjusting to meet changing circumstances. The program embraced many more dance companies and communities coast to coast throughout the 1970s and into the early 1980s. New choreographers and dance companies sprang up, new

presenters welcomed them into their communities, and an art form heretofore enjoyed by relatively small numbers of people in few cities was finally available nationwide.

Concurrent with the Choreographer Fellowships and the Dance Touring Programs, which spurred creation of exciting new dance works and unprecedented growth in dance companies and audiences nationwide, the Dance Program panels began to focus on two additional areas of need and potential. One was the organizational development of the dance companies that were emerging in numerous communities. The other focus was the preservation of this most ephemeral of art forms, and about expanding its availability ever more broadly—both areas in which the innovative use of film, video, and television promised major advances.

Beginning in 1970 with a pilot program enabling three companies to secure development directors, NEA grants helped dance companies to employ professional managements, develop boards of directors, and engage in fundraising—all of these strategies aimed to place the companies on firmer footing in their communities.

DANCE JOURNALISM

Also in 1970 the Arts Endowment supported its first dance critics' workshop, an intensive three-week training program for journalists from across the country, held at the American Dance Festival (then at Connecticut College). The NEA understood that healthy dance companies would require informed criticism, and few journalists were familiar with dance in the agency's earliest years.

Since 2004, the Arts Endowment has revived its support for arts journalism and criticism. The NEA Arts Journalism Institutes bring together journalists and critics from across the country to hone their skills in classical music and opera at Columbia University, theater and musical theater at the University of Southern California, and dance at the American Dance Festival, now at Duke University in Durham, North Carolina.

DANCE AND MEDIA ARTS

In follow-up to a study commissioned by the Arts Endowment in 1968, the Dance/Video Program supported projects that captured dance on film or videotape to document and preserve dance performances. Around the same time, seizing the opportunities presented by television to reach millions of Americans with its superb

dance companies and artists, the Dance Program joined with the Media Arts Program in 1972 to create the Programming in the Arts category. The NEA invested in projects to improve the quality of arts programming on film, television, and radio. Choreographer Meredith Monk and filmmakers Amram Nowak and Robert Rosen received a grant for a work fusing film and dance. Grants to the Educational Broadcasting Corporation (WNET-TV) helped to support the series *Dance in America*. KCET-TV in Los Angeles produced a television special, *Conversations about the Dance*, featuring choreographer Agnes de Mille and the Joffrey Ballet.

RESEARCH AND ANALYSIS

The Arts Endowment understood that to help dance assume a prominent place in American life required more than distributing money to existing organizations and dance professionals. The field needed to collect and analyze information in order to find better ways of understanding the obstacles to success. Prior to 1965, dance existed with almost no sense of itself as a recognized cultural force, and participants had no venue in which to elevate their local concerns into a national conversation. The very existence of the Arts Endowment marked a significant step forward in the field's consolidation. It was, in effect, a de facto national service organization, a central source of communication for all interested parties.

The agency convened panels made up of dance professionals from large and small organizations across the country to review applications and discuss challenges and priorities within the discipline. The ensuing discussions made the panels into veritable think tanks that identified areas of concern and formulated ideas and policies to address them.

The Arts Endowment extended its data collection with several research reports starting in 1984 that supplied dance practitioners with crucial data about the discipline and its needs. These included the following studies:

• *Space for Dance* (1984), a collaboration between the Arts Endowment's Dance and Design Arts Programs, developed under Dance Program Director Nigel Redden. The study provided a detailed description of what architects need to consider in designing theaters and stages to accommodate the needs of dancers.

• *Dancemakers* (1993) summarized the results of the Arts Endowment's study of the general working conditions, financial status, performance opportunities, funding, and work practices of choreographers in New York, Chicago, San Francisco, and Washington, DC. The study provided benchmark statistics on a sample of the nation-

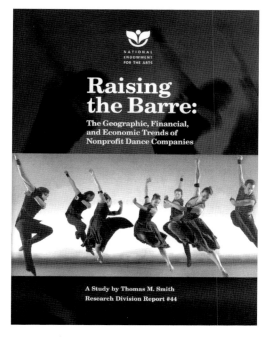

al choreographer population and documented the often difficult circumstances in which these artists work.

• *Raising the Barre: The Geographic, Financial, and Economic Trends of Nonprofit Dance Companies* (2003) was commissioned as part of the agency's ongoing efforts to conduct and disseminate research findings. The study drew on three databases: The Unified Database of Arts Organizations (UDAO), a newly available database produced jointly by the NEA, the National Center for Charitable Statistics as part of the Urban Institute, and the National Assembly of State Arts Agencies; the economic census, the census of business establishments conducted every five years by the U.S. Census Bureau; and a database of dance company applicants, produced and maintained by the NEA Dance Program staff.

These projects were among the first comprehensive and statistically valid studies to look at the lives, working conditions, and finances of individual dance professionals and of the American nonprofit dance world.

ACROSS THE NATION

From its many applications and requests for support as well as scores of panels convened annually, the Arts Endowment quickly identified the difficulty dance faced in trying to extend beyond a few major cities in the United States. Outside of the largest metropolitan areas, there were very few resident dance companies and few theaters that were appropriate for concert dance presentations.

The problem was reflected in the fact that during its first five years of grant-making, the Arts Endowment awarded direct funding to dance organizations and professionals in only 13 states and the District of Columbia: California, Connecticut, Georgia, Kansas, Massachusetts, New Jersey, New York, North Carolina, Ohio, Pennsylvania, Rhode Island, Utah, and Washington. Other dance grants were awarded to

state arts agencies to support dance activity, but not directly to dance companies, choreographers, and presenters.

With touring crucial to the health of the dance field, both artistically and financially, as well as essential to the distribution of dance outside New York and other centers, the NEA focused much of its efforts on traveling dance productions. As time passed and dance touring grew more sophisticated, the Arts Endowment created an elegant system of support for dance companies to bring that work to audiences, and grants to emerging choreographers to hone their craft.

Forty years later, in 2004–2005, Arts Endowment dance grants reached 47 states as well as the District of Columbia, Puerto Rico, and the U.S. Virgin Islands. The spread of dance beyond the traditional cultural centers of the United States is one of the most important legacies of the agency, and to accomplish it, the Arts Endowment engaged in some creative forms of support.

Outreach

The Endowment supports all arts fields, including dance, in a comprehensive way, as shown by the following examples of past and current activity:

• The Challenge Grants program, started in 1976, gave dance companies the ability to retire debt, create cash reserves, and build endowments. Early Challenge Grants aimed at ensuring financial stability were awarded to Ballet West in Salt Lake City, the Houston Ballet, the Joffrey Ballet, the Martha Graham Dance Company, the Alvin Ailey American Dance Theatre, and the New York City Ballet. Later Challenge Grants also supported artistic projects including the Kennedy Center's commissioning project for new ballets, which resulted in the Houston Ballet's world premiere of Paul Taylor's *Company B* set to the music of the Andrews Sisters. Challenge Grants have also been awarded to document and preserve choreography for the Paul Taylor Dance Company and the Alvin Ailey American Dance Theatre.

• Folk Arts grants as well as NEA National Heritage Fellowships support traditional and ethnically based dance organizations and recognize important artists working in social and vernacular dance styles such as Lindy Hop dancer extraordinaire Frankie Manning and tap dance great Jimmy Slyde.

• During the first decades, NEA's Expansion Arts Program grants supported artists and organizations working in culturally specific traditions and helped underserved communities and populations gain access to the arts. Ballet Hispanico and Dance Theatre of Harlem in New York City and the Cleo Parker Robinson Dance Company

in Denver, Colorado, were early recipients of grants from this program, enabling them to grow artistically and administratively.

• Arts Education grants sent dance specialists and dance companies into schools for direct interaction with students.

• Media Arts grants gave national exposure to the arts through support to *Dance in America* and specials such as Twyla Tharp's *Making Television Dance* and *Alvin Ailey: Memories and Visions*.

Another key component to the success of dance is found in the consumer side: audience development. The Arts Endowment has acted determinedly to create literate and informed patrons by making dance visible and engaging. One of the most effective methods has been national broadcasts of dance performances through support of such renowned series as *Great Performances: Dance in America, Live from Lincoln Center, Alive from Off Center,* and *Alive TV.* Grants also supported the production of *Dancing,* a ten-part series that explores the artistic, social, religious, and cultural history of the form, for which former NEA Dance Program Director Rhoda Grauer served as executive producer.

PRESERVATION

1999 NEA National Heritage Fellow James "Jimmy Slyde" Godbolt received the award for his tap-dancing prowess. (Photo courtesy of International Tap Association Archives)

Celebrating its thirtieth season in 2006, *Dance in America* has become an invaluable archival record of our nation's greatest choreographers and performers, documenting an ephemeral art for a field that has in the past had little access to its own history. The preservation of dance heritage has, in fact, been an ongoing concern of the agency from its earliest days. As noted above, from the 1960s to the 1980s, America experienced a "dance boom" that brought the classical traditions of Europe together with the mix of races and ethnicities to forge new and exciting expressions. The choreography of George Balanchine at the New York City Ballet, the Americana ballets of Jerome Robbins and Agnes de Mille, the piercing psychological dramas of Martha

Choreographer George Balanchine (left) with Stephanie Saland rehearsing *Apollo*. (Photo by Paul Kolnik, courtesy of New York City Ballet)

Graham, as well as the performance experimentation of Merce Cunningham and Trisha Brown—all enacted an American century in dance, and the Arts Endowment was honored to be one of its stewards.

In the late 1980s, however, the boom began to wane, and the dances of earlier artists became ever more remote and faint. Audiences no longer had ready access to the pioneering dances of Doris Humphrey, Charles Weidman, Helen Tamiris, Ted Shawn, and Ruth St. Denis. Moreover, dozens of other choreographers who had assembled companies in the early years of the dance boom saw their works fade from active performance as they disbanded those companies. It was impossible to ignore the obvious. Our dance heritage was fading at an alarming rate.

In 1990, the Arts Endowment took a proactive stance under the leadership of Dance Program Director Sali Ann Kriegsman. Partnering with the Andrew W. Mellon Foundation, the NEA commissioned *Images of American Dance,* a study of dance documentation and archival resources in six American cities (Los Angeles, Min-

neapolis, New York City, Salt Lake City, San Francisco, and Washington, DC). The conclusions of the study were stark and depressing. Little thought and few resources were being devoted to record and preserve existing dance.

Images of American Dance was directly responsible for the creation of the Dance Heritage Coalition, whose original members included the Library of Congress, the New York Public Library for the Performing Arts Dance Collection, the Harvard Theater Collection, Jacob's Pillow Dance Festival, and the San Francisco Performing Arts Library and Museum. The Dance Heritage Coalition's first task was to develop standards for cataloguing dance materials in libraries to ensure that dance-related collections were accessible to scholars, students, and the public. In addition, the coalition has published reports on the magnetic media crisis, which directly affects dance companies with extensive videotape libraries. The coalition also produced pamphlets that provide guidance on how to approach preserving and transferring deteriorating tapes, as well as establishing a working archive.

The Arts Endowment complements the work of the Dance Heritage Coalition with two more preservation programs, Save America's Treasures and American Masterpieces. Since 1999, through Save America's Treasures, the NEA has provided grants to notate dances by Agnes de Mille, Martha Graham, and Jerome Robbins, and has helped support critical work in the company archives of the New York City Ballet. It also enabled the Dance Heritage Coalition to provide technical assistance to dance archives in Arizona, Hawaii, Illinois, and New York.

American Masterpieces, an initiative inaugurated in 2005, allows the Arts Endowment to continue its support for the reconstruction, performance, and preservation of the endangered dance heritage. For instance, as the American dance field has matured since the heady days of the dance boom, and many of those early companies led by a single choreographer ceased operations, the phenomenon of choreography with no home (a so-called "orphan repertory") has become a pressing issue. The dance component of American Masterpieces is designed to help orphaned dances find homes and remain on the stage, introducing dancers and new audiences to outstanding choreography they might not otherwise see performed.

PARTNERSHIPS

As a national leader of the dance field, from its earliest years the NEA assumed as one of its primary functions the forming of critical partnerships to enhance the development and distribution of dance nationally. Dance/USA has been one of the

most important partners since its creation in 1982. Over the years, the Arts Endowment and Dance/USA, currently led by Executive Director Andrea Snyder, have worked together on numerous projects of major importance to the field. Dance/USA has administered the National College Choreography Initiative, which has made awards to college and university dance programs in all 50 states for the creation of new works and restaging of masterworks from the past. Dance/USA is also a partner with the Arts Endowment and the New England Foundation for the Arts on the development and administration of the college and university component of American Masterpieces, though 2008 marks the transition to an entirely NEA-administered university program.

The National Dance Project, administered by the New England Foundation for the Arts under former Executive Director Sam Miller and now helmed by Rebecca Blunk, supports the creation of dance and its delivery, through touring, to audiences across the country. As of 2006, the Arts Endowment's initial investment of $1 million in 1995 has yielded more than $20 million in matching funds to support dance touring.

CONCLUSION

One of the major artistic accomplishments of the United States in the twentieth century was the development of dance, especially modern dance. Many of the world's great choreographers—either native born or immigrant—transformed dance in America and worldwide.

The cumulative impact of NEA awards in dance was both immediate and long lasting, and they transformed the place of dance in American culture. Solely in terms of financial support, the funding is unparalleled. For more than 40 years, the Arts Endowment awarded more than $300 million directly to dance companies, choreographers, presenters, festivals, historians, critics, workshops, and service organizations. Grants supported the commission of new works, restaging of ballets, home seasons, touring, dance presenting series, dance film and video projects, and fellowships. By the time the Choreographer's Fellowship category concluded by Congressional mandate in 1996, the Arts Endowment had given $13.6 million in 1,500 grants.

Professional dance companies, as counted by the NEA, grew from 37 in 1965 to 157 in 1975. By 1990, this figure stood above 400, and in 2008, the number of American dance companies exceeds 600. What were once fledgling dance companies

have grown into flagship cultural institutions. Dance artists, companies, and presenters are now part of the landscape in all 50 states, and the resources and leadership of the Arts Endowment have played no small role in their advance.

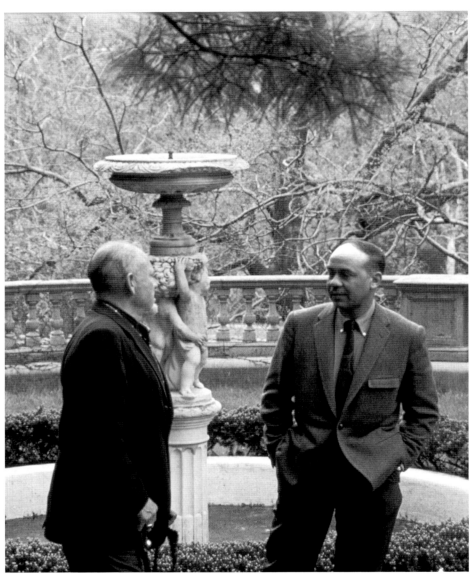

John Steinbeck and Ralph Ellison at one of the first National Council on the Arts meetings in Tarrytown, New York. (Photo by R. Philip Hanes, Jr.)

Literature

JON PARRISH PEEDE
Literature Director, Grants Programs

AMY STOLLS
Literature Program Officer, Grants Programs

INTRODUCTION

When the first NEA literature grants were awarded in 1967 to 23 writers and nine organizations, the literary ecosystem was undergoing significant change. Over the next several decades, authors of commercial bestsellers increasingly displaced their literary peers from the bookstore shelves and the public eye. To the good fortune of writers, and to the benefit of American literary culture as a whole, the NEA dedicated resources and funds to poets and fiction writers whose works might not survive in this new mass media climate despite their long-term contribution to the nation's literary life. Time and again, the Arts Endowment assisted writers at crucial moments in their careers, as well as nonprofit publishers, by building supportive networks that proved essential.

NEA FELLOWSHIPS

The NEA Literature Fellowships program is arguably the most democratic grant program in its field. The $25,000 fellowships are highly competitive, but unlike most other literary awards, they are selected through an anonymous screening process in which the only criteria for review are artistic excellence and artistic merit. The NEA assembles a different panel of judges every year, each diverse with regard to geogra-

phy, ethnicity, gender, age, aesthetics, and life experience.

The Arts Endowment has had an outstanding track record of nurturing talented writers early in their careers. As of 2008, 52 of the 84 recipients of the National Book Award, the National Book Critics Circle Award, and the Pulitzer Prize in Poetry and Fiction since 1990 were previous NEA Fellows. Furthermore, all but three received NEA Fellowships before any other major national award, usually at least a decade earlier. If one scans the list of 2,876 writers and translators who have received NEA Literature Fellowships, a full and varied landscape of the best contemporary American literature comes into view.

NEA Literature awards began in May 1966, after the NEA and its advisory board—the National Council on the Arts—were established. Council members Ralph Ellison and Paul Engle proposed the development of a program to provide grants to creative writers. While the Arts Endowment awarded individual grants to all types of artists in 1966—Donald Justice, X. J. Kennedy, Leonie Adams, and W. D. Snodgrass among them—a formal program to support creative writers did not begin until 1967 with grants to such writers as William Gaddis, Tillie Olsen, Gracy Paley, May Sarton, Richard Yates, and Isaac Bashevis Singer. With his grant money, Singer was able to focus on completing his novel *The Manor;* 11 years later, he received the Nobel Prize for Literature. Similarly, numerous poets well-known today—Hayden Carruth, Maxine Kumin, and Robert Duncan—were awarded NEA grants that year at a time when their national literary reputations were still developing.

To facilitate the new program, the Arts Endowment appointed poet Carolyn Kizer in 1968 as the first NEA Literature director. From that time to today, the Literature Program has been committed to supporting the individual writer. For the first six years of the program, there were several variations of such support. One important focus was supporting emerging writers. Another one gave grants to help writers and other artists teaching in institutions of higher learning take one-year sabbaticals to pursue their creative work. And the agency awarded grants for travel, research, or finishing a work-in-progress.

The issue of whether to fund established writers for their accomplishments or help younger writers find time and resources to write was at the forefront of internal and external debates in the early days of the program. For several decades, the Arts Endowment gave lifetime achievement awards designed to attract national attention to writers of significant accomplishment, writers such as John Berryman, Denise Levertov, Wallace Stegner, and Gwendolyn Brooks. In the late 1960s, these awards

were called Distinguished Service Awards, worth $10,000; in the 1980s, they were called Senior Fellowships, worth $15,000 at the start, climbing to $40,000 in 1986. These awards were eliminated in 1992 due to shifting priorities and lack of funds. They never garnered enthusiastic support from Congress, and even in the arts community one could hear rumblings about "aesthetic partisanship."

In tandem with its support of established writers, the Arts Endowment initially decided to offer Discovery Awards to emerging writers. The agency hired "talent scouts" to find gifted, financially needy, little-known writers. Grants were awarded according to need: $1,000 to the single writer without dependents; $1,500 to the writer with one dependent; and $2,000 to the writer with two or more dependents. Among these recipients were the 25-year-old Alexander Theroux and the 26-year-old Nikki Giovanni. But the Discovery Awards didn't last long. The original advisory panel on literature, consisting mostly of editors and publishers, held its first meeting in September 1970 and recommended these awards be terminated. Members voted almost unanimously in opposition to the addition of economic need as a determining factor in making grant selections. In 1972, the Arts Endowment began the precursor to the current system—a competitive fellowships program based on artistic merit.

To receive a fellowship in the early 1970s, a writer had to be nominated by an established writer. An oversight committee composed of a broad spectrum of publishers, editors, agents, critics, and other experts in the field from around the country selected the nominators—among them James Dickey, Eudora Welty, Kenneth Koch, Adrienne Rich, and William Stafford. The nominators recommended potential grantees who had published a book; published short stories, poems, or essays in magazines; or had a play staged. The first year, the NEA Literature Fellowship program announced 27 awards.

Soon after, though, the system of nominations was replaced with an open application policy. In 1974, under Literature Director Len Randolph, the NEA Literature office received a whopping 1,500-plus applications, of which 120 were awarded grants at $5,000 each. The number of submissions escalated to nearly 2,500 the next year. Reflective of the time, most applications were from men, and more than half were from poets. By the mid-1980s, applicants would come to represent American writers living in all 50 states and Washington, DC, and women would make up a significant portion of grantees. Numerous American literary classics—such as Bobbie Ann Mason's first novel, *In Country,* and Sandra Cisneros's first novel, *The House on Mango Street*—were written under NEA Fellowships, as was Erica Jong's then-controversial

Fear of Flying. In more recent years, fellowships have been awarded to novelists such as Jeffrey Eugenides, David Foster Wallace, and Lorrie Moore; and to poets such as Mary Karr, Li-Young Lee, Kay Ryan, and Natasha Trethewey. What hasn't changed significantly over the decades is the percentage of applicants who are chosen to receive grants. On average, it remains less than 5 percent.

The Arts Endowment periodically has tweaked the fellowships process to meet the demands of the times and the ever-increasing workload. To adjust for cost of living, the amount of the grant has incrementally risen over the years. Film and television scriptwriters were transferred to the Arts Endowment's Media Arts Program, and playwrights were sent to the Theater Program. The NEA amended guidelines to accept manu-

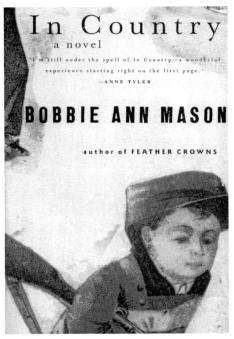

Bobbie Ann Mason's first novel, *In Country*, written with assistance from an NEA Literature Fellowship. (Cover courtesy of Viking Penguin)

scripts in languages other than English if they came with an English translation. Eligibility requirements became more stringent to address the growing number of applications. "Belles-lettres" was added as a genre eligible for funding and then changed to "creative nonfiction." And when Congress significantly reduced the budget in fiscal year 1996, the Arts Endowment moved to judging genres in alternate years (prose one year, poetry another).

Perhaps the most successful outgrowth of the 1980s was the development of a process to review fellowships in translation, which flourished under the leadership of then Literature Director Frank Conroy. Inaugurated in 1981, Translation Fellowships in poetry and prose are currently offered to published literary translators for specific translation projects from other languages into English. Unlike other NEA Literature Fellowships, the Translation Fellowships are not reviewed anonymously, and they can be for either $12,500 or $25,000, depending on the scope and merit of the project. To date, the Arts Endowment has awarded 274 Translation Fellowships, bringing to the American public more than 225 foreign works in 50 languages from

63 countries. Among them one can find FY 1999 Fellow Khaled Mattawa's translation of *Without an Alphabet, Without a Face* by Saadi Youssef, one of the Arab world's foremost contemporary poets and an astute observer of modern Iraqi culture; and FY 1992 Fellow Howard Goldblatt's translation of *Red Sorghum* by Chinese author Mo Yan, which received publicity through the critically acclaimed 1989 film by the same name.

Throughout the life of the Creative Writing and Translation Fellowships programs, however, critics have questioned their worth or, in some cases, lobbied for their demise. A larger threat to the program, and to the agency as a whole, came in 1995 when measures were introduced in the U.S. Congress to phase out the Arts Endowment or, at the very least, slash the budget and abolish all grants to individual artists. The literature field, in pure grassroots fashion, rose up in protest to the cuts. "People all across America came together to prioritize the fellowships," said Gigi Bradford, NEA Literature director from 1992 to 1997. Hundreds of writers published opinion pieces and wrote letters. Literary organization leaders held meetings every month and brought writers such as E. L. Doctorow, Wendy Wasserstein, Bobbie Ann Mason, and Walter Mosley to Capitol Hill to meet with Congressmen and Senators. Ultimately, Congress voted to eliminate individual grants awarded by application in all disciplines, except for Literature Fellowships in poetry, fiction, creative nonfiction, and translation.

The Congressional decision to continue the Literature Fellowships affirmed the integrity of the anonymous panel review process and the undeniable excellence of the fellowship recipients. "The committee recognizes that a great many of the grants to individuals have been for projects of superior merit and worth," states a 1995 majority report on the Arts, Humanities, and Museums Amendments from the Senate Labor and Human Resources Committee.

GRANTS TO LITERARY ORGANIZATIONS

The Literature Fellowships have always been the cornerstone of the NEA's support for literature, with more than a third of Literature's funds allocated toward helping writers find the time and resources to write. But from the beginning, an equally essential goal for the NEA—a goal that continues today—is to help build an infrastructure that can support American writers, connect writers with communities nationwide, and preserve excellent writing for future generations. Put simply, to build a nation of discriminating readers.

Author Toni Morrison (left) served the NEA both as a Literature Program panelist and as a member of the National Council on the Arts (1980–87). (NEA File Photo)

Under the guidance of early advisory panels, which were then consciously composed of such luminaries as Edward Albee, Toni Morrison, William Stafford, and William Styron, the NEA set out to achieve this goal. The Arts Endowment began by reaching out to small literary journals and presses; boosting the number of readings and residencies in schools, prisons, hospitals, and other venues nationwide, including book festivals in rural and inner-city pockets of the country; and supporting organizations that provide professional services to creative writers. This long-standing commitment to audience development has been particularly important in ensuring that a national literary culture thrives.

Journals and Presses

It is in the small literary magazines and presses that the writing of those whom we have come to regard as masters often first appears—writers such as Ernest Hemingway, William Carlos Williams, Wallace Stevens, T. S. Eliot, and Ezra Pound. Historically, however, these small presses have had difficulties competing with their commercial counterparts, particularly in the areas of marketing, promotion, and distribution. In

the 1970s, the NEA began giving direct grants to select publishers and journals such as *AGNI*, Alice James Books, BOA Editions, *Callaloo*, Copper Canyon Press, Curbstone Press, Feminist Press, and *Ploughshares*. At the same time, the NEA launched several projects to help distribute journals—"book buses," for example, and a special sales effort aimed at university and college bookstores.

The NEA also provided indirect support to journals through a founding grant to the Coordinating Council of Literary Magazines (CCLM), the precursor to the current-day Council of Literary Magazines and Presses (CLMP). Established as an NEA initiative in 1966, the CCLM provided funds for author payments, design, production, and marketing; support originally went to such publications as *The Hudson Review, The Kenyon Review, Poetry Magazine, The Southern Review,* and *TriQuarterly.* The NEA has continued funding of CLMP, with support such as a 1998 grant to implement the Literary Journal Institute, a national program designed to increase income for small- to mid-size literary magazines.

The resulting success stories from these grants are numerous. In 1980, for example, the NEA awarded a $3,500 grant to the Louisiana State University Press (LSU Press) to publish John Kennedy Toole's *A Confederacy of Dunces.* The novel had been rejected by dozens of commercial publishers as a bad risk because the deceased author could not publicize the book or write another. In the first year, LSU Press sold more than 50,000 copies, and Toole was awarded the 1981 Pulitzer Prize for Fiction posthumously.

In 1992, Arte Público Press in Houston, the premier publisher of Hispanic literature in North America, acquired rights to Victor Villasenor's *Rain of Gold,* after a major commercial publisher wanted to excise content deemed too ethnic for American readers. In Arte Público's hands, the acclaimed saga of the Villasenor family sold nearly 20,000 hardcover copies, was picked up by the Literary Guild Book Club, had paperback rights awarded in the U.S. and in several foreign countries, and garnered numerous awards.

Other publishing projects supported by the NEA Literature Program include the Syndicated Fiction Project (1983–93), in which a panel of distinguished writers selected previously unpublished short stories to be printed in newspapers throughout the country, and the Favorite Poem Project. Established in 1998 with support from the NEA and the Library of Congress, the Favorite Poem Project was the brainchild of U.S. Poet Laureate Robert Pinsky and resulted in more than 1,000 community readings of favorite poems across the country, including a reading at the White House by President and Mrs. Clinton, Rita Dove, Robert Hass, and Pinsky.

As important as publishers are in getting writing into the hands of readers, NEA literature panels have always understood that contact with the writers themselves can expand audiences even further by enhancing a reader's appreciation of a writer's work. Likewise, public readings and workshops provide another way active writers can receive financial help.

In addition to providing direct grants to organizations for readings and residencies, the NEA sent poets into predominantly black colleges in the South in the 1970s; launched Literature of the States in 1991 to stimulate the discovery and preservation of every city's literary heritage; and sponsored the National Writers Voice Project of the YMCA in 1995, which promoted literary programming for children at Ys throughout rural and inner-city America.

Particularly important to the NEA Literature Program over the years has been its ability to reach children. Two of the most successful programs the NEA funded in this category are Poets in the Schools, through the Academy of American Poets, and WritersCorp. Established in 1966 and continuing for more than a decade, Poetry in the Schools placed well-known poets in elementary and secondary school classrooms to discuss their poetry with students and instruct teachers on how to incorporate poetry into their curricula. Piloted in New York City, Detroit, and Pittsburgh, the first program featured Denise Levertov, Robert Lowell, Howard Nemerov, Allen Tate, and Robert Penn Warren, among others. President Nixon recognized the program's worth in 1969 when he called upon Congress to double the appropriations for the Arts and Humanities Endowments. WritersCorp, a community-oriented complement to Poets in the Schools, evolved many years later. Founded in 1994 with NEA funding, WritersCorp was born out of conversations between former NEA Chairman Jane Alexander and Eli Siegel, director of AmeriCorps. They wanted a program that enabled writers to help underserved youth improve their literacy and communication skills and offer creative expression as an alternative to violence, alcohol, and drug abuse. WritersCorp, now separate from the NEA, continues to reach thousands of at-risk youth in San Francisco, the Bronx, and Washington, DC.

SERVICES TO THE FIELD

In 1966, the NEA gave a grant to enable the American chapter of PEN International to host the 34th International PEN Congress in New York City. It was the first time

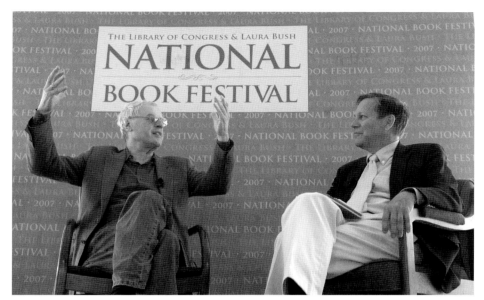

U.S. Poet Laureate (and two-time NEA Literature Fellow) Charles Simic interviewed by NEA Chairman Gioia at the National Book Festival in Washington, DC, 2007. (Photo by Tom Roster)

that the congress was held in the U.S.; more than 800 writers from all around the world discussed, debated, and exchanged ideas on writing. By 1968, NEA funds enabled the American chapter to establish a permanent headquarters and provide advisory services to translators.

Other grants to service organizations followed in the early 1970s to such organizations as Poets and Writers, Teachers and Writers Collaborative, and Associated Writing Programs (AWP), known today as the Association of Writers and Writing Programs. Founded in 1967 to serve a handful of Master of Fine Arts programs in creative writing, AWP now serves more than 28,000 writers at more than 400 colleges and universities.

"What motivates us is a commitment to literature," wrote former Literature Director David Wilk in 1980. "What excites us is the sheer quantity and breadth of current work. What challenges us is the complexity of the scene, the fact of change, and the difficulty of assessing the variety of new voices. What encourages us is our vision of what literature has always meant, and continues to mean, to human beings individually and to society as a whole."

Poet Marilyn Nelson discussing writing with a participant of the Operation Homecoming workshop at Norfolk Naval Station, Virginia, in 2004. (NEA File Photo)

THE PROGRAM IN 2008

Celebrating the discipline from which he emerged, Chairman Dana Gioia has increased the allocation for support to writers, raising the amount of fellowship awards from $20,000 to $25,000. Gioia also supported a policy shift in FY 2005, initiated by Literature Director Cliff Becker, to separate the review process for fellowships in translation from those in creative writing in order to highlight the importance of translation as its own art form. "The American arts are most vibrant when they include the best works of art from other nations," stated Gioia. "Through our commitment to funding translation, the NEA has been an essential catalyst for bringing the world's literature to our country." In addition to direct support to translators and translation publishers, in 2004 the agency committed to funding the publication of contemporary poetry or fiction anthologies—usually in a bilingual format—with numerous countries, including Mexico, Russia, Northern Ireland, and Pakistan, as well as literary publishing initiatives with Egypt, Spain, and Greece.

The same year that the NEA launched this series of international literary anthologies, the agency also created a program to give voice to another often forgotten population: those at war. The NEA created Operation Homecoming to help U.S.

troops and their families write about their wartime experiences. Through this program, some of America's most distinguished writers—such as Tobias Wolff, Richard Bausch, Jeff Shaara, and Marilyn Nelson—conducted workshops at military installations in nine nations and contributed to writing educational resources to help the troops and their families share their stories. The 57 workshops resulted in an acclaimed 2006 anthology, *Operation Homecoming: Iraq, Afghanistan, and the Home Front in the Words of U.S. Troops and Their Families,* edited by Andrew Carroll. Drawn from 12,000 submitted pages, the anthology includes nearly 100 personal letters, private journals, poems, stories, and memoirs of service and sacrifice on the front lines and at home. The book was excerpted in *The New Yorker* and named one of the best nonfiction books of the year by the *Washington Post.* The project also resulted in two documentary films, *Muse of Fire,* directed by Lawrence Bridges, and the Academy Award-nominated *Operation Homecoming,* directed by Richard Robbins.

To further cultivate an audience for literature, Chairman Gioia announced in December 2005 the creation of The Big Read, headed by Literature Director David Kipen. Modeled after successful "city reads" programs, The Big Read is a national initiative to encourage literary reading by asking communities to come together to read and discuss one book. In partnership with Arts Midwest, the NEA has brought the program to more than 400 cities and towns nationwide with engaging reader's guides; educational CDs; radio and film documentaries; school materials; a Web site; and funding to support activities and partnerships with libraries, schools, arts organizations, and local government. "The NEA's landmark 2004 study, *Reading at Risk,* showed that literary reading in the U.S. is in steep decline," said Gioia. "No single program can entirely reverse this trend. But if cities nationally unite to adopt The Big Read, together we can restore reading to its essential place in American culture."

This populist approach to building a larger audience for contemporary literature resulted in the creation of Poetry Out Loud, a national poetry recitation contest for high school students, which includes an educational Web site, teaching guides, and other resources. Beginning in 2003, the NEA initiated and sponsored a poetry pavilion at the National Book Festival on the Mall in Washington, DC, to bring distinguished poets to the attention of an annual festival audience of 100,000.

Across some five decades, the NEA has nurtured literary writers and organizations, supported publishers and journals, and invested in the creation of literary audiences across the nation. While the method of achieving these goals has constantly evolved, the core objectives—and the agency's deep commitment to them—have remained steadfast and unwavering.

The American Film Institute (AFI), with NEA support, has been at the forefront of preserving America's rich film heritage, including *The Kid* (1921), starring Charlie Chaplin and Jackie Coogan. (Photo courtesy of AFI Stills Collection)

Media Arts

TED LIBBEY
Media Arts Director

Introduction

To understand the role the Arts Endowment played in the broadcast arena during the early years of its history, it is important to remember that for many decades prior to the NEA's creation both radio and television had delivered superb fine arts programs to audiences across the nation. In fact, the 1930s through the 1950s were a halcyon period for the arts in the broadcast media. During those decades, serious theater and music flourished on some of the most listened to and watched shows on the air.

The power of radio was thrillingly demonstrated on October 30, 1938, when the young Orson Welles produced a radio adaptation of H. G. Wells's novella *The War of the Worlds* and delivered it in the style of a live news report. Thousands of Americans who tuned in while the show was in progress panicked, believing that Martians were actually attacking America.

The nation's radio networks maintained a strong commitment to classical music programming throughout the 1930s and 1940s. In 1931, the Metropolitan Opera inaugurated live coast-to-coast broadcasts of its Saturday matinee performances. In 1937, after the celebrated conductor Arturo Toscanini stepped down as music director of the New York Philharmonic, NBC created an orchestra especially for him to lead, and began a series of regular broadcasts from Studio 8H in Manhattan's Rockefeller Center. For 17 years, until the maestro retired, these broadcast concerts were among the most respected programs on American radio.

Television arrived following World War II and, as with radio, its early engagement with the arts seemed promising. During the 1950s, live drama was featured regularly on series such as *Playhouse 90, Kraft Theatre,* and *Studio One.* Music, too, was well represented. Symphonic music and selections from opera and Broadway shows

were the main offerings on *The Bell Telephone Hour,* a radio series that made the jump to television in 1959. Already in 1948, the *NBC Opera Theatre,* under the direction of Peter Herman Adler, had begun to broadcast live studio productions of original and standard repertory works. And in 1954, NBC staged a coup when it commissioned Gian Carlo Menotti to write the opera *Amahl and the Night Visitors* for a Christmastime broadcast on *The Hallmark Hall of Fame.*

But by 1960, as television increased its market penetration and radio fought to attract a mass audience that would keep it competitive, arts programming on American media began to diminish. Radio, once synonymous with variety, started shifting toward more mainstream programming. Classical music, folk music, and theater became increasingly hard to find, while stations blaring the Top 40 proliferated from one end of the dial to the other. For its part, network television quickly cast off programming that honored the arts. With the introduction of videotape and filmed drama, live drama all but vanished from the small screen, while situation comedies, game shows, and serial westerns such as *Gunsmoke* and *Bonanza* flourished. Dance, classical music, and opera appeared sporadically, if at all, on variety programs such as *The Ed Sullivan Show,* sandwiched between other acts. Only a handful of series— *The Bell Telephone Hour, Omnibus,* and *Camera Three* all on CBS—still provided regular offerings of the performing arts. By 1962, *Omnibus* was gone, and *Camera Three* winked out in 1965. After that, televised specials such as the New York Philharmonic's Young People's Concerts with Leonard Bernstein represented but the occasional fine arts oasis on the small screen.

PUBLIC BROADCASTING ACT

The separation between commercial broadcasters and the arts was finalized in 1967 with the passage of the Public Broadcasting Act, which established the Corporation for Public Broadcasting (CPB) in order to direct Congressionally appropriated funds to the nation's nonprofit television and radio community. "While we work every day to produce new goods and to create new wealth, we want most of all to enrich man's spirit," President Johnson declared when he signed the bill. His hope was to give a "stronger voice to educational radio and television." One unintended effect of the legislation was to relieve commercial media of any obligation to present arts programming. In the nation's biggest cities, a few well entrenched commercial radio stations continued to broadcast jazz and classical music, but their number would fall steadily. Commercial television instantly became a wasteland.

By 1969, the nation's public television stations had come together to create the Public Broadcasting Service (PBS), a nonprofit corporation chartered for the purpose of acquiring and distributing programming to its owners, the member stations. National Public Radio (NPR), founded in 1970, quickly took a leading role as a content provider for public radio stations. (Over the years, organizations such as Public Radio International (PRI), Pacifica, American Public Media, and the WFMT Radio Network have also provided much valuable arts programming to public stations.) Into this brave new media world strode the National Endowment for the Arts, at a time when leadership was desperately needed.

The NEA and the Arts on Radio and Television

In 1972, the NEA created the funding category Programming in the Arts (PITA) within the Public Media Program (since 1999, this grant category has been known as the Arts on Radio and Television). For the first two years, PITA funded a handful of radio projects and television specials. Then, in 1974, the Arts Endowment started to direct resources toward establishing major performing arts series on public television. That decision proved to be remarkably prescient. In years to come these series, with Arts Endowment support, would produce an extraordinary body of programming of inestimable artistic and archival value for broadcast into homes across America.

Television and the Endowment

The search for a mechanism to provide major arts programming on PBS was led by Nancy Hanks, the Arts Endowment's second chairman, and Chloe Aaron, the Public Media Program's founding director. Hanks realized that the NEA's pilot media funding had not had as big an impact as it should, and she sought advice from Jac Venza, a veteran producer at New York public television station Thirteen/WNET, who recommended generous Endowment funding for television programming that would showcase leading American companies and exemplary works of dance, music, and theater.

Important projects soon followed. For instance, in partnership with the Ford Foundation, the NEA directed significant research and development funding to Lincoln Center and television producer John Goberman for the purpose of adapting low-light cameras for theatrical use. These cameras could record a live performance

without disturbing the audience or the performers. The development of this technology paved the way for a series that would later become one of the centerpieces of arts programming on public television, *Live from Lincoln Center*. Simultaneously, the Endowment joined with Exxon and CPB to award a $3 million grant to Thirteen/WNET for the development of a new public television series focusing on dance called *Dance in America*. Both *Dance in America* and *Live from Lincoln Center* entered the PBS schedule in January of 1976.

Great Performances and Dance in America

Dance in America debuted January 21, 1976. Among the highlights: the Paul Taylor Dance Company in *Esplanade*, Martha Graham's *Appalachian Spring*, Alvin Ailey's *Cry*, Jerome Robbins's *Fancy Free*, and the New York City Ballet's production of George Balanchine's *The Prodigal Son*, featuring Mikhail Baryshnikov. These programs thrilled audiences and their archival value grows with every year that passes.

Soon after its launch, *Dance in America* was absorbed under the umbrella of Thirteen/WNET's flagship series *Great Performances*, which had been in production since 1972 as a showcase for music, musical theater, and drama. Thirty-seven years later, *Great Performances* remains the gold standard among performing arts programs on television. Those whose work it has brought to the viewing public include Aaron Copland, Leonard Bernstein, Dizzy Gillespie, Renée Fleming, the San Francisco Opera, the Houston Grand Opera, and the Philadelphia Orchestra. In recent years, airings of *Great Performances* have attracted cumulative audiences of 3.2 million viewers.

Live from Lincoln Center

Live from Lincoln Center launched on January 30, 1976, with a broadcast from Avery Fisher Hall. Under the baton of André Previn, the New York Philharmonic presented Grieg's Piano Concerto in A minor, with Van Cliburn as soloist, and Richard Strauss's *Ein Heldenleben*. Subsequent

Yuriko Kimura and Tim Wengerd star in Martha Graham's classic work *Appalachian Spring* in a 90-minute special on Graham as part of PBS series *Dance in America*. (Photo courtesy of Thirteen/WNET)

Paul McCartney (from left) with Sun Records artists D. J. Fontana and Scotty Moore from the *American Masters* program "Good Rockin' Tonight: The Legacy of Sun Records." (Photo by Dan Griffin)

broadcasts during the show's first season featured the New York City Opera performing Douglas Moore's *The Ballad of Baby Doe* and American Ballet Theatre's production of *Swan Lake*.

The show, now in its fourth decade, produces six programs a year that reach five million viewers per program.

American Masters

In the late 1970s, the Arts Endowment expanded its media initiative to support media arts that were not performance-based. One result was *American Masters,* a series of film documentaries on leading American artists. The goal of the series was to engage top filmmakers to tell the stories of these artists and to mine the archive— interviews, still images, documentary footage, and performance video—in ways that would make its treasures more readily accessible to students of the arts and the American public.

With Susan Lacy as producer, *American Masters* made its PBS debut in 1986. As of 2006, its twentieth-anniversary season, it had aired more than 130 documentaries,

reaching 4.2 million viewers per hour. Among the outstanding filmmakers who have contributed material to the series were Martin Scorsese, whose two-part film on singer Bob Dylan won a 2006 Peabody Award, and Sidney Pollack, who produced a profile of Frank Gehry. The impact of Endowment funding for the series was exemplified with the 2003 airing of *Robert Capa: In Love and War,* a documentary by Anne Makepeace. This biography of the noted war photographer secured his place in the history of the twentieth century and underscored his extraordinary capacity to capture the impact of major crises through his images. Like many *American Masters* profiles, it is permanently available on DVD.

RADIO AND THE ENDOWMENT

Through the Arts on Radio and Television initiative, the Endowment has funded the finest music and performing arts programs on American radio. A celebrated early success was *A Prairie Home Companion,* starring Garrison Keillor, which remains one of the nation's most listened-to weekly shows. Another early hit was the radio drama series *Earplay,* heard on NPR from 1972 into the 1990s.

Music programming on public radio has received particularly strong support from the Arts Endowment's Media Arts Program. Listeners with a passion for jazz have been able to tune to *JazzSet* with Dee Dee Bridgewater and Marian McPartland's *Piano Jazz.* Those with eclectic tastes have enjoyed *American Routes,* hosted by Nick Spitzer. Syndicated concert series of the New York Philharmonic and the Chicago Symphony Orchestra are among the many classical music offerings the Endowment has supported on radio. Best known of all is *Performance Today,* which airs on more than 250 stations nationwide. Produced and distributed by NPR from 1987 to 2006, and by American Public Media since 2006, *Performance*

NEA Jazz Master Marian McPartland plays a duet with Chicago jazz musician Jodie Christian during a taping of her weekly National Public Radio series, *Piano Jazz.* (Photo by Melissa Goh)

Today is the nation's most widely heard daily classical music program, and the Endowment has funded it since its inception.

RADIO AND TELEVISION IN THE TWENTY-FIRST CENTURY

The Media Arts Program's advisory panels have been quick to recognize innovation in the field, which has allowed the Arts Endowment to provide crucial early support to ventures that are now reshaping the broadcast landscape. Two classical music productions stand out. *Keeping Score,* a public television offering featuring the San Francisco Symphony Orchestra and its charismatic music director, Michael Tilson Thomas, made its series debut in 2006 with three programs looking at revolutions in music. The PBS series blends documentary segments with performance video and maintains a robust Web site that delivers in-depth analyses of musical structure and material on the background, history, and influences that shaped composers and their works. The radio series *Exploring Music* with Bill McGlaughlin, produced and distributed by the WFMT Radio Network in Chicago, debuted in 2003. Hosted by one of America's most knowledgeable classical-music commentators, this daily, hour-long show has a unique format. Each week's programming is thematic—usually focusing on a broad musical topic or the life and works of a single composer—which allows McGlaughlin room to guide listeners in a deep exploration all too rare in mass media today.

Independent Voices

Among its media arts goals, the Endowment aims to build a wider audience for independent radio and television producers. On radio, the agency has funded *Lost & Found Sound,* by the California-based production team known as The Kitchen Sisters; (((*Hearing Voices*))), a Montana-based collective that has produced more than 250 radio pieces since 2001; and *StoryCorps,* Dave Isay's project in personal storytelling. What these producers have in common is their interest in using the medium of radio as an art form. Similar thinking motivates the Endowment's regular funding of *P.O.V.* and *Independent Lens,* both of which are distributed by PBS. These highly successful television series bring the leading-edge work of contemporary independent filmmakers and video artists to a very wide public, and uphold the notion that story-telling through the medium of television is an art.

Movies had been around for three-quarters of a century when the Endowment appeared on the scene. For most of that time, they had been processed using nitrate-based film stock, easy to work with but chemically unstable. As a result, by 1965, many groundbreaking creations from the early years of American cinema were turning to dust—their images oxidizing right on the reel, in a slow-burning fire of self-extinction. Roughly half of the more than 21,000 feature-length films produced in the United States prior to 1951 had been irretrievably lost. The survival rate for newsreel and documentary footage was less than 50 percent.

Recognizing that the loss of any more of America's film heritage would be a cultural calamity, the Endowment acted quickly. By the summer of 1967 it had successfully partnered with the Motion Picture Association of America and the Ford Foundation to bring the American Film Institute (AFI) into being. An initial grant of $1.3 million from the Endowment, for fiscal years 1968–70, made it possible for AFI to begin collecting nitrate films for preservation and placement in a special archive at the Library of Congress. By 1971, more than 4,500 films, including many long believed lost, had been secured. Among these were significant works of early cinema, films like *Broken Blossoms* (1919), starring Lillian Gish, and *The Kid* (1921), starring Charlie Chaplin and Jackie Coogan.

In 1971 the Endowment established the AFI/NEA Film Preservation Program to award sub-grants through the AFI to more than 40 archives, historical societies, libraries, and universities engaged in film preservation. Among the recipients were the Museum of Modern Art; the George Eastman House in Rochester, New York; the National Center for Jewish Film in Waltham, Massachusetts; and University of California, Los Angeles. From 1971 to 1995, more than $12.7 million was awarded through this initiative.

In 1983, the Endowment and the AFI established the National Center for Film and Video Preservation. From 1983 to 1996, the Arts Endowment awarded $3 million to the center to support activities in three areas: development of a moving image database; research for and publication of the decade-by-decade *AFI Catalog of American Feature Film;* and national coordination of film and video preservation activities. The Arts Endowment's annual support for AFI activities peaked in 1987 with awards totaling $3.5 million. The film preservation sub-grant program ended in FY 1994, and support for the film preservation center terminated in FY 1996.

Independent Film Production

From the mid-1970s until the late-1990s, when Congress eliminated most forms of direct NEA support for individual artists, the Endowment played a leading role in funding new work by independent filmmakers. NEA grants went to many talented and innovative figures and facilitated the production of several important films. Among the best known of these were: *Harlan County, USA* (1976), a documentary about striking coal miners, directed by Barbara Kopple; *Fast, Cheap & Out of Control* (1997), a documentary about four men in different walks of life, directed by Errol Morris; *Slacker* (1991), by Richard Linklater; and *Chan Is Missing* (1982), a Chinatown comedy directed by Wayne Wang. *Chan Is Missing* was Wang's first feature-length work, and its success launched him on a major career, of which subsequent highlights have included *The Joy Luck Club* (1993) and *Because of Winn-Dixie* (2005).

Filmmaker Training

In the late 1970s, actor-director Robert Redford approached Brian O'Doherty, who had succeeded Chloe Aaron as Media Arts director in 1976, with his idea for a non-profit institute in the American West dedicated to independent filmmaking. The

institute was to be named for the character Redford played opposite Paul Newman in their 1969 blockbuster *Butch Cassidy and the Sundance Kid*.

A modest grant of $5,000 from the Media Arts Program in 1980 helped the Sundance Institute hold its first Filmmakers Lab in the spring of 1981. The Arts Endowment has funded various projects at Sundance every year since. In the early years, NEA support included funding for the Sundance Film Festival as well as the Filmmakers Lab. In recent years, it has been directed solely to the lab, now known as the Sundance Feature Film Program, which offers an array of workshops for screen-

Actor and producer Robert Redford founded the Sundance Institute, which has received NEA support since its first workshop in 1981. (Photo by John Schaefer)

The Black Maria Film and Video Festival is a traveling showcase for cutting-edge new film works. (Image courtesy of Black Maria Film and Video Festival)

writers, composers, producers, and directors, and assists narrative and documentary filmmakers from the conception of their work to its completion.

One need only look at the roster of Sundance participants to get a sense of the impact the NEA's support has had. Some of the best known names are: Jim Jarmusch, Steven Soderbergh, Nicole Holofcener, Victor Nunez, Todd Haynes, Errol Morris, Kimberly Pierce, and Quentin Tarantino. In every case, these directors can trace their growth as artists and their successful careers in film back to Sundance.

FILM EXHIBITION

Providing access to the arts for all Americans is one of the Arts Endowment's core missions. In the realm of film this has led the agency to focus its support on public exhibition projects, specifically film festivals and curated series, a priority that emerged naturally in response to the decline of art-house cinema during the 1990s. Film as an art form can only be served if there are places where it can be experienced as it was intended to be, projected on a large screen, and can only be appreciated

fully if audiences are encouraged to recognize the breadth of the repertory and learn the fine points of filmmaking. Festivals and curated series are an ideal setting for this process.

Every year the Arts Endowment typically funds 30 to 40 of these events through its Media Arts Program. Some focus on a particular genre: documentaries, foreign films, short films. Others direct their offerings toward a particular cultural or demographic niche: Latino film, Asian/Pacific American film, and children's films. A number of these entities have traveling components, and some include competitions. Among the most prominent are Film Forum in New York, the Film Society of Lincoln Center, the San Francisco International Film Festival, the Telluride Festival, and the Black Maria Film and Video Festival (a traveling showcase, based in New Jersey). In addition to keeping the art form alive, they reach sizable audiences, averaging 100,000 at Film Forum and more than 80,000 at the San Francisco International Film Festival.

CONCLUSION

The National Endowment for the Arts arrived on the media scene at a time when problems with film were particularly pressing, and it quickly made those problems a top priority. By creating the American Film Institute, issuing a mandate to the field to restore imperiled works on film, and investing millions of dollars in the preservation effort, the Arts Endowment fundamentally altered the "picture" of one of America's most important and widely appreciated art forms. The challenge was monumental, but by successfully taking on the problems as early as it did, the agency prevented thousands of works from being lost forever. Four decades later, this is still among the NEA's most important achievements.

History has also shown the wisdom of the Endowment's approach to the broadcast media. In addition to guaranteeing excellence and breadth of exposure, the Endowment has consistently supported television and radio programming that provides Americans access to the best of their artistic heritage as well as the opportunity to experience a particular repertory, genre, or tradition in depth. As the Endowment enters its fifth decade, grants from its Media Arts Program annually fund approximately 140 hours of television programming that are seen by an estimated cumulative audience of 300–350 million viewers, along with thousands of hours of radio that are heard border to border and coast to coast. No other agency programs come close to serving such a large portion of the American public.

Dorothea Lange's iconic image from the Great Depression, *Migrant Mother, Nipomo, California,* 1936, toured the country as part of the George Eastman House's American Masterpieces exhibition, *Seeing Ourselves: Masterpieces of American Photography.* (Photo courtesy of George Eastman House)

Museums and Visual Arts

ROBERT FRANKEL
Museums and Visual Arts Director

Introduction

From its inception, the National Endowment for the Arts has supported and facilitated the creation, exhibition, publication, and conservation of the visual arts. Initially, museum and visual arts projects were administered within one program. The decision of how and what kinds of projects should be funded came from the National Council on the Arts and policy panels that were appointed by the chairman of the Arts Endowment. The members of these panels were museum directors, curators, and other visual arts professionals who made recommendations as to the needs of the field. Programs such as exhibition and collections support, object purchase plans, conservation, Challenge Grants, and funds for endowments and cash reserves evolved from these panel meetings. However, it became clear that the needs of small visual arts organizations and larger museums required different approaches, and in 1972 an independent museum program was established. From that point, the new Visual Arts Program focused support primarily on projects that enhance and showcase the life and work of living artists.

Visual Arts

Early on, support from the National Endowment for the Arts gave credibility to small visual arts organizations allowing them to develop and grow. Direct grants were given to individual artists, and programs were crafted to address the needs of the field. By 1981, there were as many as 15 categories of funding, including support for public art projects, workshops, exhibition programs, fellowships, artists residencies, publications, and services to the field.

Fellowships and Residencies

Sixty artist fellowship awards were made in 1966, the first year the grants were given. Among the recipients were Sam Gilliam, Donald Judd, Agnes Martin, and Mark di Suvero. Because the program was new and not yet well known within the field, for the first two years of awards, the agency relied on nominations from panelists. By 1968 it was no longer necessary to seek nominations for awards. Eventually, more than 10,000 applications, which were reviewed by panels made up primarily of working artists, reached the Arts Endowment annually.

Over the years, the panels that determined the recipients of the Visual Artists Fellowship program of the National Endowment for the Arts established an impressive roster of artists. Although many of the awards were made to early- and mid-career artists at crucial stages of their careers, a review of the recipients' names today reads like a virtual "Who's Who" of the art world. A sampling includes a wide range of styles and genres by artists such as painters Jennifer Bartlett, Chuck Close, Sam Gilliam, Alice Neel, Susan Rothenberg, and Ed Ruscha; sculptors Dan Flavin, Nancy Graves, Donald Judd, Bruce Nauman, Martin Puryear, and Joel Shapiro; public artists Scott Burton, Maya Lin, Mary Miss, and James Turrell; ceramic artists Robert Arneson and Peter Voulkos and glass artist Dale Chihuly; video artists Gary Hill, Mary Lucier, Tony Oursler, Nam Jun Paik, and Bill Viola; performance artist Laurie Anderson; and photographers Robert Adams, Harry Callahan, Lee Friedlander, Joel Meyerowitz, Cindy Sherman, and William Wegman.

Big Self-Portrait, 1967–1968, by Chuck Close, who received a 1973 Visual Arts Fellowship. (Image courtesy of Collection Walker Art Center, Art Center Acquisition Fund, 1969)

Referring to panelists who recommended recipients to the National Council and the chairman, art critic Nancy Princenthal wrote, "The panelists looked not for evidence of popular acclaim, but for those who deserved it; without setting themselves to the goal of predicting success, their decisions were often premonitory." Between 1966 and 1995, when the Visual Artists Fellowship program was discontinued due to Congressional mandates, 6,500 fellowships

were awarded to 5,147 artists in the disciplines of painting, sculpture, crafts, works on paper, photography, printmaking, video, performance art, installation work, artists books, and other visual art forms.

Throughout the existence of the Visual Artists Fellowships, visual artists working in a wide range of styles and genres—from representational to abstract to conceptual, and in various media from paint, paper, and fiber to stone, steel, and wood—were awarded grants. In the beginning, the category was titled simply Artists Fellowships and consisted mostly of grants to painters and sculptors. However, as developments occurred in the visual arts field, panelists recommended expansion of the breadth of category, and over the years, the number and titles of subcategories changed to keep pace with changes in the field. In 1971, a separate subcategory for photography was added; in 1973, one was established for crafts; video followed in 1975; and conceptual and performance in 1976. In this way, the Arts Endowment provided leadership, recognizing the importance of the various areas in which visual artists worked and bestowing credibility to media such as crafts, photography, and video before they were fully recognized as valid visual art forms by museums and other established institutions.

As part of the program's leadership in support of crafts and photography, additional categories were established in the mid-1970s to support exhibitions, publications, and workshops. Support for crafts and photography exhibitions in museums was transferred to the Museum Program beginning in FY 1982.

Though the Arts Endowment no longer awards grants to individual visual artists, they benefit from funding the agency provides for exhibitions, commissions, and, increasingly, residencies. A wide range of organizations offer residencies that provide artists with concentrated periods for the creation of new work. Residencies range in duration from a few weeks to a year, and the location can vary from an artist community in a rural setting completely removed from the public to an urban setting allowing for interaction with the public. In urban areas, residencies not only provide an environment in which art can be produced, but provide people living in the surrounding communities a direct experience with a practicing artist. For many people in these communities, experiencing the work of the artist resident marks their first exposure to someone involved directly in the creative process, and for some of the artists this will be the first time they are able to have direct conversations with their viewers.

At the Skowhegan School of Painting and Sculpture in Maine, founded in 1946 by a group of artists, individuals graduating from student to professional artist enjoy

the opportunity of interacting with a faculty of established practitioners. The goal is for these young people to gain confidence in their work through mentoring from faculty, and the NEA has consistently supported Skowhegan's residency program—a place run by artists for artists. According to Linda Earle, executive director of the Skowhegan School of Painting and Sculpture, "The NEA's continued support for Skowhegan both as an idea and as an institution is a powerful expression of the Endowment's own mission. It acknowledges that creative development and creative communities have resonance in society beyond that completion of a particular work, or the career of a particular artist. The fact that the NEA's investment in Skowhegan is made on behalf of the American public makes it an especially significant affirmation of our goals and our constituency. We are honored by it."

Visual Arts Organizations
Though the NEA funds projects organized through non-arts groups such as hospitals, social service groups, and religious organizations, the majority of grants that support the visual arts go to visual arts organizations. The development of these groups has been fostered by the NEA since its inception, and they are now at the core of the visual arts discipline. The organizations that apply in this category are generally small, often artist-run, and in many cases provide the only access to visual art and artists in their communities. The "alternate spaces" movement began in large cities in the 1960s and has spread throughout the country. They were established by artists as alternatives to museums, university art centers, and commercial galleries in their communities. In larger urban areas, they often are part of a network of providers that offer their constituents materials, programs, and services that would otherwise be unavailable.

The NEA awarded its first grants to visual arts organizations established in the late 1960s and early 1970s, and most of them are still in existence. Early examples include Artists Space, Franklin Furnace Archive, and P.S. 1/The Clocktower in New York City; 80 Langton Street/New Langton Arts in San Francisco; and the Visual Studies Workshop in Rochester, New York. In the next decade, artists would establish organizations in other cities, and grants were awarded to Los Angeles Contemporary Exhibitions, Randolph Street Gallery in Chicago, DiverseWorks in Houston, Nexus in Atlanta, and the Contemporary Arts Center in New Orleans.

Space One Eleven, a later example, received its first Arts Endowment award in 1991. NEA Chairman John Frohnmayer publicly presented the grant to the organization in Birmingham, Alabama. According to Space One Eleven founders Peter

With the help of NEA seed money, Project Row Houses transformed a Houston neighborhood by turning rundown housing into artists' studios and exhibition spaces. (Photo courtesy of Project Row Houses)

Prinze and Anne Arrasmith, "This award catapulted SOE into the national arts and funding arena. It provided recognition of SOE and affirmed to Birmingham artists that their work is of quality. Further, it provided the seed for subsequent grants. . . . This support and guidance of the NEA allowed the artists of SOE to present more than 60 exhibitions, and paid artists fees to more than 300 professional visual artists. NEA funds have supported more than 2,500 low-income youth and local artist/teachers in SOE's free after-school and summer arts education program, the acclaimed City Center Art."

For these groups, even a modest grant can mean the difference between providing and not providing a program. One example is Project Row Houses, a neighborhood-based art and culture organization located in Houston's Third Ward that was established in 1993 by artist Rick Lowe. With the goal of bringing the work of artists into the neighborhood to foster revitalization efforts in the community, Project Row Houses has successfully developed programs that combine arts and cultural education, historic preservation, and community development. With the financial and material resources of Houston's corporations, foundations, and art organizations, volunteers have renovated 22 abandoned shotgun houses dating from the 1930s. With support from the NEA, ten of these renovated houses are dedicated to art, photography, and literary projects, which are installed on a rotating six-month basis. The

commissioned artists are assigned a house to transform in ways that reflect the history and culture of African-American life in the city. In addition, seven houses adjacent to those dedicated to art are used for the Youth Mothers Residential Program, which provides transitional housing and services to young mothers and their children through 13 units of low-income housing.

The Arts Endowment not only supports current art projects but also actively helps visual arts organizations build their archives to make their collections accessible to the public. These archives provide a crucial source of information about the recent history of new or experimental art in America, including remarkable documents and artifacts such as original drawings, proposals, and correspondence. In many instances, the archived materials address early periods in artists' careers, before they became well known. These initial collaborations reveal important information about the genesis and development of the artists' work. By digitizing records and producing Web-based material, broad public access to a major corpus of artwork and records is now possible. Artist directories, digital archives of past activity, and programs to provide access to information for artists and arts organizations are now funded regularly by the NEA.

Art in Public Places
Initiated in 1967, the NEA's Art in Public Places program contributed to a period of substantial growth in public art projects throughout the country. The Arts Endowment was at the forefront of this movement, funding more than 700 works from 1967–1995. The first of these was Alexander Calder's monumental stabile, *La Grande Vitesse,* commissioned for the Vandenberg Center in Grand Rapids, Michigan. The catalytic NEA grant of $45,000 was matched by individuals and organizations in Grand Rapids to meet the $127,000 purchase price. It became a symbol of the city's revitalization and was applauded by President Gerald Ford in one of his few speeches on arts funding.

The agency's Art in Public Places grants were one of its most important efforts to ensure that high-quality art reached a broad public audience. From the beginning of the program, a wide range of projects were supported in both abstract and representational styles, in all kinds of visual arts media including murals and earthworks, and in communities large and small across the country at sites ranging from city plazas to waterfront parks to subways. Other examples of projects funded in the early years of the Art in Public Places include commissions by artists Claes Oldenburg in Des Moines, Richard Hunt in Memphis, Roy Lichtenstein in Miami Beach,

Nancy Holt's *Stone Enclosure: Rock Rings*, 1977–78, at Western Washington University in Bellingham, Washington, was part of the NEA's Art in Public Places program. (Photo courtesy of the artist)

Isamu Noguchi in Seattle, James Rosenquist for the Florida state capitol, Dan Flavin for New York's Grand Central Station, Tony Smith for the University of Hawaii, and Richard Serra for Western Washington University in Bellingham.

As the program evolved, so did the definition of what was considered public art. In addition to free-standing sculptural objects, public art included site-specific works that take into account the complete environment and temporary works that directly engage the public. One of the more innovative aspects of the program was an initiative titled Design Arts/Visual Arts Collaborations. It was a three-year partnership (1986–88) between the agency's Design Arts and Visual Arts Programs to respond to the newest development in the public art field—collaborations among visual artists, architects, urban designers, and landscape architects to integrate the public art aspects of new design projects into the original planning phase to ensure the equal involvement of artists and design professionals. Examples of projects funded include the involvement of artists, architects, and engineers on the design team for a light rail system in St. Louis; a collaboration between artists and designers for the develop-

ment of a new civic center complex for Seattle; and a collaborative effort between an architect and a sculptor to transform Hunters Point in New York into a public park.

Because of their locations, works of public art invite comment and debate in their communities long after the process is complete. The Arts Endowment exerted considerable national leadership in the public art field. Most projects were expensive and the processes complex, and some were controversial. The guidelines for the category specified substantial community involvement in the project's planning process, and required plans for maintaining the completed works. In 1988, a workbook was published with NEA support that outlined some of the most successful public art projects around the country. It became a much sought-after guide by communities wanting to establish or improve their public art programs. Although a separate public art program no longer exists, numerous public art projects still receive funding from the NEA.

Publications

Many young or mid-career artists have exhibitions for which there is no publication, brochure, or catalogue of their work. Often the only record is a review or notice in a

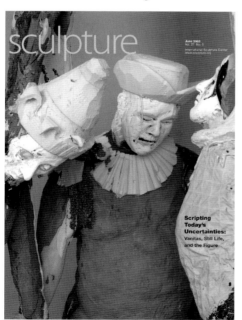

Sculpture magazine, which covers contemporary visual arts, has been consistently supported by the NEA. (Cover image courtesy of *Sculpture*)

magazine or newspaper. Documenting exhibitions of the work of living artists continues to be funded through visual arts grants to nonprofit publications. Because of rising costs, these publishing organizations are increasingly in jeopardy. The material they cover may be encyclopedic or more specific to a single discipline such as photography, sculpture, or glass. Some are national, some regional, but all are important to the field and are read both here and abroad. Examples of nationally distributed publications that have been consistently supported include *Art Papers,* based in Atlanta; *ARTLIES—The Texas Art Journal,* based in Houston; *Nueva Luz,* a photography journal based in New York; *Public Art Review,* based in St. Paul; *Sculpture,* based in New Jersey; *Camerawork: A Journal of Photographic Arts,* based in San

Francisco; *Metalsmith* magazine, based in Oregon; and *Afterimage,* published and distributed by the Visual Studies Workshop in Rochester, New York.

MUSEUMS

Museums collect, care for, document, exhibit, and interpret their collections. All of these functions have been and continue to be supported by the NEA's Museums discipline grants. Institutions of all sizes—ranging from those with small or volunteer staff to the largest organizations in the country—receive funding. To serve the complex needs of the field, each aspect of the operation of a museum, as well as its programming, is a priority to the NEA.

In 2007, the exhibitions, collections, and materials of the NEA's museum award recipients will reach approximately 13 million people. According to Jay Gates, former director of the Phillips Collection in Washington, DC, "As a direct result of the funding patterns and leadership of the National Endowment for the Arts, art museums in America not only look different but function differently, function better and serve a broader, deeper public than at any other time in our history. The NEA is a federal program that worked."

Exhibitions

The experience of a museum visitor is enhanced by the presentation of an exhibit. Temporary exhibitions can add to scholarly knowledge, shed new light on a subject, expand viewer awareness, and sometimes simply provide pleasure by bringing works to a community that otherwise would not have the opportunity to see them. Since the creation of the Museums Program as a separate discipline in 1972, approximately 50 percent of the grants have gone to exhibition projects. The nature of these exhibitions has ranged from large-scale international shows such as *Gilded Splendor: Treasures of China's Liao Empire (907–1125),* organized by the Asia Society in New York, and *Cezanne* organized by the Philadelphia Museum of Art, to those which are more intimate, such as *Ellsworth Kelly: Red Green Blue* organized by the Museum of Contemporary Art San Diego. While the exhibitions supported by the Arts Endowment are diverse, there is one constant that remains the same—artistic quality and scholarship.

The NEA has continually supported museums to help ensure that the visitor will have the best experience possible. Often visitors are drawn to temporary exhibitions and forget that at the core of any collecting institution is its permanent collection—

the objects it holds in trust for the public. The way that constituents perceive an exhibition is influenced by many factors including the juxtaposition of works, the progression of spaces through which the viewer moves, the lighting and even the color of the wall on which the work is displayed. It is necessary to examine on a regular basis best practices in exhibition design and consider how collections are arranged, and what should be done to enhance and facilitate the experience of the visitor. The NEA, through the funding of collection research and the reinstallation of institutional holdings, continues to work to enhance the participation of the public.

As the director of the Brooklyn Museum, Arnold Lehman, explains, "The National Endowment for the Arts' partnership has been critical to the Brooklyn Museum in advancing our mission of inclusiveness and accessibility. Beyond funding support alone, the NEA has been a major catalyst for private support in the museum's large-scale and strategic permanent collection reinstallations. The NEA's collaboration in the past and into the future is an essential element of Brooklyn's success in engaging visitors at every level of prior experiences."

Collection Information and Conservation

Museums have always looked to technology to document their collections properly and to enhance the experience of their users. From the beginning, the Endowment has funded projects that take advantage of innovations in record-keeping and communicating with users. As the technology has changed, so have the requests to the NEA for support, starting with film and advancing to tape to DVD to Internet access. It is now possible to provide broad public access to collections through the use of new technology, and this is an important area of funding for museums as it is with visual arts organizations. Digital or Web-based programs reach out to local communities and individuals far from the site—people unable to take advantage of the resources of the institution inside its bricks-and-mortar space.

In order for a museum's art and resources to be available for future audiences, their condition must regularly be surveyed and appropriate conservation must be done as needed. The Arts Endowment has, from its first years, partnered with museums to protect these collections which are part of our nation's patrimony and history. Too often, if there are limited resources available for the operation of a museum, the funds for the care of the collection are reduced during the budgeting process. It is not uncommon for conservation to be deferred. In a situation such as this, a grant from the Arts Endowment for the preservation of a collection may be the only way to get essential work done before critical damage occurs. These grants help fund crucial

preservation steps such as the creation of proper storage facilities with appropriate temperature and humidity control, a survey of the condition of the collection, repair of existing damage, and preventive measures which will avoid future loss.

Museum Professionals Fellowships

Though fewer were given, fellowships for museum professionals were the equivalent of individual artist grants. The fellowships, which were awarded from 1972 to 1992, addressed the need for professional study, travel, research, and project development for which funding was and continues to be scarce in America's museums. Applicants were able to take time for concentrated work in order to enhance their contributions to the organization for which they worked. These periods could lead to new exhibitions, publications, and acquisitions. During the course of the museum fellowship program, 368 grants were awarded, providing funds for research, travel, and individual projects.

American Masterpieces

American Masterpieces, a major initiative established by Chairman Dana Gioia, presents the best of America's cultural and artistic legacy to the people of the United States. Through the visual arts component, the National Endowment for the Arts celebrates the extraordinary and rich evolution of the arts in the country over the last three centuries.

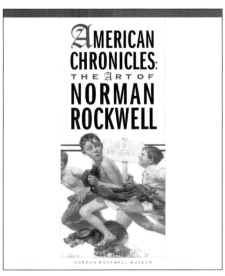

The program supports tours of major exhibitions to audiences of all sizes, with some exhibitions scaled down in order to be shown in small and mid-sized museums in rural and underserved areas. The organizing institutions provide related educational and interpretative materials to accompany each exhibition and relate it to national, state, and local arts education standards. During the first three years of the program, 34 exhibitions covering a wide range of subjects were funded. These range from the history of photography in this country, to surveys of styles such as American Impressionism and Modernism, to monographic exhi-

The exhibition *American Chronicles: The Art of Norman Rockwell* by the Norman Rockwell Museum toured the country through the NEA's American Masterpieces initiative. (Image courtesy of Norman Rockwell Museum)

bitions of artists as diverse as Georgia O'Keeffe, Jacob Lawrence, and Norman Rockwell.

Federal Arts and Artifacts Indemnity Program
The Arts and Artifacts Indemnity Program was established in 1975 by Congress to help minimize the costs of insuring international exhibitions, thereby making cultural treasures from outside of the country accessible to the American people by helping to bring great works to the United States from overseas. The program is administered by the Arts Endowment on behalf of the Federal Council on the Arts and the Humanities, which is composed of the heads of 19 federal agencies.

In FY 1976, the first annual report on the program lists ten exhibitions totaling $101,509,524, yielding savings of $724,278 in premiums. In FY 2006, certificates of indemnity were issued for 44 exhibitions traveling to 48 museums in 20 states, the District of Columbia, and Beijing, China—the largest number ever in a single year.

Raphael's *Two Women with Children* was part of the indemnified exhibition *Italian Drawings, 1350–1800: Master Works from the Albertina*. (Photo courtesy of the Albertina)

Coverage was requested for 4,796 objects totaling $13,793,746,599 in value. Given figures supplied by the applicants, they would have paid $21,355,154 if they had insured these projects commercially. Without the indemnity program, it simply would not be possible to cover these exhibitions.

By 2007, 856 exhibitions had been indemnified, saving participating museums more than $200 million in insurance premiums. Because of the program, the American people have been able to see large-scale exhibitions such as *Mongolia: The Legacy of Chinggis Khan* at the Asian Art Museum of San Francisco, *Diego Rivera: Art and Revolution* at the Cleveland Museum of Art, and *The Ancient Americas: Art From Sacred Landscapes* at the Art Institute of Chicago, as well as small but important shows like *Magna Carta and Four Foundations of Freedom* at the Contemporary Art Center of Virginia. Claims against the program total $104,000—the result of paying for the loss of two paintings in 1982. The works were subsequently recovered, and the payout costs were reimbursed to the federal government leaving a zero-loss ratio.

The reason for this sterling record is the rigorous review of applications by the Indemnity Advisory Panel and the Federal Council, along with the high level of care practiced by the museum professionals who come into contact with these works.

"The indemnity program," according to Nancy Netzer, director of the McMullen Museum of Art at Boston College, "allows smaller institutions like ours to mount exhibitions that we could only dream about otherwise. It allows us to access superb examples of artists' works in foreign collections, many of which have never been on public display in America."

The council is currently authorized to commit the U.S. Treasury to up to $10 billion at any one time (the original limit was $250 million). A single exhibition may be covered up to $1.2 billion (initial cap was $50 million). The program remains a priority in the agency, and continues to make coverage available to all eligible institutions organizing international exhibitions. In 2007, more than six million visitors viewed shows indemnified by the program.

In 2008, Congress authorized the expansion of the program to include domestic indemnity. In doing so, it made possible increased cooperation among American museums. Chairman Gioia noted, "The new legislation is enormously important both to American museums and to the millions of people who visit them each year. It allows American museums to share their collections with one another in an affordable way. The skyrocketing cost of insuring art exhibitions is a major issue. The domestic program will do immeasurable good in increasing access to great visual art across the country."

CONCLUSION

From its earliest days, the National Endowment for the Arts has sought to aid museums and visual arts organizations for their work in reaching new audiences; discover the most effective ways to involve communities with low participation rates; define roles that technology plays in providing access to the visual arts; and determine best practices in exhibition and care of art objects. The last few decades demonstrate an evolution of communities served by visual arts institutions. Through its support of exhibitions, infrastructure, and programming, the National Endowment for the Arts has been partnering with organizations across the nation, both large and small, to help them meet their needs and to find the means to best serve the American public.

NEA Opera Honors recipient Leontyne Price in the title role of Verdi's *Aida* in a Metropolitan Opera 1976 production. (Photo by J. Heffernan, courtesy of the Metropolitan Opera Association)

Music and Opera

WAYNE S. BROWN
Music and Opera Director

INTRODUCTION

The cultural climate of music in the United States leading up to the creation of the Arts Endowment in 1965 was rich and diverse. In 1956, "Heartbreak Hotel" by Elvis Presley helped to establish him as a rock star worldwide. One year later, composer and conductor Leonard Bernstein completed the musical *West Side Story*. In 1959, the The National Academy of Recording Arts and Sciences sponsored the first Grammy Awards, and the legendary vocalist Frank Sinatra won best album for *Come Dance with Me*. John Coltrane, in 1960, formed his own quartet and became the voice of jazz's New Wave era. Three years later, Beatlemania swept the U.S. as the Beatles exploded into pop music. And in 1965, tenor Plácido Domingo joined the New York City Opera in the roles of Don José in *Carmen* and Pinkerton in *Madame Butterfly*. The same year, pianist Vladimir Horowitz returned to the stage (following a 12-year absence) in a Carnegie Hall triumph, and Luciano Pavarotti made his American debut in the Greater Miami Opera production of Donizetti's *Lucia di Lammermoor*.

By 1965, when the Arts Endowment was created, television had become the primary medium of culture for most Americans. At the time, instead of driving people away from great musicians and musical traditions, as we might assume, television offered viewers many chances to see brilliant performers they had never before encountered. Less than a decade had passed since the young pianist Van Cliburn had been saluted on the *Ed Sullivan Show* upon his triumphant return from the First International Tchaikovsky Competition in Moscow in 1958. Likewise, every night the *Johnny Carson Show* introduced mass audiences to many young talents such as violinist Itzhak Perlman, opera singer Beverly Sills, and the rising cellist Yo-Yo Ma.

In a similar fashion, film and radio presented equally compelling opportunities to

introduce American audiences to classical music. The great conductor Leopold Stokowski, leading the Philadelphia Orchestra, would become known for his familiar profile in the Walt Disney movie *Fantasia*. The Metropolitan Opera's Saturday afternoon broadcasts had become a gathering point in homes nationwide—a tradition that began in 1930 and continues to date.

Most of the viewers and listeners interested in this genre of music could explore their tastes further in their own communities. By 1965 there were 1,365 symphony orchestras performing in large urban centers and in smaller communities. In large urban centers, the symphony orchestra served as the centerpiece of the performing arts. By the mid-twentieth century, this design was emulated in smaller communities from northern industrial areas to cities in the South, East, and West. In the case of larger communities, the musicians were paid professionals. In smaller urban areas, the orchestras were comprised of musicians who also served as teachers, insurance salesmen, and other professions apart from music.

In 1965, the United States boasted 27 opera companies. The Metropolitan Opera was in its 82nd season and approaching the thirty-fifth anniversary of its popular weekly broadcasts on Saturday afternoons. In addition, the Met toured various cities following the conclusion of its regular New York season, including Atlanta, Baltimore, Cleveland, Detroit, and Washington. This tour was an annual tradition that continued through the 1970s, with occasional breaks during economically challenging years.

As a precursor to federal support for the arts, one of the most significant early acknowledgments of the role of orchestras and American music performances in concert halls, on the radio, and through recordings was reflected through two grants of immense proportion. These grants were designed to document and promote new American orchestral works, and also to provide sustainable financial bases to orchestras to build capacity and offset growing operational costs.

• The Rockefeller Fund provided grant support totaling $500,000 between 1953 and 1955 to the Louisville Orchestra and its music director Robert Whitney to underwrite a series of recordings devoted to orchestral works. These funds represented an unprecedented level of support by a private foundation to a symphony orchestra for programming new American works.

• The Ford Foundation made an unprecedented investment in 1966 of slightly more than $80 million in matching grants to 61 symphony orchestras. Once matched, the participating organizations stood in a stronger position to increase their educational and community-based services.

The tremendous presence of music and opera signified an increasing consciousness of cultural values across the United States during the mid-twentieth century. More and more, cities began to consider cultural identity to be as critical to their community as economic prosperity or educational institutions. The creation of the National Endowment for the Arts brought the federal government into the cultural crescendo, and the NEA quickly took its place at the forefront.

Music, Opera, and the National Council on the Arts

The first Presidentially appointed arts advisory body, the National Council on the Arts, boasted some of the leading musical giants in the country. Founding members included contralto Marian Anderson, conductor and composer Leonard Bernstein, violinist Isaac Stern, pianist Rudolph Serkin, and jazz great Duke Ellington. In the twenty-first century, the council continues to have august representation from the music and opera fields with University of Michigan School of Music former dean Karen Lias Wolff, opera singer Mary Costa, art critic Terry Teachout, and champion of American orchestral works and Seattle Symphony Music Director Gerard Schwarz.

Robert Shaw conducting the Atlanta Symphony Orchestra and Chorus in the early 1960s. (Photo by Joseph Reshower deCasseres)

Throughout the history of the Arts Endowment, the council has weighed in on the major policy issues that have defined the agency. These artist citizens—individuals who continue to be deeply immersed in their respective art forms—have forged an agency that reflects American culture at its best. This diverse body of informed, respected individuals frequently has faced the dilemma of reconciling perspectives that would be used to shape and define various programs. On one such occasion, the council was stymied as to whether the agency should confine its support to professional choruses (meaning only those that paid their singers) or extend it to those of amateur status. Council member Robert Shaw, one of the most highly regarded choral

conductors of the twentieth century, led the discussion with a passionate plea for the agency to support not only professional choruses, but also choruses comprising unpaid singers. He maintained that funding should be determined based on the excellence of choral singing, and not based on whether choristers were being financially compensated.

In subsequent years, the position that Shaw espoused was validated through countless examples of how artistic standards were achieved with non-paid singers. In one case, the Washington Chorus (non-paid singers) received a Grammy Award in 2000 for its recording of Benjamin Britten's *War Requiem*. This message underscores one other essential point: The expertise demonstrated by members of the council continues to be an invaluable ingredient in the agency's success.

AGENCY SUPPORT FOR MUSIC AND OPERA PROGRAMS

Since the Arts Endowment was created, more than 11,000 music projects have been supported with an investment in excess of $375 million. During a 40-year period, the Arts Endowment has supported more than 4,000 opera projects with an investment of more than $160 million. As a result, newly commissioned operas and symphonic, chamber, and choral works have been created and performed; numerous tours and residencies have taken place; and thousands of concert halls, schools, outdoor venues, and recordings have showcased musical works and opera productions in the United States and, in certain instances, around the world.

From the earliest days, grant support from the Arts Endowment enabled music organizations to support the creation and performance of musical works, increase organizational capacity, and document and disseminate artistic works through recordings. It has served as a form of risk capital, enabling organizations to leverage support locally, and as an imprimatur to demonstrate an asset worthy of private investment.

Among recipients of significant music grants awarded during the first decade of the Arts Endowment were:

1966

• American Symphony Orchestra League—$33,531 to establish workshops on orchestra management and related issues, and provide technical assistance to orchestras.

• Boston Opera Company—$50,000 as a matching grant to assist the company in producing the U.S. premiere of *Moses and Aaron* by Arnold Schoenberg.

1967

• American Choral Foundation—$50,000 to support a summer institute at SUNY-Binghamton and University of Wisconsin-Madison to provide choral conductors with practical experience working with professional choruses and orchestras.

• Metropolitan Opera National Company—$150,000 for audience development, which enabled additional performances for labor groups and students in many states throughout the country.

• San Francisco Opera—$115,000 for audience development and formation of the Western Opera Theatre to perform condensed and full-length versions of operas for schools and community organizations in Arizona, California, Nevada, and Oregon.

• Douglas Beaton—$35,000 to study existing opera facilities in the Southeast and submit a comprehensive report to the National Council on the Arts for evaluation and recommendations.

1975

• Boston Symphony Orchestra—$7,500 to support the recording of Elliott Carter's *Piano Concerto* for distribution to music schools in the United States and abroad, as well as to United States Information Service centers.

In 1965, orchestras, opera companies, and chamber ensembles devoted modest attention to works by American composers. Today, due to an emphasis on American music by the Arts Endowment, a typical season reflects both a concerted commitment to American works as well as to the standard repertoire. Given the number of grants supported by the NEA and dedicated to the creation, performance, and recording of new works, this cultural shift is not surprising. Music and opera organizations are increasingly taking meaningful steps to understand and participate in community-based discussions about what defines a healthy and vibrant society. The resulting programs reflect a continuing growth in community partnerships that promotes music creation and enjoyment across the U.S.

The Arts Endowment's disciplines of music and opera support activities and programs nationwide in the following areas:

• Orchestras (including symphonic, chamber, and youth)
• Opera (opera and musical theater between 1978 and 1995)
• Jazz
• Chamber music (Western classical, contemporary, and jazz)
• Choruses (professional, amateur, and children's choirs)
• Professional training
• Music presenters, music festivals

The Glens Falls Symphony Orchestra performing Joan Tower's *Made in America*. (Photo by Michael Mason, courtesy of Glens Falls Symphony Orchestra)

Orchestras

During its existence, the Arts Endowment has supported orchestras of all kinds—including symphonic, chamber, and youth. Since 1965, the number of operating orchestras in the United States has increased from barely over 100 to 1,800 in 2008. Considering the number of musicians, volunteers, trustees, and administrative staff connected to an orchestra, this amounts to an estimated 636,500 people. According to the latest statistical report by the League of American Orchestras (formerly American Symphony Orchestra League), in the 2003–2004 season alone, orchestras engaged more than 76,000 musicians to perform for 28 million people. As of 2008, the financial investment by the Arts Endowment to orchestras exceeded $250 million.

One of the NEA's most significant orchestra projects in the past several decades was the Bicentennial Commissioning Grants. Three grants to three orchestras totaling $140,000 supported commissioning projects that celebrated the U.S.

Bicentennial. A total of 34 orchestras of all sizes from across the country commissioned 16 composers. Every orchestra performed each work multiple times. For instance, the Boston Symphony Orchestra received $70,000 from 1974 to 1977. It commissioned composers John Cage, Elliott Carter, David del Tredici, Jacob Druckman, Leslie Bassett, and Morton Subotnick, and the orchestras that performed the new works included the Boston Symphony Orchestra, New York Philharmonic, Chicago Symphony Orchestra, Cleveland Orchestra, Philadelphia Orchestra, and Los Angeles Philharmonic. Jacksonville received $40,000 from 1975 to 1977 and commissioned composers Norman Dello Joio and Ulysses Kay. Their work was performed by orchestras from Birmingham, Charlotte, Chattanooga, Florida Gulf Coast, Jackson, Jacksonville, Knoxville, Memphis, Miami Beach, Nashville, Norfolk, Richmond, Shreveport, Savannah, and Winston-Salem.

From 2005 to 2007, the NEA awarded $74,500 to the Glens Falls Symphony Orchestra. This grant supported *Made in America,* a collaborative commissioning, performance, and outreach project. A new work composed by Joan Tower was commissioned and performed by 60 small-budget orchestras in all 50 states. Subsequently the program was renamed *Ford Made in America.* The program addressed the need for orchestras with annual operating budgets of $500,000 or less to have the ability and resources to commission and program new music.

The Meet the Composer Orchestra Residencies program was launched in 1985 as a partnership between the Arts Endowment, Exxon Corporation, and the Rockefeller Foundation. From 1985 to 1996, when Congressional reforms made funding the program no longer possible, the NEA contributed $963,200 to the program. More than 21 major American orchestras placed 33 composers in residence during a seven-year period. The program produced more than 500 commissions, thousands of performances of new American works, and 25 recordings of works composed in residence. In 1992, Meet the Composer initiated a New Orchestra Residencies Program, a community-based program for orchestras and choruses, as well as opera, dance, and theater companies, working in partnership with local civic organizations.

To encourage the appreciation and understanding of contemporary music, the Arts Endowment created the Composer-in-Residence program, which allowed composers to work directly with orchestras (and other ensembles) for an extended period. To ensure presentation of works past their premiere, the NEA created the Consortium Commissioning Program which funded two to three ensembles collaborating with two to three composers, each ensemble performing the new works at least three times.

The Arts Endowment has fostered support for the creation and performance of new American works through several genres in music and opera. Over the years, this has resulted in the commissioning, performance, and recording of repertoire reflective of unique American experiences. The agency has continued to reflect priorities of the times and has included support for composer fellowships, recording projects, professional training, and media projects, along with honorific fellowships for jazz. Through support of various Arts Endowment programs designed to encourage the performance of new American works, the NEA has served as a leading catalyst for the programming of American works in music and opera.

According to Henry Fogel, president of the League of American Orchestras, "The agency has encouraged projects that support music of contemporary American composers, and is acknowledged by the League as a significant influence on the balance of the repertoire performed by U.S. orchestras. . . . The NEA serves as a beacon for excellence." Today, approximately one in four compositions performed by American orchestras is written by an American composer. These orchestras present more than 100 world premieres every year, and across the country they perform more than 36,000 concerts.

Opera

Over a 40-year period, the Arts Endowment has supported hundreds of commissions, premieres, performances, and broadcasts of opera productions. Programs to support opera and opera organizations have resulted in more than 4,000 grants representing an investment of $160 million.

Early landmarks in NEA's support for opera include:

1967

• Metropolitan Opera—$63,000 to increase the number of performances in the Southeast, thus developing an audience for opera on a local scale.

• New York City Opera—$40,000 to expand its young artist program of training and on-the-job experience for young singers and conductors.

1968

• Goldovsky Opera Institute—$30,000 to bring opera to communities where it is rarely offered and to improve quality of touring productions.

• Center Opera Company of the Walker Art Center—$20,000 for seasonal support of a company presenting contemporary and lesser-known works.

1971
- Grants emphasizing artistic and administrative development of opera companies as well as a means by which companies could serve broader audiences were awarded to:
 - St. Paul Opera Association, $50,000;
 - Santa Fe Opera (Opera Association of New Mexico) (three grants), $200,000;
 - Seattle Opera Association, $100,000;
 - Western Opera Theatre/San Francisco Opera, $200,000.

Over time, as the field expanded and companies matured, the agency adapted its programs and policies. In 1980, the Arts Endowment inaugurated the New American Works category in the opera field. The program aimed to encourage "the broadening of both the concept and canon of opera-musical theater—through the creation, development, and production of new and/or seldom-seen American works." The grant category lasted for 15 years, during which the agency invested more than $9.5 million for such projects as:

- *Emmeline*, by composer Tobias Picker with libretto by J.D. McClatchy, commissioned and premiered by Santa Fe Opera in 1996.
- *Akhnaten* by composer Philip Glass, American premiere by Houston Grand Opera in 1984.
- *A Streetcar Named Desire* by composer Andre Previn and libretto by Philip Littell, commissioned and premiered by San Francisco Opera in 1998.

Such grants have enhanced the canon of American opera, and the field continues to grow at an exceptional rate.

Great American Voices
The number of collaborations taking place among opera companies is occurring at an unprecedented pace. Great American Voices, a noteworthy collaboration between the Arts Endowment and the opera field, was a national initiative sponsored by The Boeing Company. Its mission was to send vocal ensembles from opera companies to perform memorable melodies from operas and musical theater for members of the military and their families at military installations. The program was highly successful with 24 opera companies performing at 41 military bases nationwide. The program served as a catalyst for opera companies and military communities to work together and discover the mutual benefits of opera that could be shared with military families in defined communities. The end result has brought continuing relationships beyond the terms and duration of the grant period.

Singers from Pensacola Opera performing at Tyndall Air Force Base as part of NEA's Great American Voices initiative. (Photo courtesy of Pensacola Opera and Tyndall Air Force Base)

Marc Scorca, President of OPERA America, affirms the value of the Arts Endowment to the opera field in grateful testimony: "The establishment of the NEA and its continued vitality are inextricably linked with the growth and health of opera in America. More than half the opera companies performing in the United States today were established after 1970—after the formation of the NEA and the creative energy it unleashed across the country."

Opera Honors

For the first time in more than 25 years, the Arts Endowment initiated a new lifetime achievement award, this time to honor individuals in the opera field through the NEA Opera Honors. Announced on January 9, 2008, these awards recognize and acknowledge performers, creators, advocates, and critics in the American opera community who have made significant contributions to advancing the opera art form in the United States. As with the NEA's other lifetime achievement awards, the American public nominates the honorees. The awards serve as the nation's highest honor in opera and add to the meaningful legacy of opera in this country. The NEA Opera Honors was made possible by a new provision in the agency's legislation passed by Congress in 2007. In 2008, the first Opera Honors recipients were com-

poser Carlisle Floyd, advocate Richard Gaddes, conductor James Levine, and singer Leontyne Price.

Jazz

Support for jazz by the Arts Endowment goes back to the very first grants given in 1966, and to the formation of a jazz program in 1970. It is not surprising that jazz, an American musical phenomenon, would attract support in the early days of the Arts Endowment. At that time, one of the world's most influential jazz musicians, Duke Ellington, was a member of the National Council on the Arts. Along with Ellington, panelists such as legendary trumpet virtuoso John Birks (Dizzy) Gillespie, composer and author Gunther Schuller, jazz historian Dan Morgenstern, and Willis Conover (jazz producer and broadcaster for *Voice of America,* credited with keeping interest in jazz alive in Eastern Europe through his nightly broadcasts during the Cold War) were helping to shape policies and programs during those formative years. The NEA Music Program director at the time, Dr. Walter F. Anderson, was a classical concert pianist and accomplished jazz performer. In 1969, the first award in jazz was awarded to George Russell, who later received an NEA Jazz Masters award in 1990. In 1970, the Arts Endowment offered support to individual jazz composers and arrangers for commissioning new works, as well as $500 grants to students who studied jazz. There were $1,000 matching grants to colleges and schools of music to present jazz workshops and clinics, and matching grants to public and private elementary and secondary schools to present jazz concerts.

From the NEA's initial jazz grants totaling $20,000, to today's investment in jazz programming in excess of $1 million annually, the field of jazz has experienced tremendous growth. Yet jazz had no major institutions, and most of its creative activity was taking place in a variety of small venues throughout the country. Under the leadership of then-Chairman Livingston Biddle and NEA Music Program Director and composer Ezra Laderman, a jazz policy panel began to think seriously about the next steps for the jazz category. The panel included a formidable list of jazz musicians and writers, several of whom would later become NEA Jazz Masters (e.g., Donald Byrd, Frank Foster, and Cecil Taylor). Priorities that surfaced from the report included a need for more statistical studies, education and training of developing artists, increased touring activities, an expanded oral history program, a comprehensive public relations/education campaign, establishment of a permanent repository, and a "masters" award to acknowledge significant lifetime accomplishment in jazz.

Twenty-three NEA Jazz Masters, with Chairman Gioia (right), were captured in this historic photo from the 2004 NEA Jazz Masters events in New York City. (Photo by Tom Pich)

In collaboration with the Doris Duke Charitable Foundation, the NEA supported JazzNet, a five-year initiative to fund commissions of new music and performances around the country in partnership with local presenters. The NEA also sponsored Jazz Sports, developed by the Thelonious Monk Institute of Jazz, which provided students with instrument training and performance opportunities at basketball games in Los Angeles and Washington, DC. The NEA also has taken the lead in developing research about the jazz field. In 2003, an important report was released on the current state of jazz musicians, *Changing the Beat: A Study of the Worklife of Jazz Musicians*. This report provided a detailed examination of working jazz musi-

cians in four major metropolitan areas: New York, Detroit, San Francisco, and New Orleans. Many of these pioneers of the field were aging (some dying before their contributions were recognized), and many were living on very modest incomes.

NEA Jazz Masters

Perhaps the NEA's most enduring contribution to jazz music, the NEA Jazz Masters Fellowship was established in 1982 to acknowledge the efforts of the genre's best, most innovative, and most supportive constituents, The NEA Jazz Masters award has since become the nation's highest honor in jazz. Over the course of nearly 30 years, the commendation has been bestowed upon numerous leaders in the field such as Dizzy Gillespie, Miles Davis, Dave Brubeck, and Tony Bennett.

In 2004, the NEA's support for jazz expanded exponentially. The number of annual recipients of awards increased from three to six, and the monetary award increased to $25,000. NEA Jazz Masters on Tour commenced, and a curriculum for high school teachers, NEA Jazz in the Schools, celebrated the story of jazz in a class-room-friendly format not only for music classes but also for civics, social studies, and U.S. history classes. In 2004, the Arts Endowment and Verve Music Group produced a special commemorative recording of the music of 27 NEA Jazz Masters, and in 2005, a partnership with National Public Radio gave rise to a series of 14 one-hour documentaries profiling honorees. Finally, in April of 2006, the *Legends of Jazz* program launched on public television, comprising a series of telecasts of the 2006 NEA Jazz Masters.

CHAMBER MUSIC

"Were it not for the National Endowment for the Arts, there would be no Chamber Music America," Margaret Lioi, chief executive officer of the organization, has stated. The service organization started in 1977 with 34 ensembles, primarily string quartets, as members. Today, the number of members stands at more than 800 and includes ensembles of all types that perform Western classical, contemporary, jazz, and world genres. "Through its various funding initiatives throughout the years," Lioi said, "the NEA has encouraged chamber musicians' creativity through commissioning, audience education and development through residencies, and capacity-building through challenge and matching grants. The result of this support is a vibrant, imaginative, and expanding field that is making music in thousands of communities nationwide."

Lioi's words are apt. Prior to the creation of the Arts Endowment, federal support for the performance of chamber ensembles was nonexistent, primarily because most chamber ensembles were not operating as nonprofit organizations. With a growing public appetite for intimate performance settings, and widespread desire for small ensembles to join presenters of chamber concerts throughout the country, a case for supporting this activity was affirmed by the mid-1970s. In 1977, the Arts Endowment helped to establish a service organization for chamber music, Chamber Music America. Thereafter, in 1979, the Arts Endowment formalized a chamber music category. Since that time, the agency has supported more than 1,800 chamber music projects with an investment exceeding $12 million.

One of the signature music programs for chamber music was the NEA Rural Residencies program, a collaboration with Chamber Music America that began in 1992 as an experiment to bring together young professional chamber musicians and rural communities.

Under the NEA Rural Residencies program, professionally trained musicians in ensembles such as the Ying, the Fry Street, and the Chiara Quartets became fully integrated into the life of each community—offering open rehearsals and live concerts for small audiences. They worked closely with classroom teachers and town officials to create relationships that would span a lifetime. Ultimately, 40 ensembles participated in this project and many have continued to retain performance links to the communities that were supported by the residencies.

In 2006, the Arts Endowment launched a new national initiative known as American Masterpieces: Chamber Music, designed to celebrate significant chamber works in settings throughout the country. Chamber music joins other disciplines in the American Masterpieces program, including dance, visual arts, choral music, and presenting.

Choruses

Choral music is celebrated by more then 28 million people who sing regularly in one form of chorus or another. Given the scale of choral music performance, it should not be surprising that the Arts Endowment has supported this art form with major resources over a 40-year period. Choral organizations that have benefited from that support include chamber, symphonic, and youth choirs, and festivals throughout the nation. As mentioned earlier, Robert Shaw, one of the most significant choral experts of the twentieth century, served as a member of the National Council on the

Arts and was passionate about the importance of the federal government providing support to the choral field.

In 1977, the Arts Endowment played a critical role in the field of American choruses by helping to establish a service organization for choral music, now known as Chorus America. According to Ann Meier Baker, president and CEO of Chorus America, "From the very start, the National Endowment for the Arts has been an important partner with us in helping to strengthen the choral field so that more people are enriched by the beauty and power of its music."

In 2006, the choral field was among the initial disciplines to benefit from American Masterpieces: Choral Music, recognizing 300 years of artistic genius by awarding eight choral organizations with performance, workshop, and recording grants totaling nearly half a million dollars. This exceptionally high level of investment supported regional choral music festivals, including the Providence Singers and Seattle Pro Musica Society. The festivals were designed to draw upon choral ensembles within a 200-mile radius, and featured residencies by prominent composers and workshops for participating choral ensembles to become better acquainted with choral literature. Featured composers included National Medal of Arts recipient Morten Lauridsen, Libby Larsen, and Alice Parker. As of 2008, the project has reached more than 70,000 individuals who have continued to celebrate American stories through choral music.

FELLOWSHIPS

While no longer a grant category at the Arts Endowment, NEA Music Fellowships to individuals were an important source of support for composers, solo recitalists, jazz musicians, and opera-musical theater producers. One of the earliest fellowship recipients from the Arts Endowment was composer John Adams, who has publicly stated that the honor served as an early indication of his recognition as a serious composer. Although the grant was modest, it served as a tipping point at a significant time in his development. Within the past 40 years, more than 11,000 individual grants were made to artists at various stages of their careers. In several instances, fellows also received recognition for their accomplishments as recipients of MacArthur Fellowships, Grammy Awards, and Pulitzer Prizes.

Among the numerous recipients in music and opera are composers William Bolcom, Donald Grantham, John Harbison, and Gunther Schuller. Bolcom received an NEA Composer-Librettist Fellowship in 1975, enabling him to begin composing a

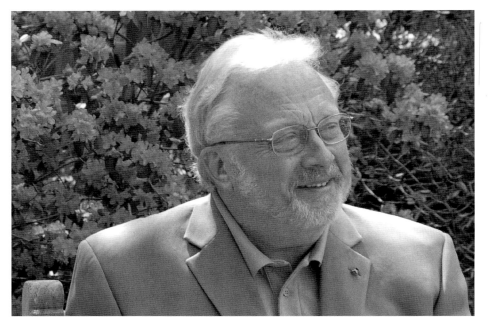

Composer William Bolcom received an NEA Composer-Librettist Fellowship in 1975. (Photo by Kate Conlin)

setting of William Blake's *Songs of Innocence and Experience* for which he was awarded a Pulitzer Prize for Classical Music. Another NEA fellowship recipient, composer Ned Rorem, avowed, "I had six fellowships from the NEA between 1975 and 1986, and yes, they made a difference; they changed my life."

Conclusion

The NEA serves as a conduit for and reflection of the innovation, experimentation, and excellence of our shared American culture. For more than 40 years the Arts Endowment has awarded thousands of grants for projects that celebrate artistic excellence in communities nationwide. The agency's investment in orchestras, opera companies, chamber music, jazz, choruses, and music presenters continues to play a catalytic role in the transformation of arts organizations, these art forms, and our communities.

LaJara Henderson and Charles S. Dutton in Yale Repertory Theatre's production of *Joe Turner's Come and Gone* by August Wilson. (Photo by Paul J. Penders)

Theater

BILL O'BRIEN
Theater Director

INTRODUCTION

In a speech to regional theater directors, whom she had assembled in 1935, Hallie
Flanagan, theater producer, director, and playwright, insisted that theater in America
". . . must experiment with ideas, with the psychological relationship of men and
women, with speech and rhythm forms, with dance and movement, with color and
light or it must and should become a museum product." The group was assembled to
help launch Franklin Roosevelt's Federal Theatre Project (FTP)—a division of the
Works Progress Administration. Flanagan recognized that the commercial concerns
that had governed the field since the nation was established did not always support
this type of exploration. To ensure artistic advances, and widespread access to them
by the general public, federal support would be necessary.

There had been no single national theater in the United States, such as those in
Russia, England, France, and many other developed nations of the world. Apart from
the brief, but influential tenure of the FTP (from 1935–39), the evolution of Ameri-
can theater progressed without the benefit of coordinated federal planning or
consistent investment. Despite this lack of centralized support, talented artists and
leaders began to emerge in the early and mid-twentieth century who were intent on
creating a proud American theatrical tradition that would appropriately reflect the
nation's new position in the world. By the time they were through, a fledgling decen-
tralized national theater movement had emerged, one that rivaled the ongoing
dramatic achievements of any nation in the world.

Nonetheless, American theater still struggles with rising costs, audience loyalty,
and rival entertainments. Theater in America has been marked by a long struggle
between art and commerce, and its evolution from popular entertainment forms

such as vaudeville and melodrama have, at times, hampered its ability to be perceived as a serious art form. Still, in the twentieth century playwrights have marked one of our country's most distinguished artistic traditions. Eugene O'Neill, Arthur Miller, and Tennessee Williams, among others, have created classics destined to endure as part of our national legacy.

These playwrights' success lies partly in the fact that by the midpoint of the century amateur and educational theater was flourishing in many locations in the United States. Professional theater centered in New York and Broadway, the undisputed capital of the industry. But elsewhere, an active and talented set of artists and leaders explored new ways to produce theater. Their results were inspirational and helped to set a course for a more expansive national theater movement than had ever been seen before. One of them was Margo Jones from Dallas, Texas, who established the first nonprofit professional theater company in America in 1947, entitled Theatre '47 (the name changed each year). Jones based her institution on a vision of a "golden age of American theatre." In her influential 1951 book, *Theatre-in-the-Round,* she described her dream of a future in which theater plays a part in everybody's life, and in which "civilization is constantly being enriched." Other leaders emerged in communities spread out across the country to join in the effort:

- Nina Vance and the Alley Theatre in Houston
- Zelda Fichandler and the Arena Stage in Washington, DC
- Gordon Davidson and the Mark Taper Forum in Los Angeles
- Jon Jory and Harlan Kleiman and the Long Wharf Theatre in New Haven, Connecticut
- Richard Block and the Actors Theatre of Louisville in Kentucky
- William Ball and the American Conservatory Theater in San Francisco
- Joseph Papp and the New York Shakespeare Festival in New York

These and other pioneering thespians sought to plant the theater in the midst of American life, to make it as essential to ordinary citizens as any other entertainment they might enjoy. And they tried to base it in communities and to define it as much by artistic innovation as by market constraints.

In the 1950s, the Ford Foundation's W. McNeil Lowry conceived a new strategy to support the nascent nonprofit theater. The foundation began to award arts grants, national in distribution, as leveraged investments in the development of resident theaters across the country. Support was provided to, among others, an ambitious new theater in Minneapolis. The Guthrie Theater, established by Sir Tyrone Guthrie, Peter Zeisler, and a group of energetic artists, opened its doors in a sparkling facility

as a repertory ensemble company. Elsewhere, notably in Stratford, Connecticut, and Ashland, Oregon, new theater festivals were created. Concurrently, in New York City, brilliant young playwrights gathered at La MaMa Experimental Theatre Club and other little-known spaces to produce exciting pieces "off-off-Broadway."

In the 1960s, the landscape of theater began to change as a confluence of societal forces—including improved public education, relative prosperity, increased leisure time, and advances by women and minorities in public life—sparked more consumer interest in the arts. These same influences helped bring the National Endowment for the Arts into being.

The NEA Enters The Scene

By 1965, the year the Arts Endowment was established, theater in America had become a vibrant and vital cultural tradition, though mainly in New York City and the handful of other communities fortunate enough to have a professional regional theater company. The movement was primed for growth and the potential of the Endowment's influence was felt almost immediately in the theater world.

The first National Council on the Arts contained several noteworthy figures from the field, such as Helen Hayes, Charlton Heston, Gregory Peck, Sidney Poitier, and Richard Rodgers. In May of 1966, the council declared that one of its primary goals was to support "the development of a larger and more appreciative audience for the theatre." Among its first actions was a decision to undertake studies of several pilot projects in the field of repertory theater. The council understood that many of the best theater companies already benefited from grants from a number of foundations, including the Ford Foundation, which continued to back regional theaters in the 1960s. While the council felt that their ability to win sup-

National Council on the Arts members Gregory Peck (left) and Agnes DeMille during a break at one of the first meetings in Tarrytown, New York. (Photo by R. Philip Hanes, Jr.)

port elsewhere should not exclude these organizations from receiving federal awards, it also reasoned that it would be imperative to broaden Arts Endowment support in a way that would appropriately reflect the national reach and responsibility of the new agency. Hence, the council also set about encouraging "grants to professional groups to be formed with strong local and regional support," and "grants, research, and liaison work with the idea of sending the best repertory companies on tour to play in university theaters."

Another early action by the National Council on the Arts generated an experimental program entitled the Laboratory Theatre Project. Formed in cooperation with the U.S. Department of Education and state and local school boards, the program aimed to provide American cities with professional theater companies that would present outstanding performances at no charge to secondary school children during weekday afternoons and to adult audiences during weekend performances.

In 1966, the first two Laboratory Theatre Project grants were awarded to Trinity Square Repertory Company in Rhode Island and Repertory Theatre of New Orleans. Under the direction of Adrian Hall and John McQuiggan, Trinity Square used the award to produce Anton Chekhov's *Three Sisters,* Shakespeare's *A Midsummer Night's Dream,* George Bernard Shaw's *Saint Joan,* and Eugene O'Neill's *Ah, Wilderness!* The Repertory Theatre of New Orleans, under the direction of Stuart Vaughn, received funds to present Brandon Thomas's *Charley's Aunt,* Shakespeare's *Romeo and Juliet,* Thornton Wilder's *Our Town,* and Richard Sheridan's *The Rivals.* Theater critics responded quickly to the productions. William Glover of Associated Press wrote, "The biggest theatrical angel this season isn't on Broadway—but in Washington. He is Uncle Sam, backing a multipurpose test of drama in education. . . . Taking part, in a rare display of agency togetherness, are the National Endowment for the Arts, the United States Office of Education and state and local boards of Education. . . . It is the first time that two Federal units have meshed efforts and cash in the cause of culture."

Other grants awarded that year went to the New York Shakespeare Festival for its mobile theater units, to San Francisco's American Conservatory Theater for its training and educational programs, to the Experimental Playwrights' Theater to produce outstanding new American plays, and to the National Repertory Theatre to support touring classical productions throughout the country.

Almost from its inception the Arts Endowment relied on the peer-panel review system to identify the strongest applications and ensure informed decision-making in the agency. The significance of the panels in the early years is vividly illustrated by

The Actors Theatre of Louisville started its Humana Festival of New Plays in 1976, with NEA support, which introduced audiences to emerging playwrights such as Theresa Rebeck and Alexandra Gersten-Vassilaros, whose play *Omnium Gatherum* was performed at the 2002 festival. (Photo by John Fitzgerald)

the roster of theater professionals who served on them. In 1972, for instance, the members included Harold Prince, Joseph Papp, Lloyd Richards, Zelda Fichandler, Peter Zeisler, Robert Brustein, Gordon Davidson, John Lahr, Jean-Claude van Itallie, Donald Seawell, and Earle Gister.

A Separate Program

In 1967, the Arts Endowment established theater as an independent program. Under the leadership of Ruth Mayleas, the agency's first Theater director, the recommendations of the panels and decisions by the National Council on the Arts had a significant impact on the future of theater in America. Through both the Theater Program and the Expansion Arts Program, support extended to a rapidly growing national network of theaters. The program's commitment to new work was reflected in its support for new play festivals such as Actors Theatre of Louisville's Humana Festival of New American Plays, and for playwriting workshops including the Eugene O'Neill Memorial Theater Center in Waterford, Connecticut. A Playwriting

The Guthrie Theater toured *A Midsummer Night's Dream* to nine Midwestern communities in seven states as part of the Regional Theater Touring program. (Photo by Michal Daniel)

Fellowship category was offered in the Literature Program through the 1970s, until it was transferred to the Theater Program in 1980. Support for playwrights through institutions and fellowships was integral to the explosion of new theaters and new work throughout the decade.

The agency also worked on behind-the-scenes issues such as the payment of reasonable fees and salaries to artists. The Arts Endowment offered Challenge or Advancement Grants to help companies acquire new facilities, hire new management, and build institutional capacity. A professional theater training program was established as well as a program to help young directors through the transition from training to professional career. Earmarked support was also directed to presenting companies, touring projects, theater for youth, mimes, translators, and designers.

During its first year, the NEA Theater Program invited resident theaters to apply for matching grants of between $10,000 and $25,000 to "be used for general artistic and organizational development, and to include any special programs or projects in line with this development." The category targeted geographically diverse groups of performing arts organizations, and was intended to assist the growth and develop-

ment of a decentralized American professional theater by helping to strengthen existing companies. By 1971, grants totaling $559,000 were awarded to 26 theaters across the country. Recipients included:

- Front Street Theater, Memphis, Tennessee
- Cleveland Play House
- Dallas Theatre Center
- Cincinnati Playhouse in the Park
- Milwaukee Repertory Theater
- Seattle Repertory Theatre
- Olney Theatre, Maryland

The Arts Endowment continued to focus on strengthening the burgeoning, decentralized nonprofit professional theater movement. Support for services to the field, such as publications, management programs, artists services, and meetings administered by the Theatre Communications Group—a national service organization dedicated to strengthening, nurturing, and promoting nonprofit theater— ensured field-wide support to shore up administrative and organizational capacity for nonprofit theaters throughout the nation. The NEA awarded funding to new play producing groups in order to ensure a reinvigorated corpus of new works that could be made available to producing organizations and their audiences across the nation. Support also continued for the Theatre Development Fund and its visionary ticket subsidy programs. This program was dedicated to creating affordable admission for audience members from underserved and disadvantaged populations and helped to ensure broader public participation in the art form.

In 1973, the Theater Program initiated a pilot project for Regional Theater Touring. While agency support of the regional theater movement had already expanded the geographic reach of live theater in numerous metropolitan areas across the nation, this program would work to create opportunities for participation in areas that were more geographically isolated. The touring program awarded five grants totaling $209,243 to recipients including Center Stage of Baltimore for its production of Robert Sherwood's *The Petrified Forest* and The Guthrie Theater for its production of John Steinbeck's *Of Mice and Men*.

NEW GROWTH—NEW CHALLENGES

In 1976, 45 nonprofit professional theater companies received grants from the Arts Endowment. One-third of the main stage productions mounted that season were

Peter Coyote and Jim Haynie in Sam Shepard's *True West* at San Francisco's Magic Theatre, supported by an NEA grant. The 1980 world premiere production was directed by Robert Woodruff. (Photo courtesy of Magic Theatre)

new plays (124 out of 378). The proportion is an indication of how the Arts Endowment influenced the field in its first decade. In 1966, nearly all new plays that reached a wide audience originated on the commercial stage and then filtered down to other, non-commercial levels of the theater. Ten years later, the situation had nearly reversed, with most new work being generated by nonprofit theater institutions. Perhaps the most compelling transformation was how the movement had succeeded in becoming effectively decentralized. That year, Peter Donnelly, managing director of the Seattle Repertory Theatre, wrote, "What has been accomplished in the last decade with the assistance of the Endowment has been quite phenomenal. A theatre which for all practical purposes did not exist except in New York has been created nationally."

Many institutions from many regions received agency support under the Professional Theater Companies category, including Actors Theatre of Louisville, the Alley Theatre in Houston, the Cincinnati Playhouse in the Park, the Circle in the Square in New York, the Long Wharf Theatre in New Haven, Milwaukee Repertory Theater, The Old Globe Theatre in San Diego, South Coast Repertory in Costa Mesa, and the Studio Arena Theatre in Buffalo. Additional funding was also made available in other

categories, such as Professional Theater Companies with Short Seasons; Theater for Youth; and Developmental Theater, New Plays, New Playwrights, New Forms.

After roughly one decade of agency support, it appeared as though Margo Jones's dream of an American civilization being enriched by theater—in every region of the nation—was beginning to come true.

The institutional growth was encouraging, but it also introduced new perils for the art form that it supported. Growing dependence on larger box office receipts, subscriptions, and other sources of income—coupled with the demands and expenses incurred from larger venues and their necessary support staff—threatened to eat away at the adventurous spirit that had launched the movement in the first place. The pressure to install cautious programming that would not put an institution at risk was always present. Arthur Ballet, Theater Program director, recognized this concern and how the agency could respond to it when he wrote in the Arts Endowment's 1979 *Annual Report:*

"The Endowment's Theater Program stands at a crossroads. On one hand, the Program can choose safety, staying just behind the field, behind inflation, behind the sure warhorses of production and plays. Or the Program can begin to shift priorities, to try new ideas, new directions. We are taking the latter path."

This latter path resulted in establishing new funding programs designed to encourage and support young artists with fresh concepts and new ideas:

• Director Fellowships to assist the career development of directors who have demonstrated an ability and commitment to work in professional theater

• Artistic Advancement/Ongoing Ensembles to help existing theater companies create or strengthen relationships with their resident artists

• Professional Theater Presenters to reach underserved audiences by supporting performances by nonprofit professional touring companies in places where such work is not usually available to audiences

• Designer Fellowships to provide individual stage designers of exceptional talent, who work in the American nonprofit professional theaters, with financial support and creative opportunities

The structure of the Theater Program continued to evolve. By 1984, the Arts Endowment was providing funding via ten separate theater categories, including those focused on touring, training, direction, playwriting, translation, and other special projects, but by 1986 these had been consolidated into four major core categories: Support to Individuals, National Resources, Professional Theater Companies, and Artistic Advancement.

During this time, various economic and cultural shifts and pressures in the country fed a burgeoning solo performance scene whose artists reflected a wide variety of tastes and influences. These artists had minimal production costs and demands, and were able to create unconventional, highly individualistic pieces that could be performed practically anywhere. The flexible nature of this new arena provided a platform for a wide variety of artists to present—or confront—an audience with all manner of ideas, performance styles, and individual perspectives. The influence that these artists carried with them was as broad as any that had been exhibited from the American stage and included not only classical and modern theater, but popular dance and downtown art scenes as well.

In May of 1990, Chairman John Frohnmayer, acting on recommendation of the National Council on the Arts, rejected grants to performance artists Karen Finley, Tim Miller, John Fleck, and Holly Hughes (who collectively became known as The NEA Four). The four artists sued the agency for the amounts of the grants resulting in a public controversy that led to pressure from Congress to eventually discontinue NEA support for individual artists and to make drastic cuts in its budget and staffing. As the NEA's grant process shifted away from discipline-based applications toward four new agency-wide categories—Creation and Presentation, Education and Access, Heritage and Preservation, Planning and Stabilization—the agency was pressed to demonstrate more directly the public benefits of its grants. The Theater Program turned directly toward its service organizations to sustain the infrastructure of the field, with the Theatre Communications Group (TCG) being the most prominent. Since then, the NEA has collaborated with TCG in a number of ways. For instance, the NEA/TCG Theater Residency Program for Playwrights was created in 1996 at the initiation of Chairman Jane Alexander and Theater Director Gigi Bolt, and support for early-career directors and designers was reshaped into the NEA/TCG Career Development Programs for Directors and Designers.

SHAKESPEARE ON MILITARY BASES

In 2004, in an effort to make good on its commitment to bring the arts to all Americans, the Arts Endowment created the first program in its history dedicated to reaching military personnel and their families. As part of the agency's Shakespeare in American Communities program, professional Shakespeare productions were presented at bases in 14 states. Supported by $1 million from the Department of Defense (DOD), the military tour was an unprecedented partnership at the time.

Alabama Shakespeare Festival's production of *Macbeth* was taken to 13 military installations in 2004. (Photo by Phil Scarsbrook)

Through this initiative, Alabama Shakespeare Festival brought its production of *Macbeth* to 13 military installations, with additional bases visited by the Aquila Theatre Company, The Acting Company, and Artists Repertory Theatre. Performances were accompanied by educational workshops for base youth whenever possible. Most bases did not have a conventional theater, therefore performances were presented in movie theaters, auditoriums, and in one case, an airplane hangar shared with fighter jets.

CONCLUSION

From its inception, the Arts Endowment's Theater Program focused on solidifying the artistic gains that had taken root in the field. The NEA was uniquely suited to enter into this struggling but potentially fertile environment, and to enable the best theater artists to pursue their best art and to broaden their exposure and impact.

The Arts Endowment is the largest funder of nonprofit theater in the United States, and can lay claim to playing a primary role in the expansion of nonprofit professional theater over the last 40 years. In 1965 there were a limited number of professional theater companies operating outside of New York. Since the Arts Endowment's creation, American theater has grown exponentially. According to IRS records, by 1990, there were 991 nonprofit theaters throughout the country that reported annual budgets of $75,000 or more. Today there are more than 2,000.

The quality of theater that has been produced through the Arts Endowment's support is remarkable. Of the 35 Pulitzer Prizes awarded in drama since 1965, 30 have gone to works that originated in an NEA-supported nonprofit theater, including *August: Osage County* by Tracy Letts, developed at Steppenwolf Theatre in Chicago; *Anna in the Tropics* by Nilo Cruz, developed by Florida's New Theater and New Jersey's McCarter Theatre; Suzan-Lori Parks's *Top Dog/Underdog*, developed at the Public

August: Osage County by Tracy Letts, winner of the 2008 Pulitzer Prize in Drama, was developed with NEA support by the nonprofit company Steppenwolf Theatre in Chicago, Illinois. (Photo by Michael Brosilow)

Theater in New York; and Doug Wright's *I Am My Own Wife*, developed through workshops at Chicago's About Face Theatre and California's La Jolla Playhouse.

The economic and cultural impact that American theater now has on the nation is substantial. According to TCG's "Theatre Facts 2005," the 1,490 documented professional theaters in America during that year alone contributed $1.53 billion to the U.S. economy in the form of payments for goods, services, and salaries (not including related induced spending for eating out, parking, babysitters, artists' living expenses, and other goods and services). The positive impact that these activities have had on the cultural health of the nation is no less compelling, if harder to quantify.

These numbers indicate a strong level of interest and participation among the American public in live theater. The field continues to face new challenges, however, in ensuring its ongoing health and vitality. Production costs and ticket prices continue to rise. As we move into the twenty-first century, entertainment and cultural programming available to the public via cable and satellite programming as well as through the on-demand convenience of TiVo, Netflix, and pay-per-view, provide the public with a wealth of cheap and convenient choices for their limited time and dollars.

The challenges facing the field of American theater today are substantial, but history has shown us that our greatest theatrical achievements of our past transpired in response to its greatest challenges. As Hallie Flanagan asserted in 1935 and Margo Jones and her many influential colleagues understood in the decades that followed, in order to thrive, the future of our American theater must be guided by deeply committed and authentic artistic ambitions. It must continue to engage our public in meaningful and transformative experiences that inform our understanding of ourselves and each other. Throughout its existence, the National Endowment for the Arts has sought out, celebrated, and supported the best of those efforts and has helped spur an enormous growth in the number of nonprofit theaters across the nation. Their combined civic impact, via the production of excellent plays, along with the delivery of arts education, outreach, and other civic-minded programs, has been one of the most encouraging cultural evolutions of our time.

Appendices

NATIONAL ENDOWMENT FOR THE ARTS CHAIRS

Roger Stevens
1965–69

Nancy Hanks
1969–77

Livingston Biddle
1977–81

Frank Hodsoll
1981–89

John Frohnmayer
1989–92

Jane Alexander
1993–97

Bill Ivey
1998–2001

Michael Hammond
2002

Dana Gioia
2003–09

President George W. Bush meets with members of the National Council on the Arts in the Oval Office in July 2006; from left: Teresa Lozano Long, Don V. Cogman, Mary D. Costa, Jerry Pinkney, Chairman Dana Gioia, President Bush, Karen Lias Wolff, Maribeth Walton McGinley, Gerard Schwarz, and Mark Hofflund. (White House Photo by Eric Draper)

NATIONAL COUNCIL ON THE ARTS MEMBERS 1964–2008

Maurice Abravanel
1970–76

Kurt Herbert Adler
1980–87

Margo Albert
1980–85

Marian Anderson
1966–72

Martina Arroyo
1976–82

Elizabeth Ashley
1965–66

William Bailey
1992–97

David Baker
1987–94

James Ballinger
2004–10

James Barnett
1980

Thomas Bergin
1979–84

Robert Berks
1969–70

Phyllis P. Berney
1986–91

Leonard Bernstein
1965–68

Theodore Bikel
1978–82

Anthony A. Bliss
1965–68

Sally Brayley Bliss
1987–94

Angus Bowmer
1974–79

Willard Boyd
1976–82

David Brinkley
1965

Nina Brock
1987–94

Richard F. Brown
1972–78

Trisha Brown
1994–97

Albert Bush-Brown
1965–70

Philip Brunelle
1992–96

Miguel Campaneria
2007–12

Henry J. Cauthen
1972–78

Norman B. Champ, Jr.
1979–86

Van Cliburn
1974–80

Don Cogman
2002–06

Mary D. Costa
2002–06

Phyllis Curtin
1988–91

Jean Dalrymple
1968–74

Gordon Davidson
1999–2004

Patrick Davidson
1996–2002

Hal C. Davis
1976–78

Kenneth Dayton
1970–76

Agnes de Mille
1965–66

Katharine Cramer DeWitt
2002–06

René d'Harnoncourt
1965–68

J. C. Dickinson, Jr.
1976–82

Richard C. Diebenkorn
1966–69

Ben Donenberg
2006–12

C. Douglas Dillon
1982–89

Allen Drury
1982–88

Charles Eames
1970–76

Clint Eastwood
1972–78

William Eells
1976–82

Duke Ellington
1968–74

Ralph Ellison
1965–66

Paul Engle
1965–70

Joseph Epstein
1985–94

Terry Evans
1996–2002

JoAnn Falletta
2008–12

Leonard L. Farber
1980

Ronald Feldman
1994–99

O'Neil Ford
1968–74

William P. Foster
1996–98

Helen Frankenthaler
1985–92

Martin Friedman
1979–84

Makoto Fujimura
2003–08

Hsin-Ming Fung
2001–02

Robert Garfias
1987–96

David H. Gelernter
2002–06

Virginia B. Gerity
1970–72

Roy M. Goodman
1989–96

Martha Graham
1985–87

Lee Greenwood
2008–14

Barbara Grossman
1994–99

Sandra Hale
1980

Donald Hall
1991–97

Lawrence Halprin
1966–72

Chico Hamilton
2006–2007

Marvin Hamlisch
1989

R. Philip Hanes, Jr.
1965–70

Hugh Hardy
1992–97

Joy Harjo
1998–2003

Mel Harris
1988–91

Huntington Hartford
1969–72

Rev. Gilbert Hartke, O.P.
1965–66

Helen Hayes
1966–69; 1971–72

Peter deCourcy Hero
1991–96

Charlton Heston
1966–72

Ronnie Heyman
1996–2002

Margaret Hillis
1985–91

Mark Hofflund
2005–08

Celeste Holm
1982–88

Richard Hunt
1968–74

Joan Israelite
2006–12

Marta Istomin
1991–97

Arthur I. Jacobs
1981–87

Judith Jamison
1972–77

Kenneth M. Jarin
1994–98

Colleen Jennings-
Roggensack
1994–97

Speight Jenkins
1996–2000

Robert Joffrey
1980–87

Bob Johnson
1987–94

James Earl Jones
1970–76

Herman David Kenin
1965–68

Charlotte Kessler
2006–12

M. Ray Kingston
1985–92

Ardis Krainik
1987–94

Eleanor Lambert
1965–66

Jacob Lawrence
1978–84

Warner Lawson
1965–68

Raymond J. Learsy
1982–88

N. Harper Lee
1966–72

Erich Leinsdorf
1980–84

Nathan Leventhal
1997–2004

Harvey Lichtenstein
1987–94

Samuel Lipman
1982–88

Teresa Lozano Long
2002–06

Bernard Lopez
1979–84

Bret Lott
2006–12

Wendy Luers
1988–96

Talbot MacCarthy
1985–91

Roger Mandle
1989–96

Jimilu Mason
1966–72

Marsha Mason
1997–2003

James McBride
2004–05

Louise McClure
1991–97

Maribeth McGinley
2002–06

Wallace D. McRae
1996–98

Charles McWhorter
1970–76

Robert Merrill
1968–74

Arthur Mitchell
1987–94

Toni Morrison
1980–87

Carlos Moseley
1985–91

Jacob Neusner
1985–90

Rev. Leo J. O'Donovan, S. J.
1994–98

Gregory Peck
1965–66; 1968–74

I.M. Pei
1980–87

William L. Pereira
1965–68

Jorge M. Perez
1994–98

Roberta Peters
1991–97

Jerry Pinkney
2003–08

Sidney Poitier
1966–70

Stephen Porter
2007–12

Earl A. Powell, III
2003

Barbara Ernst Prey
2008–14

Frank Price
2006–12

Harold Prince
1976–82

Lloyd Richards
1985–92

Jerome Robbins
1974–79

Cleo Parker Robinson
1999–2004

James D. Robertson
1972–78

Kevin Roche
1989

Richard Rodgers
1965–68

Lida Rogers
1980–87

Maureene Rogers
1978–84

Deedie Potter Rose
2002–06

James Rosenquist
1978–84

Judith Rubin
1994–2002

Rosalind Russell
1972–76

George Schaefer
1982–88

Franklin Schaffner
1976–82

Thomas Schippers
1974–76

Gunther Schuller
1974–80

Gerard Schwarz
2004–06

Rudolf Serkin
1968–74

George Seybolt
1974–80

Robert Shaw
1979–84

Beverly Sills
1970–76

David Smith
1965

Oliver Smith
1965–70

Joan Specter
1998–2003

Robert Stack
1982–88

John Steinbeck
1966–68

Isaac Stern
1965–70

Richard Stern
1996–2002

George Stevens, Sr.
1965–70

Ruth Carter Stevenson
1969–70

Jocelyn Levi Straus
1988–96

William E. Strickland, Jr.
1991–97

Geraldine Stutz
1976–82

James Johnson Sweeney
1965–68

Billy Taylor
1972–78

Terry Teachout
2004–10

Luis Valdez
1996–2003

William Van Allen
1982–88

Edward Villella
1968–74

E. Leland Webber
1970–76

Harry Weese
1974–80

Donald Weismann
1966–72

Eudora Welty
1972–78

Dolores Wharton
1974–80

George White
1992–97

Nancy White
1966–72

Anne Porter Wilson
1972–78

Robert Wise
1970–76

Otto Wittmann
1965–66

Catherine Yi-yu Cho Woo
1991–96

Townsend D. Wolfe, III
1996–2002

Karen Lias Wolff
2003–08

James Wood
1985–94

Jessie Woods
1979–85

Rachael Worby
1994–98

James Wyeth
1972–78

Rosalind W. Wyman
1979–85

Minoru Yamasaki
1965–69

Stanley Young
1965–66

National Medal of Arts Recipients

2008

Olivia de Havilland
actress

Fisk University Jubilee
Singers
choral ensemble

Ford's Theatre Society
theater and museum

Hank Jones
jazz musician

Stan Lee
comic book writer

José Limón Dance
Foundation
*modern dance company and
institute*

Jesús Moroles
sculptor

The Presser Foundation
music patron

The Sherman Brothers
songwriting team

2007

Morten Lauridsen
composer

N. Scott Momaday
author

Craig Noel
theater director

Roy R. Neuberger
arts patron

Les Paul
guitarist, inventor

Henry Steinway
piano manufacturer

George Tooker
painter

Andrew Wyeth
painter

U. of Idaho
Lionel Hampton
International Jazz Festival
music competition and festival

2006

William Bolcom
composer

Cyd Charisse
dancer

Roy DeCarava
photographer

Wilhelmina Cole Holladay
arts patron

Interlochen Center
for the Arts
school of fine arts

Gregory Rabassa
literary translator

Erich Kunzel
conductor

Preservation Hall Jazz Band
jazz ensemble

Viktor Schreckengost
industrial designer, sculptor

Ralph Stanley
bluegrass musician

2005

Louis Auchincloss
author

James DePreist
conductor

Paquito D'Rivera
jazz musician, composer

Robert Duvall
actor

Leonard Garment
arts patron

Ollie Johnston
film animator

Wynton Marsalis
jazz musician, arts advocate

Dolly Parton
singer, songwriter

Tina Ramirez
choreographer, artistic director

Pennsylvania Academy of
the Fine Arts
*school of fine arts and
museum*

2004

Ray Bradbury
author

Carlisle Floyd
opera composer

Frederick Hart
sculptor

Anthony Hecht
poet

John Ruthven
wildlife artist

Vincent Scully
*architectural historian and
educator*

Twyla Tharp
choreographer

Andrew W. Mellon
Foundation
philanthropic foundation

2003

Beverly Cleary
writer

Rafe Esquith
arts educator

Suzanne Farrell
dancer

Buddy Guy
blues musician

Ron Howard
*actor, director, writer,
producer*

Mormon Tabernacle Choir
choral group

Leonard Slatkin
conductor

George Strait
country singer, songwriter

Tommy Tune
*dancer, actor, choreographer,
director*

Austin City Limits
PBS television program

2002

Florence Knoll Bassett
architect

Trisha Brown
*artistic director,
choreographer, dancer*

Philippe de Montebello
museum director

Uta Hagen
actress, drama teacher

Lawrence Halprin
landscape architect

Al Hirschfeld
artist

George Jones
*country music composer,
performer*

Ming Cho Lee
theater designer

William "Smokey"
Robinson
singer songwriter

2001

Rudolfo Anaya
author

Johnny Cash
singer, songwriter

Kirk Douglas
actor

Helen Frankenthaler
painter

Judith Jamison
choreographer, dancer

Yo-Yo Ma
cellist

Mike Nichols
director

Alvin Ailey Dance
Foundation
*modern dance company and
school*

2000

Maya Angelou
poet

Eddy Arnold
country singer

Mikhail Baryshnikov
dancer

Benny Carter
jazz musician

Chuck Close
painter

Horton Foote
playwright, screenwriter

Lewis Manilow
arts patron

Claes Oldenburg
sculptor

Itzhak Perlman
violinist

Harold Prince
theater director, producer

Barbra Streisand
entertainer

National Public Radio,
Cultural Programming
Division
broadcaster

1999

Irene Diamond
arts patron

Aretha Franklin
singer

Michael Graves
architect, designer

Odetta
singer, music historian

Norman Lear
producer, writer, director

Rosetta LeNoire
actress, producer

Harvey Lichtenstein
arts administrator

Lydia Mendoza
singer

George Segal
sculptor

Maria Tallchief
dancer

The Juilliard School
performing arts school

1998

Jacques d'Amboise
*dancer, choreographer,
educator*

Antoine "Fats" Domino
rock 'n' roll pianist, singer

Ramblin' Jack Elliott
folk singer, songwriter

Frank Gehry
architect

Barbara Handman
arts advocate

Agnes Martin
visual artist

Gregory Peck
actor

Roberta Peters
opera singer

Philip Roth
writer

Gwen Verdon
actress, dancer

Sara Lee Corporation
corporate arts patron

Steppenwolf Theatre
Company
arts organization

1997

Louise Bourgeois
sculptor

Betty Carter
jazz vocalist

Agnes Gund
arts patron

Daniel Urban Kiley
landscape architect

Angela Lansbury
actor

James Levine
conductor

Tito Puente
Latin jazz musician

Jason Robards
actor

Edward Villella
dancer, choreographer

Doc Watson
bluegrass guitarist, vocalist

MacDowell Colony
artist colony

1996

Edward Albee
playwright

Sarah Caldwell
opera conductor

Harry Callahan
photographer

Zelda Fichandler
theater director, founder

Eduardo "Lalo" Guerrero
composer, musician

Lionel Hampton
jazz musician

Bella Lewitzky
dancer, choreographer, teacher

Vera List
arts patron

Robert Redford
actor, director, producer

Maurice Sendak
writer, illustrator

Stephen Sondheim
composer, lyricist

Boys Choir of Harlem
performing arts youth group

1995

Licia Albanese
opera singer

Gwendolyn Brooks
poet

B. Gerald and Iris Cantor
arts patrons

Ossie Davis and Ruby Dee
actors

David Diamond
composer

James Ingo Freed
architect

Bob Hope
entertainer

Roy Lichtenstein
painter, sculptor

Arthur Mitchell
dancer, choreographer

William S. Monroe
bluegrass musician

Urban Gateways
arts education organization

1994

Harry Belafonte
singer

Dave Brubeck
jazz musician, composer

Celia Cruz
singer

Dorothy DeLay
violin teacher

Julie Harris
actress

Erick Hawkins
choreographer

Gene Kelly
dancer, singer, actor

Pete Seeger
composer, lyricist, vocalist, banjo player

Catherine Filene Shouse
arts patron

Wayne Thiebaud
artist, teacher

Richard Wilbur
poet

Young Audiences
arts presenter

1993

Walter and Leonore Annenberg
arts patrons

Cabell "Cab" Calloway
jazz musician

Ray Charles
singer

Bess Lomax Hawes
folklorist

Stanley Kunitz
poet

Robert Merrill
baritone

Arthur Miller
playwright

Robert Rauschenberg
artist

Lloyd Richards
theatrical director

William Styron
writer

Paul Taylor
dancer, choreographer

Billy Wilder
movie director, writer, producer

1992

Marilyn Horne
opera singer

James Earl Jones
actor

Allan Houser
sculptor

Minnie Pearl
Grand Ole Opry performer

Robert Saudek
television producer, Museum of Broadcasting founding director

Earl Scruggs
banjo player

Robert Shaw
conductor, choral director

Billy Taylor
jazz musician

Robert Venturi and Denise Scott Brown
architects

Robert Wise
film producer, director

AT&T
corporate arts patron

Lila Wallace-Reader's Digest Fund
foundation arts patron

1991

Maurice Abravanel
conductor

Roy Acuff
country singer, bandleader

Pietro Belluschi
architect

J. Carter Brown
museum director

Charles "Honi" Coles
tap dancer

John O. Crosby
opera director, administrator

Richard Diebenkorn
painter

R. Philip Hanes, Jr.
arts patron

Kitty Carlisle Hart
*actress, singer, arts
administrator*

Pearl Primus
choreographer, anthropologist

Isaac Stern
violinist

Texaco Inc.
corporate arts patron

1990

George Francis Abbott
*actor, playwright, producer,
director*

Hume Cronyn
actor, director

Jessica Tandy
actress

Merce Cunningham
*choreographer, dance
company director*

Jasper Johns
painter, sculptor

Jacob Lawrence
painter

Riley "B.B." King
blues musician, singer

David Lloyd Kreeger
arts patron

Harris & Carroll Sterling
Masterson
arts patrons

Ian McHarg
landscape architect

Beverly Sills
opera singer, director

Southeastern Bell
Corporation
corporate arts patron

1989

Leopold Adler
preservationist, civic leader

Katherine Dunham
dancer, choreographer

Alfred Eisenstaedt
photographer

Martin Friedman
museum director

Leigh Gerdine
arts patron, civic leader

John Birks "Dizzy" Gillespie
jazz musician

Walker Kirtland Hancock
sculptor

Vladimir Horowitz
pianist

Czeslaw Milosz
poet

Robert Motherwell
painter

John Updike
author

Dayton Hudson
Corporation
corporate arts patron

1988

Saul Bellow
author

Helen Hayes
actress

Gordon Parks
photographer, film director

I.M. Pei
architect

Jerome Robbins
dancer, choreographer

Rudolf Serkin
pianist

Virgil Thomson
composer, music critic

Sydney J. Freedberg
art historian, curator

Roger L. Stevens
arts administrator

(Mrs. Vincent) Brooke Astor
arts patron

Francis Goelet
music patron

Obert C. Tanner
arts patron

1987

Romare Bearden
painter

Ella Fitzgerald
singer

Howard Nemerov
poet

Alwin Nikolais
dancer, choreographer

Isamu Noguchi
sculptor

William Schuman
composer

Robert Penn Warren
author

J. W. Fisher
arts patron

Dr. Armand Hammer
arts patron

Mr. and Mrs. Sydney Lewis
arts patrons

1986

Marian Anderson
opera singer

Frank Capra
film director

Aaron Copland
composer

Willem de Kooning
painter

Agnes de Mille
choreographer

Eva Le Gallienne
actress, author

Alan Lomax
folklorist, scholar

Lewis Mumford
philosopher, literary critic

Eudora Welty
author

Dominique de Menil
arts patron

Seymour H. Knox
arts patron

Exxon Corporation
corporate arts patron

1985

Elliott Carter, Jr.
composer

Ralph Ellison
author

José Ferrer
actor

Martha Graham
dancer, choreographer

Louise Nevelson
sculptress

Georgia O'Keeffe
painter

Leontyne Price
soprano

Dorothy Buffum Chandler
arts patron

Lincoln Kirstein
arts patron

Paul Mellon
arts patron

Alice Tully
arts patron

Hallmark Cards, Inc.
corporate arts patron

NOTE: In 1983, prior to the official establishment of the National Medal of Arts, the following artists and patrons received a medal from President Reagan at a White House luncheon arranged by the President's Committee on the Arts and the Humanities. They were: (artists) Pinchas Zukerman, Frederica Von Stade, Czeslaw Milosz, Frank Stella, Philip Johnson and Luis Valdez; (patrons) The Texaco Philanthropic Foundation, James Michener,* Philip Morris, Inc., The Cleveland Foundation, Elma Lewis, and The Dayton Hudson Foundation.

* who was considered a patron

NEA Jazz Masters

2009

George Benson
Jimmy Cobb
Lee Konitz
Toots Thielemans
Rudy Van Gelder
Snooky Young

2008

Candido Camero
Andrew Hill
Quincy Jones
Tom McIntosh
Gunther Schuller
Joe Wilder

2007

Toshiko Akiyoshi
Curtis Fuller
Ramsey Lewis
Dan Morgenstern
Jimmy Scott
Frank Wess
Phil Woods

2006

Ray Barretto
Tony Bennett
Bob Brookmeyer
Chick Corea
Buddy DeFranco
Freddie Hubbard
John Levy

2005

Kenny Burrell
Paquito D'Rivera
Slide Hampton
Shirley Horn
Artie Shaw
Jimmy Smith
George Wein

2004

Jim Hall
Chico Hamilton
Herbie Hancock
Luther Henderson
Nancy Wilson
Nat Hentoff

2003

Jimmy Heath
Elvin Jones
Abbey Lincoln

2002

Frank Foster
Percy Heath
McCoy Tyner

2001

John Lewis
Jackie McLean
Randy Weston

2000

David Baker
Donald Byrd
Marian McPartland

1999

Dave Brubeck
Art Farmer
Joe Henderson

1998

Ron Carter
James Moody
Wayne Shorter

1997

Billy Higgins
Milt Jackson
Anita O'Day

1996

Tommy Flanagan
J. J. Johnson
Benny Golson

1995

Ray Brown
Roy Haynes
Horace Silver

1994

Louie Bellson
Ahmad Jamal
Carmen McRae

1993

Milt Hinton
Jon Hendricks
Joe Williams

1992

Betty Carter
Dorothy Donegan
Harry "Sweets" Edison

1991

Danny Barker
Buck Clayton
Andy Kirk
Clark Terry

1990

George Russell
Cecil Taylor
Gerald Wilson

1989

Barry Harris
Hank Jones
Sarah Vaughan

1988

Art Blakey
Lionel Hampton
Billy Taylor

1987

Cleo Patra Brown
Melba Liston
Jay McShann

1986

Benny Carter
Dexter Gordon
Teddy Wilson

1985

Gil Evans
Ella Fitzgerald
Jonathan "Jo" Jones

1984

Ornette Coleman
Miles Davis
Max Roach

1983

Count Basie
Kenneth Clarke
Sonny Rollins

1982

Roy Eldridge
Dizzy Gillespie
Sun Ra

NEA OPERA
HONORS
RECIPIENTS

2008

Carlisle Floyd
Richard Gaddes
James Levine
Leontyne Price

NEA National Heritage Fellows

2008

Horace P. Axtell
Nez Perce drum maker, singer, tradition-bearer

Walter Murray Chiesa
traditional arts specialist and advocate

Dale Harwood
saddlemaker

Bettye Kimbrell
quilter

Jeronimo E. Lozano
Peruvian retablo maker

Oneida Hymn Singers of Wisconsin
hymn singers

Sue Yeon Park
Korean dancer and musician

Moges Seyoum
Ethiopian liturgical musician and scholar

Jelon Vieira
capoeira master

Dr. Michael White
traditional jazz musician and bandleader

Mac Wiseman
bluegrass musician

2007

Nicholas Benson
stone letter cutter and calligrapher

Sidiki Conde
Guinean dancer and musician

Violet de Cristoforo
haiku poet and historian

Agustin Lira
Chicano singer, musician, and composer

Julia Parker
Kashia Pomo basketmaker

Mary Jane Queen
Appalachian musician

Roland Freeman
photo documentarian, author, exhibit curator

Pat Courtney Gold
Wasco sally bag weaver

Eddie Kamae
Hawaiian musician, composer, and filmmaker

Joe Thompson
African-American string band musician

Irvin J. Trujillo
Rio Grande weaver

Elaine Hoffman Watts
klezmer musician

2006

Charles M. Carrillo
Santero

Delores Elizabeth Churchill
Haida cedar bark weaver

Henry Gray
blues piano player, singer

George Na'ope
Kumu hula (hula master)

Wilho Saari
Finnish kantelle player

Mavis Staples
gospel, rhythm and blues singer

Doyle Lawson
Gospel and bluegrass singer, arranger, bandleader

Esther Martinez
American Indian storyteller

Diomedes Matos
Puerto Rican luthier

Nancy Sweezy
folklorist

Treme Brass Band
New Orleans brass band

2005

Eldrid Skjold Arntzen
Norwegian American rosemaler

Earl Barthé
Creole building artisan

Chuck Brown
African-American musical innovator

Janette Carter
Appalachian musician, advocate

Michael Doucet
Cajun fiddler, composer, and band leader

Jerry Grcevich
Tamburitza musician, prim player

Grace Henderson Nez
Navajo weaver

Wanda Jackson
early country, rockabilly, and gospel singer

Herminia Albarrán Romero
paper-cutting artist

Beyle Schaechter-Gottesman
Yiddish singer, poet, songwriter

Albertina Walker
gospel singer

James Ka'upena Wong
Hawaiian chanter

2004

Anjani Ambegaokar
North Indian Kathak dancer

Charles "Chuck" T. Campbell
sacred steel guitar player

Joe Derrane
Irish-American button accordionist

Jerry Douglas
dobro player

Gerald "Subiyay" Miller
Skokomish oral tradition bearer, carver, basketmaker

Chum Ngek
Cambodian musician and teacher

Milan Opacich
tamburitza instrument maker

Eliseo and Paula Rodriguez
straw appliqué artists

Koko Taylor
blues musician

Yuqin Wang and Zhengli Xu
Chinese rod puppeteers

2003

Rosa Elena Egipciaco
Puerto Rican mundillo (bobbin lace) maker

Agnes "Oshanee" Kenmille
Salish beadworker and regalia maker

Norman Kennedy
weaver, singer, storyteller

Roberto and Lorenzo Martinez
Hispanic musicians

Norma Miller
African-American dancer, choreographer

Carmencristina Moreno
Mexican-American singer, composer, teacher

Ron Poast
Hardanger fiddle maker

Felipe and Joseph Ruak
Carolinian stick dance leaders

Manoochehr Sadeghi
Persian santur player

Nicholas Toth
diving helmet designer and builder

Jesus Arriada
Johnny Curutchet
Martin Goicoechea
Jesus Goni
Basque (Bertsolari) poets

2002

Ralph Blizard
old-time fiddler

Loren Bommelyn
Tolowa tradition bearer

Kevin Burke
Irish fiddler

Rose Cree and Francis Cree
Ojibwe basketmakers and storytellers

Luderin Darbone and Edwin Duhon
Cajun fiddler and accordionist

Nadim Dlaikan
Lebanese nye (reed flute) player

David "Honeyboy" Edwards
blues guitarist and singer

Flory Jagoda
Sephardic musician and composer

Clara Neptune Keezer
Passamaquoddy basketmaker

Bob McQuillen
contra dance musician and composer

Domingo "Mingo" Saldivar
Conjunto accordionist

Losang Samten
Tibetan sand mandala painter

Jean Ritchie
Appalachian musician and songwriter

2001

Celestino Avilés
santero

Mozell Benson
African-American quilter

Wilson "Boozoo" Chavis
Creole zydeco accordionist

Hazel Dickens
Appalachian singer-songwriter

João Oliveira dos Santos
Capoeira Angola master

Evalena Henry
Apache basketweaver

Peter Kyvelos
oud maker

Eddie Pennington
thumbpicking-style guitarist

Qi Shu Fang
Beijing opera performer

Seiichi Tanaka
Taiko drummer and dojo founder

Dorothy Trumpold
rug weaver

Fred Tsoodle
Kiowa sacred song leader

Joseph Wilson
folklorist, advocate and presenter

2000

Bounxou Chanthraphone
Laotian weaver

The Dixie Hummingbirds
African-American gospel quartet

Felipe García Villamil
Afro-Cuban drummer and santero

José González
hammock weaver

Nettie Jackson
Klickitat basketmaker

Santiago Jiménez, Jr.
Tejano accordionist and singer

Genoa Keawe
native Hawaiian singer and ukulele player

Frankie Manning
Lindy hop dancer, choreographer, and teacher

Joe Willie "Pinetop" Perkins
blues piano player

Konstantinos Pilarinos
orthodox Byzantine icon woodcarver

Chris Strachwitz
record producer and label founder

Dorothy Thompson
weaver

Don Walser
western singer and guitarist

1999

Frisner Augustin
Haitian drummer

Lila Greengrass Blackdeer
Ho-Chunk black ash basketmaker and needleworker

Shirley Caesar
African-American gospel singer

Alfredo Campos
horse-hair hitcher

Mary Louise Defender Wilson
Dakotah-Hidatsa traditionalist and storyteller

Jimmy "Slyde" Godbolt
tap dancer

Ulysses Goode
Western Mono basketmaker

Bob Holt
Ozark fiddler

Zakir Hussain
North Indian master tabla drummer

Elliott "Ellie" Mannette
steelpan builder, tuner, and player

Mick Moloney
Irish musician

Eudokia Sorochaniuk
*Ukrainian weaver and textile
artist*

Ralph W. Stanley
master boatbuilder

1998

Apsara Dancers
*Cambodian traditional
dancers and musicians*

Eddie Blazonczyk
*Polish-American musician
and bandleader*

Dale Calhoun
Anglo-American boat builder

Bruce Caesar
*Sac and Fox-Pawnee German
silversmith*

Antonio De La Rosa
Tejano conjunto accordionist

Epstein Brothers
Jewish klezmer musicians

Sophia George
Yakama-Colville beadworker

Nadjeschda Overgaard
*Danish-American Hardanger
needleworker*

Harilaos Papapostolou
Greek Byzantine chanter

Claude "The Fiddler"
Williams
*African-American jazz and
swing fiddler*

Roebuck "Pops" Staples
*African-American gospel and
blues musician*

1997

Edward Babb
shout band leader

Charles Brown
blues pianist and composer

Gladys Clark
Cajun spinner and weaver

Hua Wenyi
Chinese Kunqu opera singer

Ali Akbar Khan
*North Indian sarod player
and raga composer*

Ramón José López
Santero and metalsmith

Jim and Jesse McReynolds
bluegrass musicians

Phong Nguyen
*Vietnamese musician and
scholar*

Hystercine Rankin
African-American quilter

Francis Whitaker
*blacksmith and ornamental
ironworker*

1996

Obbo Addy
Ghanian-American drummer

Betty Pisio Christenson
*Ukranian-American egg
decorator*

Paul Dahlin
Swedish-American fiddler

Juan Gutiérrez
Puerto Rican drummer

Solomon and Richard
Ho'opi'i
Hawaiian singers

Will Keys
Appalachian banjo player

Joaquin Flores Lujan
Chamorro blacksmith

Eva McAdams
Shoshone regalia maker

John Mealing and Cornelius
Wright, Jr.
*African-American railroad
worksong singers*

Vernon Owens
stoneware potter

Dolly Spencer
Inupiat dollmaker

1995

Bao Mo-Li
*Chinese-American jing erhu
player*

Mary Holiday Black
Navajo basketweaver

Lyman Enloe
old-time fiddler

Donny Golden
Irish-American stepdancer

Wayne Henderson
luthier

Bea Ellis Hensley
blacksmith

Nathan Jackson
Tlingit Alaska native woodcarver, metalsmith, and dancer

Danongan Kalanduyan
Filipino-American kulintang musician

Robert Jr. Lockwood
African-American delta blues guitarist

Israel "Cachao" Lopez
Afro-Cuban bassist, composer, and bandleader

Nellie Star Boy Menard
Lakota Sioux quiltmaker

Buck Ramsey
cowboy poet and singer

1994

Liz Carroll
Irish-American fiddler

Clarence Fountain and the Blind Boys
African-American gospel singers

Mary Mitchell Gabriel
Passamaquoddy Native American basketmaker

Johnny Gimble
Anglo western swing fiddler

Frances Varos Graves
Hispanic-American colcha embroiderer

Violet Hilbert
Skagit Native American storyteller

Sosei Shizuye Matsumoto
Japanese chado tea ceremony master

D.L. Menard
Cajun musician and songwriter

Simon Shaheen
Arab-American oud player

Lily Vorperian
Armenian marash-style embroiderer

Elder Roma Wilson
African-American harmonica player

1993

Santiago Almeida
Texas-Mexican conjunto musician

Kenny Baker
bluegrass fiddler

Inez Catalon
French Creole singer

Nicholas and Elena Charles
Yupik woodcarver, maskmaker, and skinsewer

Charles Hankins
Boatbuilder

Nalani Kanaka'ole and Pualani Kanaka'ole Kanahele
hula masters

Everett Kapayou
Mesquakie Native American singer

McIntosh County Shouters
African-American spiritual/shout performers

Elmer Miller
bit and spur maker/silversmith

Jack Owens
blues singer and guitarist

Mone and Vanxay Saenphimmachak
Lao weavers, needleworkers, and loommakers

Liang-xing Tang
Chinese-American pipa (lute) player

1992

Francisco Aguabella
Afro-Cuban drummer

Jerry Brown
southern stoneware tradition potter

Walker Calhoun
Cherokee musician, dancer, and teacher

Clyde Davenport
Appalachian fiddler

Belle Deacon
Athabascan basketmaker

Nora Ezell
African-American quilter

Gerald R. Hawpetoss
Menominee/Potawatomi regalia maker

Fatima Kuinova
Bukharan Jewish singer

John Naka
bonsai sculptor

Ng Sheung-Chi
*Chinese Toissan muk'yu folk
singer*

Marc Savoy
*Cajun accordion maker and
musician*

Othar Turner
African-American fife player

T. Viswanathan
South Indian flute master

1991

Etta Baker
African-American guitarist

George Blake
*Hupa-Yurok Native
American craftsman*

Jack Coen
Irish-American flutist

Rose Frank
*Native American cornhusk
weaver*

Eduardo "Lalo" Guerrero
*Mexican-American singer,
guitarist, and composer*

Khamvong Insixiengmai
Lao southeast Asian singer

Don King
western saddlemaker

Riley "B.B." King
African-American bluesman

Esther Littlefield
Tlingit regalia maker

Seisho "Harry" Nakasone
*Okinawan-American
musician*

Irván Perez
Isleno (Canary Island) singer

Morgan Sexton
*Appalachian banjo player and
singer*

Nikitas Tsimouris
*Greek-American bagpipe
player*

Gussie Wells
African-American quilter

Arbie Williams
African-American quilter

Melvin Wine
Appalachian fiddler

1990

Howard Armstrong
*African-American string band
musician*

Em Bun
Cambodian silk weaver

Natividad Cano
Mexican mariachi musician

Giuseppe and Raffaela
DeFranco
*Southern Italian musicians
and dancers*

Maude Kegg
*Ojibwe storyteller and
craftsman*

Kevin Locke
*Lakota flute player, singer,
dancer, and storyteller*

Marie McDonald
Hawaiian lei maker

Wallace McRae
cowboy poet

Art Moilanen
Finnish accordionist

Emilio Rosado
woodcarver

Robert Spicer
flatfoot dancer

Douglas Wallin
Appalachian ballad singer

1989

John Cephas
*Piedmont blues guitarist and
singer*

The Fairfield Four
*African-American a capella
gospel singers*

Jose Gutierrez
*Mexican jarocho musician
and singer*

Richard Avedis Hagopian
Armenian oud player

Christy Hengel
*German-American concertina
maker*

Ilias Kementzides
Pontic Greek lyra player

Ethel Kvalheim
Norwegian rosemaler

Vanessa Paukeigope
Morgan
Kiowa regalia maker

Mabel E. Murphy
Anglo-American quilter

LaVaughn E. Robinson
African-American tapdancer

Earl Scruggs
bluegrass banjo player

Harry V. Shourds
wildlife decoy carver

Chesley Goseyun Wilson
Apache fiddle maker

1988

Pedro Ayala
Mexican-American accordionist

Kepka Belton
Czech-American egg painter

Amber Densmore
New England quilter and needleworker

Michael Flatley
Irish-American stepdancer

Sister Rosalia Haberl
German-American bobbin lace maker

John Dee Holeman
African-American dancer, musician, and singer

Albert "Sunnyland Slim" Luandrew
African-American blues pianist and singer

Yang Fang Nhu
Hmong weaver and embroiderer

Kenny Sidle
Anglo-American fiddler

Willa Mae Ford Smith
African-American gospel singer

Clyde "Kindy" Sproat
Hawaiian cowboy singer and ukulele player

Arthel "Doc" Watson
Appalachian guitar player and singer

1987

Juan Alindato
carnival maskmaker

Louis Bashell
Slovenian accordionist and polka master

Genoveva Castellanoz
Mexican-American corona maker

Thomas Edison "Brownie" Ford
Anglo-Comanche cowboy singer and storyteller

Kansuma Fujima
Japanese-American dancer

Claude Joseph Johnson
African-American religious singer and orator

Raymond Kane
Hawaiian slack key guitarist and singer

Wade Mainer
Appalachian banjo picker and singer

Sylvester McIntosh
Crucian singer and bandleader

Allison "Tootie" Montana
Mardi Gras chief and costume maker

Alex Moore, Sr.
African-American blues pianist

Emilio and Senaida Romero
Hispanic-American craftsworkers in tin embroidery

Newton Washburn
Split ash basketmaker

1986

Alphonse "Bois Sec" Ardoin
African-American Creole accordionist

Earnest Bennett
Anglo-American whittler

Helen Cordero
Pueblo potter

Sonia Domsch
Czech-American bobbin lace maker

Canray Fontenot
African-American Creole fiddler

John Jackson
African-American songster and guitarist

Peou Khatna
Cambodian court dancer and choreographer

Valerio Longoria
Mexican-American accordionist

Joyce Doc Tate Nevaquaya
Comanche flutist

Luis Ortega
Hispanic-American rawhide worker

Ola Belle Reed
Appalachian banjo picker and singer

Jennie Thlunaut
Tlingit Chilkat blanket weaver

Nimrod Workman
Appalachian ballad singer

1985

Eppie Archuleta
Hispanic weaver

Periklis Halkias
Greek clarinetist

Jimmy Jausoro
Basque accordionist

Meali'i Kalama
Hawaiian quilter

Lily May Ledford
Appalachian musician and singer

Leif Melgaard
Norwegian woodcarver

Bua Xou Mua
Hmong musician

Julio Negrón-Rivera
Puerto Rican instrument maker

Alice New Holy Blue Legs
Lakota Sioux quill artist

Glenn Ohrlin
Cowboy singer, storyteller, and illustrator

Henry Townsend
blues musician and songwriter

Horace "Spoons" Williams
spoons player and poet

1984

Clifton Chenier
Creole accordionist

Bertha Cook
knotted bedspread maker

Joseph Cormier
Cape Breton violinist

Elizabeth Cotten
African-American songstress and songwriter

Burlon Craig
potter

Albert Fahlbusch
hammered dulcimer maker and player

Janie Hunter
African-American singer and storyteller

Mary Jane Manigault
African-American seagrass basketmaker

Genevieve Mougin
Lebanese-American lace maker

Martin Mulvihill
Irish-American fiddler

Howard "Sandman" Sims
African-American tap dancer

Ralph Stanley
Appalachian banjo player and singer

Margaret Tafoya
Santa Clara pueblo potter

Dave Tarras
klezmer clarinetist

Paul Tiulana
Eskimo maskmaker, dancer, and singer

Cleofes Vigil
Hispanic storyteller and singer

Emily Kau'i Zuttermeister
hula master

1983

Sister Mildred Barker
Shaker singer

Rafael Cepeda
bomba musician and dancer

Ray Hicks
Appalachian storyteller

Stanley Hicks
Appalachian musician, storyteller, and instrument maker

John Lee Hooker
blues guitarist and singer

Mike Manteo
Sicilian marionettist

Narciso Martínez
Texas-Mexican accordionist and composer

Lanier Meaders
potter

Almeda Riddle
ballad singer

Simon St. Pierre
French-American fiddler

Joe Shannon
Irish piper

Alex Stewart
cooper and woodworker

Ada Thomas
Chitimacha basketmaker

Lucinda Toomer
African-American quilter

Lem Ward
decoy carver and painter

Dewey Williams
shape note singer

1982

Dewey Balfa
Cajun fiddler

Joe Heaney
Irish singer

Tommy Jarrell
Appalachian fiddler

Bessie Jones
Georgia Sea Island singer

George López
Santos woodcarver

Brownie McGhee
blues guitarist

Hugh McGraw
shape note singer

Lydia Mendoza
Mexican-American singer

Bill Monroe
bluegrass musician

Elijah Pierce
carver and painter

Adam Popovich
Tamburitza musician

Georgeann Robinson
Osage ribbonworker

Duff Severe
western saddlemaker

Philip Simmons
ornamental ironworker

Sanders "Sonny" Terry
blues musician

CHAIRMAN'S MEDAL

Created in 2003, this medal recognizes individuals who have provided sustained and distinguished service to the NEA and the organizations it supports.

2008

Susan T. Chandler
*Arts Midwest
Assistant Director*

Richard J. Deasy
*Arts Education Partnership
Director*

David J. Fraher
*Arts Midwest
Executive Director*

Makoto Fujimura
*National Council on the Arts
former member*

Chico Hamilton
*National Council on the Arts
former member*

Mark Hofflund
*National Council on the Arts
former member*

Felicia Knight
Former NEA Director

Anne-Imelda Radice
*Institute of Museum and
Library Services Director*

2007

Andrew Carroll
*Editor, Operation
Homecoming anthology*

Dan Harpole
*Idaho Commission on the
Arts Executive Director*

Bill McFarland
*International Association for
Jazz Education President*

Stephen Lang
*Writer and Actor, Beyond
Glory*

2006

Edward H. Able Jr.
*American Association of
Museums*

Don Cogman
*National Council on the Arts
former member*

Mary D. Costa
*National Council on the Arts
former member*

Carlos de Icaza
*Ambassador of Mexico
to the US*

Katharine Cramer DeWitt
*National Council on the Arts
former member*

Anne Heiligenstein
*Director of Projects, Office of
Mrs. Bush*

Hernán Lara Zavala
Writer and educator

Teresa Lozano Long
*National Council on the Arts
former member*

Maribeth McGinley
*National Council on the Arts
former member*

Alejandro Negrin
*Minister for Cultural Affairs
of the Embassy of Mexico*

Deedie Potter Rose
*National Council on the Arts
former member*

2005

Lawrence Bridges
Red Car Productions

Gordon Davidson
*Mark Taper Forum/Center
Theatre Group*

Rebecca Turner Gonzales
Former NEA Director

R. Philip Hanes, Jr.
*National Council on the Arts
former member*

Frank Hodsoll
Former NEA Chairman

Louise McClure
*National Council on the Arts
former member*

Suraya Mohamed
National Public Radio

Molly Murphy
National Public Radio

Benjamin K. Roe
National Public Radio

A. B. Spellman
Former NEA Deputy

NEA Discipline Directors

Arts Education

John Kerr
1969–84

Joe Prince
1981–86

Warren Newman
1987–89

David O'Fallon
1991–92

Doug Herbert
1992–2004

David Steiner
2004–05

Sarah Bainter Cunningham
2005–present

Dance

June Arey
1967–73

Don Anderson
1972–74

Joseph Krakora
1975

Suzanne Weil
1976–77

Rhoda Grauer
1978–81

Nigel Redden
1982–85

Sali Ann Kriegsman
1986–95

Douglas C. Sonntag
1997–present

Design

Paul Spreiregen
1966–70

Bill Lacy
1970–77

Michael Pittas
1978–84

Adele Chatfield-Taylor
1984–88

Randolph McAusland
1989–91

Mina Berryman
1991–93

Samina Quraeshi
1994–97

Mark Robbins
1999–2002

Jeff Speck
2003–07

Maurice Cox
2007–present

Expansion Arts

Vantile Whitfield
1971–77

A. B. Spellman
1978–91

Patrice Walker Powell
1991–95

FOLK AND TRADITIONAL ARTS

Alan Jabbour
1974–76

Bess Lomax Hawes
1977–92

Daniel Sheehy
1992–2000

Barry Bergey
2001–present

INTER-ARTS/ PRESENTING

Esther Novak
1980–81

Renee Levine
1982–85

Peter Pennekamp
1987–89

Lenwood Sloan
1990–94

Omus Hirshbein
1995–97
Music, Opera, Presenting

Patrice Walker Powell
1997–99

Vanessa Whang
1999–2003

Mario Garcia Durham
2004–present

LITERATURE

Carolyn Kizer
1967–69

Len Randolph
1970–78

David Wilk
1979–81

Frank Conroy
1982–87

Stephen Goodwin
1988–90

Joe David Bellamy
1990–92

Gigi Bradford
1992–97

Cliff Becker
1998–2005

David Kipen
2005–present
National Reading Initiatives

Jon Parrish Peede
2007–present
Grants Programs

LOCAL ARTS AGENCIES

Robert Cannon
1983–87

Richard Huff
1988–91

Diane Mataraza
1992–95

Patrice Walker Powell
1995–present

MUSEUMS

Thomas Leavitt
1970–73

John Spencer
1973–77

Tom Freudenheim
1979–82

Andrew Oliver
1983–94

Jennifer Dowley
1994–99
Museums, Visual Arts

Saralyn Reece Hardy
1999–2002
Museums, Visual Arts

Robert H. Frankel
2002–present
Museums, Visual Arts

MUSIC

Frances Taylor
1966–68

Walter Anderson
1968–77

Ezra Laderman
1978–81

Adrian Gnam
1982–84

Edward Birdwell
1984–86

William Vickery
1988–90

D. Antoinette Handy
1990–93

Omus Hirshbein
1993–97
Music, Opera, and Presenting

Wayne S. Brown
1997–present
Music, Opera

OPERA/
MUSICAL THEATER

James Ireland
1979

Edward Corn
1980–81

Ann Francis Darling
1982–83

Patrick J. Smith
1985–89

Tomas C. Hernandez
1991–94

Omus Hirshbein
1994–97
Music, Opera, and Presenting

Wayne S. Brown
1997–present
Music, Opera

Gigi Bolt
1996–2006
Theater, Musical Theater

Bill O'Brien
2006–present
Theater, Musical Theater

PUBLIC MEDIA/
MEDIA ARTS

Chloe Aaron
1970–76

Brian O'Doherty
1976–96

Ted Libbey
2002–present

STATE AND
REGIONAL
PARTNERSHIPS

Charles Mark
1967–68

Clark Mitze
1968–74

Henry Putsch
1976–79

Anthony Turney
1980–82

Ed Dickey
1988–2004

John E. Ostrout
2004–present

THEATER

Ruth Mayleas
1965–77

Arthur Ballet
1978–81

Edward Martenson
1982–86

Robert Marx
1987–89

Jessica Andrews
1989–90

Ben Cameron
1990–92

Keryl McCord
1992–95

Gigi Bolt
1995–2006
Theater, Musical Theater

Bill O'Brien
2006–present
Theater, Musical Theater

VISUAL ARTS

Henry Geldzahler
1966–69

Brian O'Doherty
1969–76

James Melchert
1977–81

Benny Andrews
1982–84

Richard Andrews
1985–87

Susan Lubowsky
1989–92

Rosalyn Alter
1992–94

Jennifer Dowley
1994–99
Museums, Visual Arts

Saralyn Reece Hardey
1999–2002
Museums, Visual Arts

Robert H. Frankel
2002–present
Museums, Visual Arts

Index

Page numbers in *italics* indicate photographs.

Brustein, Robert, 106, 245
Buchanan, John E., 164
Buchanan, Patrick, 92, 108
budget for NEA. *See* funding for
	NEA
Bun, Em, 272
Burger, Warren E., 71
Burke, Kevin, 268
Burrell, Kenny, 265
Burton, Scott, 210
Bush-Brown, Albert, 17, 255
Bush, George H. W., 90, 92,
	94–95, *95*, 111
Bush, George W., 106, 134, 135,
	138, 139, *143*, 145, 147,
	162–63, 255
Bush, Laura, 135, 143, *143*, 150,
	154, 157–58, 162
Business Committee for the
	Arts, 17
*Butch Cassidy and the Sundance
	Kid* (film), 205
Buying Time (ed. Walker), 75–76
Byrd, Donald, 233, 265

C
Caesar, Bruce, 270
Caesar, Shirley, 269
Cage, John, 229
Calder, Alexander, 23, 42, 137,
	214
Caldwell, Sarah, 261
Calhoun, Dale, 270
Calhoun, Walker, 271
Calla Lily (photograph;
	Mapplethorpe), *93*
Callahan, Harry, 210, 261
Callaloo (publisher), 191
Calloway, Cabel "Cab," 262
Camera Three (television), 198
*Camerawork: A Journal of
	Photographic Arts,* 216
Camero, Candido, 265
Cameron, Ben, 279
Campana, Dino, 26
Campaneria, Miguel, 255
Campbell, Charles "Chuck" T.,
	268
Campos, Alfredo, 269
*Can Poetry Matter?: Essays on
	Poetry and American Culture*
	(Gioia), 147
Cannon, Hal, 77
Cannon, Robert, 278

Cano, Natividad, 272
Cantor, B. Gerald and Iris, 262
Cantor Fitzgerald, 137
Capra, Frank, 24, 75, 264
Card, Andrew, 99
Carrillo, Charles M., 267
Carmen (opera), 223
Carnegie Hall, NYC, 27, 223
Carnegie-Mellon University Art
	Gallery, 89
Carroll, Andrew, 152, 195
Carroll, Liz, 271
Carruth, Hayden, 26, 186
Carter, Benny, 260, 266
Carter, Betty, 261, 265
Carter, Elliott, Jr., 74, 227, 229,
	264
Carter G.Woodson Foundation,
	114
Carter, Janette, 267
Carter, Jimmy, 52, *53,* 55, 57
Carter, Ron, 265
Carver, Raymond, 76
Casals, Pablo, *4,* 5, 9
Cash, Johnny, 143, 260
Castellanoz, Genoveva, 273
Castle of Chillon (painting;
	Courbet), 101
Castro, Fidel, 92
Catalon, Inez, 271
Cather, Willa, 158
Catholic University of America
	Speech and Drama Depart-
	ment, 17
Cauthen, Henry J., 255
CCLM (Coordinating Council
	of Literary Magazines),
	now Council of Literary
	Magazines and Presses
	(CLMP), 25, 65, 191
ceiling on grants, removal of,
	62
censorship issues. See contro-
	versial NEA awards
Census Bureau, 101, 116, 177
Center for Contemporary
	Music, Mills College, 60
Center Opera Company of the
	Walker Arts Center, 230
Center Stage of Baltimore, 247
Central City Opera, Denver,
	CO, 40
Cepeda, Rafael, 274
Cephas, John, 272

Cezanne (exhibit), 217
Chairman's Medal, 276
Challenge America, 130, 134,
	163, 165
Challenge Grants Program,
	44–46, 103, 114, 178, 209,
	246
Chamber Music America, 236
Chamber Music Rural Residen-
	cies, 114, 235
Champ, Norman B., Jr., 255
Chan Is Missing (film), 205
Chandler, Dorothy Buffum, 75,
	264
Chandler, Susan T., 276
*Changing the Beat: A Study of the
	Worklife of Jazz Musicians*
	(NEA), 234–35
Chanthraphone, Bounxou, 269
Chaplin, Charlie, 83, *196,* 204
Chapman, Aida, 72
Charisse, Cyd, 259
Charles, Nicholas and Elena,
	271
Charles, Ray, 262
Charley's Aunt (play; Thomas),
	244
Charlin Jazz Society, 73
Chase, Lucia, 19
Chase, Shana, 164
Chatfield-Taylor, Adele, 80, 277
Chavis, Wilson "Boozoo," 269
Chekhov, Anton, 25, 244
Chenier, Clifton, 58, 274
Chevron (USA), 72
Chiara Quartet, 236
Chicago Symphony Orchestra,
	40, 202, 229
Chiesa, Walter Murray, 267
Chihuly, Dale, 210
Chin, Mel, 108
choral music, 61, 225–27,
	236–37. *See also* music
Choreographer Fellowships,
	174, 175, 182
choreography. *See* dance
Chorus America, 237
Christenson, Betty Pisio, 270
Christian, Jodie, *202*
Chu, David, 277
Churchill, Delores Elizabeth,
	267
Cincinnati Playhouse in the
	Park, 247, 248

Miss, Mary, 210
Mississippi Opera Association,
40
Mitchell, Arthur, 143, 257, 262
Mitchell, Waddie, 77
Mitze, Clark, 279
Mo-Li, Bao, 270
Mo Yan, 189
Mobile Jazz Festival, 40
Modern Jazz Quartet, 72
Mohamed, Suraya, 276
Moilanen, Art, 272
Molitor, Gary, 21
Moloney, Mick, 270
Momaday, N. Scott, 259
Mona Lisa (painting; da Vinci),
6
Mondale, Joan, 56
Mondale, Walter, 56
*Mongolia: The Legacy of Chinggis
Khan* (exhibit), 220
Monk, Meredith, 176
Monroe, Bill, 58, 275
Monroe, William S., 262
Montana, Allison "Tootie," 273
Monte, Elisa, *103*
Moody, James, 265
Moore, Alex, Sr., 273
Moore, Douglas, 201
Moore, Lorrie, 188
Moore, Scotty, *201*
Moreno, Carmencristina, 268
Morgan, Vanessa Paukeigope,
272
Morgenstern, Dan, 233, 265
Mormon Tabernacle Choir, 260
Los Moros y los Cristianos (play),
57
Moroles, Jesús, 259
Morris, Errol, 205, 206
Morrison, Toni, 41, *190*, 190,
257
Moseley, Carlos, 257
Moses and Aaron (opera;
Schoenberg), 226
Mosley, Walter, 189
Motherwell, Robert, 21, 263
Motion Picture Association of
America, 24, 150, 204
motion pictures. *See* film
Mougin, Genevieve, 274
movies. *See* film
Mua, Bua Xou, 274
Mulvihill, Martin, 274

Mumford, Lewis, 75, 264
Murphy, Molly, 276
Murphy, Mabel E., 272
Muse of Fire (film), 153, 195
Museum of Contemporary Art,
Chicago, 90
Museum of Contemporary Art,
San Diego, 217
Museum of Fine Arts, Boston,
131
Museum of Modern Art, NYC,
17, 34, 204
museums, 209, 217–21. *See also*
visual arts, and individual
museums
American Masterpieces, 219
audience development,
217–18
directors of museum pro-
gram, list of, 278
exhibitions, 211, 217–18
fellowships for museum pro-
fessionals, 219
indemnity program, 44, 164,
220–21
preservation and documenta-
tion, 218
Museums USA: A Survey Report
(NEA), 50
music, 223–38. *See also* com-
posers; jazz; opera; and
specific artists, companies,
and pieces
under Alexander, 114
audience development, 227
before the NEA, 223–25
under Biddle, 60–62, 233
chamber music, 114, 235–36
choral singing, 61, 225–27,
236–37
directors, list of, 278
fellowships, 237–38
under Hanks, 40
NCA and, 225–26
NEA Opera-Musical Theater
Program, 60–62, 278
orchestras, 228–30
research project on classical
music on nonprofit radio,
143
residence programs, 114, 229,
236
significant NEA grants for,
20, 26–27, 226–27

musical theater, 60–62, 278
My Antonia (novel; Cather), 158

N
Nadler, Jerrold, 162
Nafisi, Azar, 161
Nagin, Ray, 80
Naka, John, 272
Nakasone, Seisho "Harry," 272
Nancy Hanks Center (Old
Post Office Building,
Washington, D.C.), 43, 53,
137, 159–60
Na'ope, George, 267
A Nation at Risk (Department of
Education report), 85
National Academy of Recording
Arts and Sciences (Gram-
mies), 127, 128, 223, 226,
237
National Arts and Cultural
Development Act (1964), 15
National Arts Foundation,
legislation establishing, 14
National Assembly of State Arts
Agencies, 17, 122, 177
National Association for
Regional Ballet, 64
National Association of Artists'
Organizations, 114
National Book Award, 186
National Book Critics Circle
Award, 186
National Book Festival, *193*, 195
National Center for Charitable
Statistics, 177
National Center for Film and
Video Preservation, 24, 83,
204
National Center for Jewish
Film, Waltham, MA, 204
National College Choreography
Initiative, 182
National Council on the Arts
(NCA)
advisory panels. *See* advisory
panels
Congressional ex officio
members, 259
establishment and first
meetings of, 14, 15–16, *184*
jazz, attitude towards, 50
members of, 16–17, 41, 120,
225–26, 243, 255–59